GREEK MONUMENTAL
BRONZE SCULPTURE

GREEK MONUMENTAL BRONZE SCULPTURE

Photographs by
DAVID FINN

Text by
CAROLINE HOUSER

THE VENDOME PRESS
New York Paris

Designer: Ulrich Ruchti
Assistant designer: Leslie Rosenberg
Editor: Daniel Wheeler

Copyright © 1983 The Vendome Press
First published in Great Britain by Thames and Hudson

First published in the United States of America by
The Vendome Press, 515 Madison Avenue, N.Y., N.Y. 10022
Distributed by The Viking Press, 40 West 23rd Street, N.Y., N.Y. 10010
Distributed in Canada by Methuen Publications

Library of Congress Cataloging in Publication Data
Finn, David.
 Greek monumental bronze sculpture.
 Bibliography: p.
 1. Bronzes, Greek. 2. Gods, Greek, in art.
3. Statues—Greece. I. Houser, Caroline. II. Title.
NB140.F5 1983 733'.3 83-14661
ISBN 0-86565-037-3

Printed and bound in Italy by
Grafiche Editoriali Ambrosiane SpA, Milan

CONTENTS

CHRONOLOGY

Among the eighteen sculptures reproduced in this book, only the *Delphi Charioteer* can be dated by historical evidence. For the dates of the other works we are dependent upon stylistic comparisons made with marble sculpture, and any chronology prepared by this means must remain inexact, since the marble works themselves cannot be dated with certainty. Moreover, they are, for the most part, Roman copies made after lost Greek originals. The eighteen bronzes seen here all issued directly from the hands of ancient Greek masters, whose artistic personalities, like those of creative individuals in any other culture or period, would have developed at different rates. While this poses serious problems for anyone eager to assign precise dates to specific statues, the very strength of ancient Greek artistry has endowed each of our eighteen sculptures with stylistic qualities that are unmistakable. This, in turn, permits us to group the pieces in relation to periods during which scholarly opinion holds that those qualities generally prevailed.

LATE ARCHAIC, c. 530-480 B.C.
520-510 B.C. *Apollo* found in Piraeus. Piraeus Museum. See pages 52-57.
c. 500 B.C. *Zeus* from the sanctuary at Olympia. National Museum, Athens. See pages 34-35.
c. 500 B.C. *Poseidon* found in Livadhostro Bay. National Museum, Athens. See pages 44-48.

EARLY CLASSICAL, c. 480-450 B.C.
Early 5th century B.C. *Youth* from the Athenian Acropolis. National Museum, Athens. See pages 40-41.
c. 477 B.C. *Charioteer* from the sanctuary at Delphi. Delphi Museum. See pages 20-31.
c. 460 B.C. *Zeus* found offshore from Cape Artemision. National Museum, Athens. See pages 78-85.
Second quarter 5th century B.C. *Apollo* found near

the sanctuary at Tamassos, Cyprus. British Museum, London. See pages 72-75.

HIGH CLASSICAL, c. 450-400 B.C.
Mid-5th century B.C. *Warrior A* found near Riace Marina. National Museum, Reggio di Calabria. See pages 118-127.
Mid-5th century B.C. *Warrior B* found near Riace Marina. National Museum, Reggio di Calabria. See pages 128-133.

LATE CLASSICAL, c. 400-350/325 B.C.
Mid-4th century B.C. *Athena* found in Piraeus. Piraeus Museum. See pages 58-61.
Second half 4th century B.C. *Young Man (Paris?)* found offshore from Antikythera. National Museum, Athens. See pages 92-99.
Second half 4th century B.C. *Artemis A* found in Piraeus. Piraeus Museum. See pages 62-65.
Second half 4th century B.C. *Youth* found in the Bay of Marathon. National Museum, Athens. See pages 104-107.
Second half 4th century B.C. *Boxer* found in the sanctuary at Olympia. National Museum, Athens. See pages 36-37.

HELLENISTIC, c. 350/325 B.C. TO THE TIME OF CHRIST
Late 4th or early 3rd century B.C. *Victor* found in the Adriatic Sea. J. Paul Getty Museum, Malibu. See pages 110-115.
First part 3rd century B.C. *Artemis B* found in Piraeus. Piraeus Museum. See pages 66-69.
3rd or 2nd century B.C. *Old Philosopher* found offshore from Antikythera. National Museum, Athens. See pages 100-101.
3rd or 2nd century B.C. *Boy Jockey and Horse* found offshore from Artemision. National Museum, Athens. See pages 86-90.

INTRODUCTION

BY CAROLINE HOUSER

The artists of Classical Greece considered bronze the ideal medium for freestanding sculpture, valuing the material not only for its lustrous beauty but, still more, for its strength, which made possible compositions difficult to realize, or unfeasible, in another material. Even such artists as Pheidias and Praxiteles, famous for their marble or chryselephantine (gold and ivory) statues, were also prolific metal-workers.

The cities and sanctuaries of ancient Greece were filled with bronze sculptures. Delphi, for example, contained so many that the Roman emperor Nero seized "five hundred bronze statues of gods and men" from the sanctuary of Apollo. But after centuries of war and riot, the vast artistic legacy of original bronze sculpture has been reduced to a precious handful of surviving examples, all lost to civilization from the end of the Classical age until very recent times. Of the vast majority that

disappeared, most went into melting pots when the metal-hungry peoples of the Early Christian and Byzantine eras found urgent uses—principally military or industrial—for the premium alloy. By comparison with this systematic destruction, such random disasters as earthquakes, wars, or shipwrecks have proved salvational, since they removed a few works from malicious hands to benign burial places in the sea or earth, which preserved them for recovery and restoration some two millennia later.

This book treats eighteen surviving original bronzes, most of which come from chance finds. Fourteen of these statues were discovered quite by accident. The other four turned up in sanctuaries during archaeological exploration. But, with the exception of the *Delphi Charioteer,* excavations carried out under controlled conditions have yielded only fragments of Greek monumental bronze sculpture. More than half the statues were found

on land, but most of the nearly complete figures emerged from the sea. Despite great advances in marine archaeology, fishermen made most of these underwater discoveries. The leading role in finding the bronze statues seen here must be credited to luck, not to our highly developed technology.

Twenty-five years ago the world knew little more than half the Greek bronze statues now available. Since the newest discoveries are among the most important of all known works of ancient sculpture, they have changed the view of Greek art that prevailed until recently. At the beginning of the nineteenth century, when the process of recovery began, not a single example of monumental bronze sculpture stood above ground or sea. As a result, many modern ideas about freestanding Classical sculpture were based on marble copies, usually made during Roman times. That such replicas offered imperfect reflections of the originals, in design as well as in quality, became evident whenever more than one replica survived, because in every case the copies differed from one another. Proof of just how different a Roman copy could be from its Greek prototype appeared in 1959 with the *Piraeus Athena,* an original bronze for which a Roman version has been recognized in a marble statue owned by the Louvre. The vastly increased number of known Greek bronzes not only gives us a more accurate sense of ancient Greek art; it also enriches the history of art with an unexpected store of unsurpassed masterpieces.

THE SURVIVING WORKS

The eighteen pieces of sculpture presented in this book include most of the major monumental statues that have come down to us from Greek antiquity. Together, they typify the full range of known surviving pieces. The sculptures are all figural, representing human forms and, in two instances, a horse or horses.

None of these bronzes has escaped the ravages of its history. Those raised from the sea surfaced with a coating of marine encrustations; they also arrived stripped of various parts that must have been washed away by the sea. The *Warriors* from Riace Marina, for example, had lost their armor, and the mysterious object once clutched by the

Marathon Youth may never be known. Some of the figures from shipwrecks were found broken into pieces, victims not only of the sea but also of whatever catastrophe struck the vessel transporting them. When discovered off the coast of Artemision, the jockey and horse seen on pages 86–90 had become separated and the horse had shattered into bits, some of which could not be recovered. The *Getty Victor,* on the other hand, stands footless as a probable consequence of its having been torn from the original base before it was loaded on board the ship that carried the statue into the Adriatic Sea. As for the bows and phiales once held by the Piraeus images of Apollo and Artemis, no one can be certain whether they disappeared at the time of the sculptures' removal from their original site or at some later date. The Piraeus cache most likely fell into the moist and salty soil of the seaport after Pontic troops had stolen it from Delos and then stored the loot in a harbor warehouse, which subsequently collapsed when put to the torch by Sulla's army. Given those circumstances, the sculpture reaches us in remarkably good condition.

The *Piraeus Athena* survived much better than did *Piraeus Artemis B,* despite their having been made of the same alloy and then sunk together off the dockside of Athens' port city. Damage inflicted upon the bronzes found in sanctuaries seems to have been of a different sort, with the burial effected only after the mischief had occurred. The *Delphi Charioteer* was interred near the Temple of Apollo, probably after it had been broken by buildings tumbled during an earthquake, and a sculptural head of a youth dug up on the Athenian Acropolis lay buried, we presume, precisely because it had been severed from the body.

THE DEVELOPMENT OF BRONZE

No one today knows who first made bronze, or exactly where and when. The Bronze Age in Greece began about 2000 B.C. Although the Greeks first used bronze for tools and weapons, hammering them into shape, they soon learned to cast the material into statuettes.

Artists on Crete produced some small pieces of bronze sculpture as early as the first half of the second millenium B.C. The casting of bronze stat-

uettes, however, did not become widely established until nearly a thousand years later. During the eighth century B.C., much of the Greek world conceived a liking for Geometric bronze statuettes, figures in which the subjects had been abstracted to the very essence of their forms. So radically simple are the shapes of these small-scale works that the sophistication of their form and technique is often overlooked.

Despite the early date at which bronze statuettes appeared, monumental statues (lifesize or larger) could not be cast in bronze until the late sixth century B.C. The delay in arriving at full-scale statuary is not surprising, since the techniques required for casting large forms differ considerably from those adequate for smaller pieces.

Production of monumental sculpture in bronze also lagged behind that in marble. Greek sculptors had carved lifesize statues in marble at the dawn of the Archaic period, during the eighth century B.C., two hundred years before large figures cast in bronze appeared at the close of the Archaic age. Proof that Archaic artists wanted to make large metal figures can be seen at Olympia in the upper portion of a siren (now missing one of its wings), an image hammered from bronze sheets. What seems evident here is that monumental bronze sculpture made by casting developed more slowly because of technological problems presented by the casting process. The Greeks cast body armor before they cast large statues, and such military production may have contributed to both the capacity to make lifesize metal statuary and the interest in doing so.

The oldest sculptures in our group are the images of Apollo discovered at Piraeus, the head from the statue of Zeus found at Olympia, and the Poseidon from Livadhostro Bay. All evince the style of Late Archaic sculpture, and they show closer affinities than any later monumental bronze statues to the traditions used for making Archaic marble sculpture as well as to those for making bronze statuettes. The *Livadhostro Poseidon* stands on a metal rectangular tablet like those normal in bronze statuettes, but nothing comparable attaches to any other large statue. The *Piraeus Apollo* has eyes made of the same material and at the same time as the rest of the head, reflecting a practice more characteristic of marble figures than of figures

cast in bronze. The eyes of the *Olympian Zeus,* for instance, were made of different material—probably colored stone, glass, or rock crystal—and the technique became standard in all the extant large bronze statues that followed. The Greeks perfected their processes for making monumental bronze figures soon after they had created their first big statues, and they continued to employ these processes right through the Classical and Hellenistic periods.

BRONZE AND ITS EFFECT ON SCULPTURE

It could have been no accident that the first monumental bronze statues appeared at the end of the Archaic period. Adoption of bronze as a medium for important art signaled the advent of the Classical style. Indeed, the technical possibilities of bronze so intertwined with the demands of Classical art that it would be impossible to determine whether the medium or the style came first.

The compact, self-contained forms of Archaic figures seem to be at one with the blocks of marble they were carved from. Classical artists, however, invented more complex compositions and required more subtly modulated surfaces, all of which could be better achieved through the more versatile technique of cast bronze. This remains true even though bronze finally becomes harder than stone, since the metal takes its shape—in the casting process used by the Greeks—from a figure modeled originally in malleable wax applied over a core of refractory material. Once the wax model had been made, the sculptor encased it in more refractory material to make a mold. He then "lost" the wax by melting or vaporizing it, so that the molten bronze could be poured into the mold to fill the space originally occupied by the wax. The final step came when the sculptor broke and removed the mold, leaving the cooled bronze in the form first realized in wax.

The tensile strength of bronze permitted Greek artists to create more complicated poses that extend into space with greater freedom than would be possible in stone. The *Artemision Zeus,* for example, whose cantilevered arms span a distance greater than the figure's height, stands perfectly balanced even though held only by three prongs set into the soles of the feet. Such a design would

have been impractical in marble, since stone carved in this design would collapse of its own weight.

The unusual way in which Greek artists worked with bronze gave their monumental sculpture a distinctive character, unlike that of sculpture made at any other time or place. Whereas the metalworkers of most civilizations have used considerable ingenuity either to cast their statues all in one piece or to conceal the fact that they cast them in sections, the Greeks exploited the process of making sections separately to distinguish the various parts of the figure. In this way, for instance, hair could truly hang free of the head, as it does with remarkable veracity in the bangs of the *Artemision Zeus.* The technique becomes self-evident in the *Tamassos Apollo* from Cyprus, whose curls have broken away on one side of the head, leaving a fully formed ear exposed.

The sense of distinct differences between one element of a figure and another, manifest in the way the parts were made and joined together, becomes still more pronounced where fabric and flesh meet. The Greeks fashioned representations of living matter separately from those of inanimate substances, thereby articulating the nature of their physical relationship. An especially clear example can be found in the *Delphi Charioteer,* whose right arm was modeled and cast as a form independent of the sleeve into which it fits. Thus, the diameter of the arm measures slightly less than that of the sleeve, and the arm was made long enough to fit well into the sleeve opening. This distinctive mode of constructing statues can be found in every Classical Greek statue representing a clothed body. The technique produced the simple, natural appearance of the drapery worn by the Athena figure from Piraeus. The wax model had to have been a feat of three-dimensional engineering to permit the casting of pieces that must fit into one another rather than just meet.

The surviving Greek statues themselves, fitted together as they are from separate parts, raise serious questions about the frequently heard theory that the model for each bronze figure was first carved from one piece of wood and then sawed apart to make various molds necessary for casting the statue piece by piece. The artistic mentality of the ancient Greeks suggests that they thought easily in separate units, evidence of which can be found in the variety of materials they used—marble, glass, and rock crystal, as well as bronze—in order to construct a complete form. A mind that moves from the part to the whole would surely find it logical to design and make a model in separable units from the beginning.

The *Piraeus Athena* also reminds us that the usual modern description of bronze casting proves inadequate as an explanation of the techniques developed in ancient Greece. It is not enough simply to label a Classical Greek bronze statue as either "hollow-cast" or "solid-cast." The metal, of course, hardened into a solid state once it had cooled. But "solid-cast" connotes a mass of metal solid throughout, although the statue came out of the creative process a hollow form. "Hollow-cast" normally designates a piece of cast metal that embraces a void, but each piece of bronze cast to represent drapery does not embrace a void. Thus, while each piece has been cast, solid or hollow, the statue stands as a construction of individual parts fitted together.

The easy naturalism of the drapery folds in the garments worn by the Piraeus images of Athena and Artemis suggests that the sculptors may have created the forms from actual cloth saturated in wax or from some other unusually thin and flexible modeling material. But whatever their modeling fabrics, the sculptors arranged them so artfully that each garment becomes a design, a relationship of lines and shapes more balanced and graceful than their counterpart in reality. The sheer, complex forms used to represent fine woolen cloth falling in overlapping folds are themselves separate sheets of bronze, which do not merely create an illusion, but actually overlap one another.

By choosing to design hollow bronze figures, Greek artists could easily set other materials into their statues. Except for the very early *Piraeus Apollo,* all the known monumental Greek statues in bronze either had or still have lifelike eyes of colored stone or glass, with eyelashes of fringed sheet bronze. Lips and nipples also generally called for special handling, either in pure copper or a bronze with a high copper content to simulate the redder tonality of those features. When parted, lips often disclose a set of sparkling teeth, fashioned of silver, marble, or ivory. By means of such additions set into the main mass, Greek sculptors

endowed their bronze statues with unparalleled verisimilitude.

Instead of artificially patinating these monumental bronze figures, the ancient Greeks polished them to bring out the warm, gleaming color of the untarnished alloy. This basic color would have been a ruddy gold, but the alloy could be altered to make the material appear either more golden or more coppery. When finally burnished, the nude images must have looked richly oiled and tanned, while the draped figures surely glowed like real gods.

THE PLACES OF DISCOVERY AND THEIR MEANING

The Greeks filled their cities and sanctuaries with sculpture. Finds confirm the statements in ancient documents telling of the vast population of statuary that spread everywhere in the Hellenic world. The sculptures seen in this book come not only from the famous sites—Delphi, Olympia, and the Athenian Acropolis—but also from obscure sanctuaries on Livadhostro Bay and at Tamassos on Cyprus.

In subject, size, and general style, Greek art seems to have been fairly consistent, whatever the importance of the site. Objects could, however, differ in quality. Strong as the images from Livadhostro and Tamassos may be, they lack the sensitive, masterful modeling present in most of the other Greek bronze statues. Patrons wealthy enough to commission work from the best artists probably gravitated to the more powerful sanctuaries.

The great bronze statues of ancient Greece always stood in public places, whether the nature of the commission was public or private. This made them public works, created for the pleasure of the many rather than of a privileged few. Some of the religious images were probably installed in shrines, but most of them stood out-of-doors, accessible to everyone.

Most Greek monumental bronze statues embodied religious dedications. Every one of our sculptures that can be linked to its original location came from a sanctuary. All the statues that portray Olympian gods—Apollo, Artemis, Athena, and Poseidon—were obviously figures of religious im-

port. But mortal or profane subjects could also reflect matters sacred to the ancient Greeks. Statues erected to celebrate athletic winners, such as the *Delphi Charioteer* and the *Olympic Boxer* stood in enclosed, consecrated areas, acknowledgments of the debt that mortal success owed to higher powers. The two other commemorations of victorious athletes, the *Jockey and Horse* from the Artemision shipwreck and the *Getty Victor,* probably also originated in sanctuaries, where they stood as offerings of thanks to the champions' guiding gods.

Archaeological evidence and ancient authors alike tell us that agoras, the civic and commercial centers of cities, constituted another popular place for the display of sculpture, especially images of people who brought glory or other major benefits to their community. The *Philosopher* from the Antikythera wreck may well have been such an image, created to grace an agora.

The monumental bronze figures betray no regional style of a descernible nature, as do the minor arts. This is not surprising since master sculptors traveled widely in antiquity, wherever the best commissions drew them.

Moreover, chauvinism seems to have played no role in the commissions given for the great bronze monuments. For example, nothing has turned up to suggest that Polyzalos, the Tyrant of Gela, chose an artist from his native Sicily when he commissioned the memorial now known as the *Delphi Charioteer.* As Bernard Ashmole has observed, tyrants are "apt to employ the best artists that money can buy irrespective of nationality." The same could be said of any wealthy patron who values quality.

THE SCULPTORS

Sculptors enjoyed enormous respect in Greek society. Ancient literature proclaims their greatness and describes their works, with the result that the fame of Greece's master artists has lived long after their creations perished. Not only did their names appear on the stone bases for their sculpture, but the words identifying a sculptor usually were inscribed in a prominent position and in letters as large as those citing the patron and dedicating the statue.

Unfortunately, none of the bronze sculpture discovered so far clearly belongs with a known inscription that names the artist. If such a labeled base were discovered, it would provide strong evidence for identifying the statue it supported as the work of the particular artist named on the inscription. The means exist, however, for making attributions. One of the most powerful is comparison, between the surviving bronzes and descriptions provided by ancient literature, between the bronzes and Greek marble statues known through convincing literary descriptions, or between the metal figures and antique copies (usually of Roman date) made before the disappearance of the originals. Moreover, new and illuminating information may yet surface, or someone may succeed in producing deeper and more convincing analyses than have been possible so far. As for now, however, none of the Greek monumental bronze statues can be securely assigned to a specific artist.

Even so, some of the suggested attributions warrant serious consideration. Observed stylistic correspondences between the marble *Apollo Patroos* in the Athenian Agora and the *Piraeus Athena* support the theory that Euphranor may have been the author of the Athena figure, since a travel book written by Pausanias in the second century, A.D., identifies the *Apollo Patroos* as the work of Euphranor. Conditions also exist for attributions, however tenuous, of two other bronzes to Euphranor. If the *Young Man* found in the shipwreck at Antikythera is an image of Paris, we must entertain the possibility that the statue issued from Euphranor, since he is the only sculptor of the time known to have portrayed that Trojan Prince. Meanwhile, *Piraeus Artemis A* appears to have been made by the Master of the Antikythera Young Man, which means that any attribution made for one of these two recoveries must be considered valid for the other. The *Piraeus Athena*, however, seems to express an artistic personality somewhat different from that of the sculptor responsible for *Piraeus Artemis A* and the *Antikythera Young Man*, which means that an attribution of all three figures to Euphranor cannot be supported on stylistic grounds.

A brief literary reference has encouraged another tentative attribution, this one for the head called the *Olympic Boxer*. Once more the source is Pausanias, who noted that the Athenian sculptor Silanion had made a portrait of the champion boxer Satyros for Olympia. Thus, even without corroborating stylistic evidence, one is tempted to identify the boxer head as the work of Silanion.

Generalized stylistic criteria have prompted other attributions. Usually this involves assigning a statue to the most famous master who worked in a mode close to that of the figure in question. Hardly had the *Marathon Boy* been found when a number of people accepted the suggestion that Praxiteles made it. Now the Marathon figure, although clearly handled in the manner of Praxiteles, seems more likely to have been produced by a follower of the fourth-century master. Stylistically, the *Getty Victor* seems unquestionably to belong to the Early Hellenistic period, and the figure incorporates features that Lysippos reportedly pioneered. In the light of this observable reality, the Getty Museum felt justified in labeling its important bronze statue as the work of Lysippos himself, although some might have preferred a firmer basis for doing so.

Another proposal now enjoying a degree of popularity concerns *Warrior A* from Riace Marina, in which enthusiastic viewers have wanted to see the genius of Pheidias. Certainly, the quality of *Warrior A* is unsurpassed by any extant ancient Greek sculpture, and this alone could cause the work's admirers to evoke the name of Pheidias, long revered as a supreme master of the High Classical style. Unfortunately, no known original sculpture can be definitely ascribed directly to Pheidias, a fact that leaves us without the means to make a persuasive stylistic comparison.

The temptation to identify the rare surviving bronze statues with known artists touches all of us, and we must explore every possibility. At the same time, we should guard against the danger inherent in our eagerness to answer the many questions posed by such tantalizingly beautiful art. But despite our uncertainty about precisely who created these monumental works, we should have no fear about their visual statement; it remains clear even today.

Tremendous value attaches to these bronze statues simply because they are original works of art created by master sculptors active at a time and in a

place that set the standard of excellence for Western civilization ever since. Comparing the *Piraeus Athena* with a Roman version of it demonstrates the extent to which Roman copies have given the world only an echo of the art they were meant to emulate.

The figures also bear dramatic witness to the high regard in which the ancient Greeks held human life and capacity. Every one of the monuments has been made in human form, supplemented in two instances by a horse or horses, the animal that gave men greater power and speed.

Although human in form, the subjects include gods as well as mortals. The convention of representing a deity in human guise is so firmly established in Western culture that we may forget that it comes to us from the Greeks. The peoples of Egypt and the Ancient Near East endowed their sacred images with human parts, but combined these with bestial or fantastic elements. The Greeks, however, created representations of human and divine subjects that are often difficult to distinguish from one another.

Modern artists follow the Romans in their tendency to portray individuals by focusing on their heads. In the monumental bronzes shown here, however, the Greeks represented heads as part of the whole body. Where only a head survives, it clearly is a fragment that originally formed part of a complete figure. By logical extension, the Greeks regarded the body as part of the total being, not simply a trunk for an exposed head. The unclothed figures betray no self-consciousness about their nudity. The bare male body is presented with the same assumption of acceptability as bare faces are in our society. Although sensual in their nudity, the handsome athletic forms do not seem erotically naked.

The figures give eloquent visual form to the Greek concept of the human being as a unity of mind and body. Believing the body to be an important component of the total person, Greek sculptors depicted physiques in states of idealized perfection. Simultaneously, they acknowledged the intellectual character of every subject—even the battered, middle-aged boxer—in thoughtful and intense expressions. Mental control increased the potential for physical power, while strong physical capacity made the desires and powers of the mind more easily realized.

The portraits of mortals appear to memorialize people for their outstanding accomplishments. In the instance of the *Delphi Charioteer,* the *Jockey and Horse* from Artemision, and the *Getty Victor,* the subjects honored were all athletic champions. The elderly visage in the head salvaged from the Antikythera shipwreck must be that of a highly respected philosopher. Recognition came from fulfilling one's capacities, from achievement rather than social or political position.

The religious and public placement of sculpture, wherever the pieces can be related to particular sites, demonstrates the public character of life and the integration of religion into the everyday existence of ancient Greeks. In the Hellenic world, therefore, even themes that post-antique society would consider profane, such as athletic events, assumed sacred overtones.

Those great statues of gleaming, polished bronze must have made Greek sanctuaries bright and colorful places. With the possible exception of the *Piraeus Apollo,* every one of our statues displayed a variety of colors and textures, thanks to the Greeks' practice of using different metals, glass, and colored stones for individual parts set into the main bronze mass.

The wealth of luminous color, no doubt designed to dazzle spectators, arose from the desire to emulate and idealize natural appearances. Teeth of white marble or silver sparkling behind the ruddy hue of copper lips, for example, helped create an illusion so lifelike that the figure looked as if it possessed the power of speech.

All the bronze figures were designed to give the illusion of human reality; yet, paradoxically, none of them replicates any specific human form. The statues transcend their sources and prototypes to become expressive forms based on knowledge of human skeletal and muscular systems.

In the metal statuary of ancient Greece balanced forms and calm stances convey ideals of equilibrium and self-control, states of mind that give way only in the driving, headlong rush of the Hellenistic *Jockey and Horse* from Artemision. Still, the Greeks acknowledged the animal instincts and passions that lay beneath disciplined surfaces, where such forces give these masterworks of sculpture their matchless vitality.

FOREWORD

A PHOTOGRAPHER'S ENCOUNTER WITH GREEK MONUMENTAL BRONZES

BY DAVID FINN

More then twenty years elapsed from the day I fell in love with Greek monumental sculpture and the time I began taking the photographs for this book. On my first trip to Greece I was overwhelmed by the grandeur of the *Artemision Zeus*, with his herculean physique, his proud, bearded head, his mighty outstretched arms. So extraordinary did the heroic figure seem to me that I would have traveled around the world just to see it. Although a novice photographer at the time, I managed to capture a few details with my beginner's camera, details that would help preserve a sense of the sculpture's monumentality in enlarged prints. I did the same with other Greek sculptures of the period—the *kouroi* in Greece's National Museum, the gods at Olympia, the reliefs in the Acropolis Museum, and, later, the Elgin Marbles at the British Museum. I thought the Parthenon the greatest work of architecture I had ever seen, and the sculpture contemporary with it the perfect complement. Once, when I learned that a close friend of mine had only a few months to live, I arranged for him to make a trip to Athens and witness what civilization had created in the moment of its greatest triumph. I felt, and still feel, that everyone should try, in the course of a lifetime, to see this supreme work of genius, the Parthenon.

Since my first encounter with the Greek masterpieces I have focused my lenses on many other great works of sculpture, and come to know their extraordinary qualities through the art of photography. The sculpture of Donatello, Ghiberti, Michelangelo, Canova, Henry Moore, and others have entered my life through the camera eye. Behind all these, however, lost in the shadows, stood the towering works of ancient Greece. Although they had not actually been seen for centuries, owing to their long burial in earth and sea, the unsurpassable sculptures carved and cast by the Greeks loomed large in the collective unconscious of all sculptors as the prototypes from which their own productions had descended.

In preparing this book, with its concentration on Greek monumental bronze sculpture, I have wanted to draw the reader's mind and eye to a group of archetypal works that are unique in the history of art.

Although I have visited Greece many times in the last twenty years, this particular project made going there with my camera a very special privilege. My good friend Katerina Rhomiopoulou kindly arranged the necessary permissions that enabled me to enter the museums with my equipment and photograph the sculptures. I spent hours with them, training my Hasselblad on their eloquent forms, shifting the instrument's many lenses, taking slow exposures with the benefit of a tripod, using a ladder to get closer to and sometimes above the figures, discovering details I had never seen before.

What a sensation it was to be inches away from

15

the magnificent *Artemision Zeus!* To see his veined arms, the monumental back, the tension in his buttocks, the marvelous shapes of his legs, his whole body poised on the heel of one foot and the ball of the other. During my session with the great sculpture, the sun shone through the tall windows for a while, making it look as though the Olympian god himself were striding forth under an open sky. The mood was intermittently broken by swarms of passing tourists (the National Museum permits photography only during public hours), their guides telling the same story over and over again in different languages. But as each group moved on I could resume my search for revealing angles, fully aware that I was shooting far more film than I could possibly use, but thrilled at the opportunity to know the work so thoroughly.

It was the same with all the other sculptures at the National Museum—the Hellenistic boy jockey riding his extraordinary horse, the sensitive Praxitilean image of a young man found in the Bay of Marathon, the noble *Antikythera Young Man,* the four individual heads, the four Piraeus figures (since moved to the Piraeus Museum), the *Livadhostro Poseidon* with his radiant, somewhat enigmatic smile, so characteristic of Archaic images.

At Delphi, where the museum prefers that photographers work when it is closed, I had the *Charioteer* all to myself. It was breathtaking—perhaps the single most stately sculpture ever created. Music rises from the folds of the *chiton* as it falls away from sleeves, neck, and belt. The arm is perfectly formed, as are the feet, which beautifully echo the long, elegant lines of the skirt. The face is incredibly serene, wonderful to photograph from every angle. I had seen great photographs of the *Charioteer* before, and felt it a challenge to discover new ways of looking at the work. To achieve my goal, I took enough photographs to do a book on that sculpture alone. When I had almost exhausted my supply of film, I wandered up and down the hillside, stopping where the *Charioteer* is thought to have stood, pointing my camera toward the majestic mountains that help to give Delphi its awesome sense of mystery.

I had seen the Riace bronzes when they were first exhibited in Florence, the relatively small gallery filled, wall to wall, with gaping visitors from morning til night. I wondered what Michelangelo would have thought had he been able to view these great works, so at one with his own exalted standards. A year later I went to Reggio Calabria where I could be alone with the sculptures during the museum's nonpublic hours. And as I focused my camera on the splendid figures I was incredulous at the power contained within their mighty frames. The amazing Greeks, even while working on an heroic scale, could address themselves to the tiniest detail—a vessel in the stomach, the muscles of the arms and legs, the curling toes, the famous copper lips and silver teeth. Through my camera eye I learned that the inner ankle is higher than the outer one, that genitals can be rendered as artistically as any other part of the body (how horrified these sculptors would have been at the sight of a fig leaf!), that the facial expressions of fierce warriors can also disclose humane, possibly even gentle, qualities if one looks carefully into the subjects' features.

The *Tamassos Apollo* in the British Museum and the *Getty Victor* in California's J. Paul Getty Museum completed my expedition, and each of the pieces warranted a detour of any length. Even now, the Tamassos head, with its perfectly formed features, has the force of a total work, and seems the very embodiment of the Greek ideal. And the *Getty Victor,* so hauntingly graceful in its posture, makes a proud addition to the family of Greek monumental bonzes, standing tall as the star of the greatest collection of Classical sculpture in North America.

Selecting the photographs for this book has been a particularly difficult task. As always, the more careful the selection, the greater the impact. Yet discarding photographs that were revelations of one or another aspect of the sculpture in favor of even more striking ones requires courage, wisdom, and restraint. As the photographer, I am grateful to both the publisher and the designer for choosing with such discretion. I would have found it difficult not to make the book twice as large, which I know would have made it half as good. I am also grateful that my photographs are being published together with Professor Caroline Houser's richly informed text, which not only gives the known historical background of the sculptures but also guides the reader's eye to those qualities that distinguish each work as a masterpiece.

THE SCULPTURES
AND THEIR HISTORY

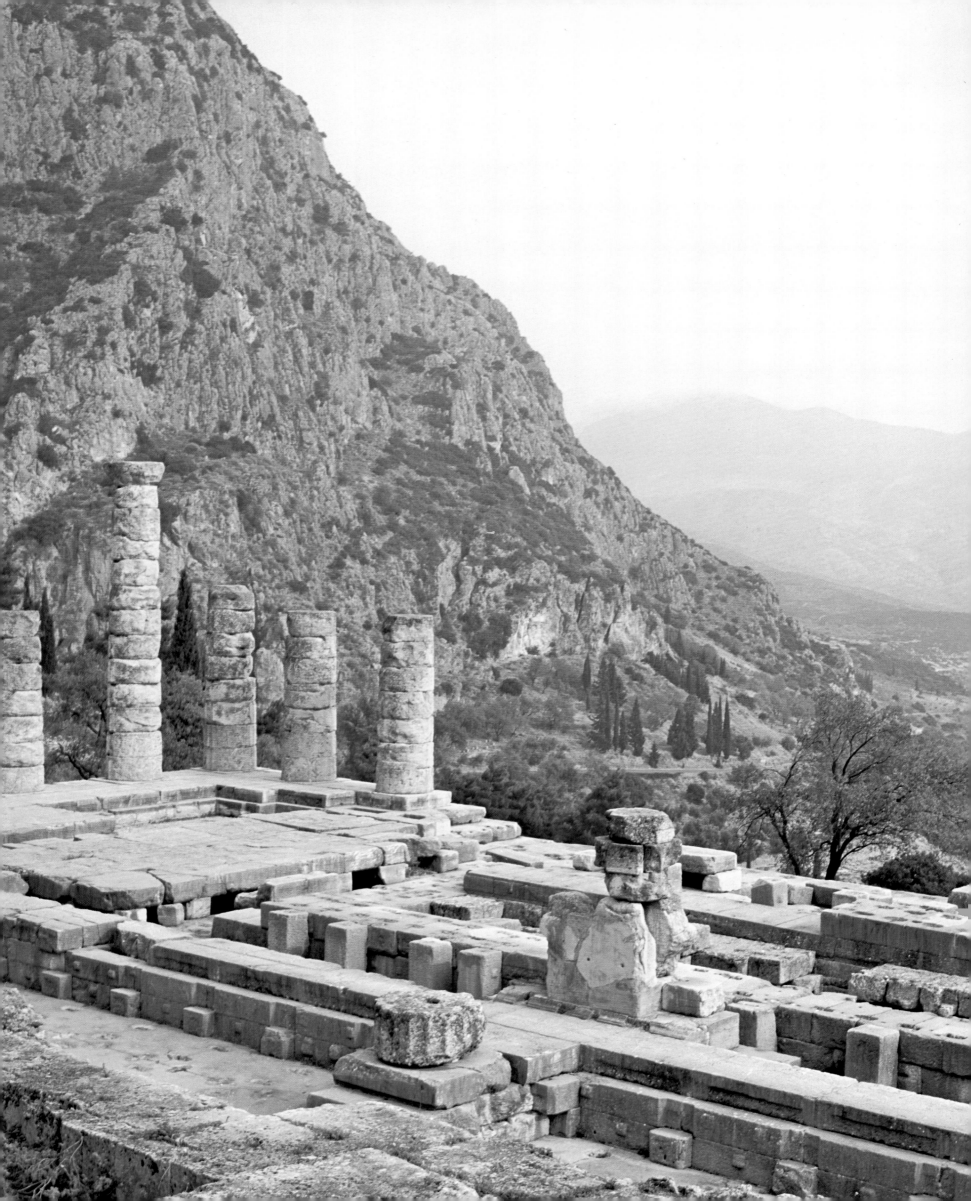

DELPHI

Delphi, situated near the foot of the south slope of Mt. Parnassus, occupied one of the most beautiful sites in Greece. During antiquity it was the seat of the Delphic oracle, so famous and important that the Greeks called Delphi "the center of the world." Hellenes came from the remotest colonies not only to consult the oracle but also to participate in the Panhellenic games held at Delphi.

By the eighth or seventh century B.C. an area on the steep hillside had been dedicated to Apollo, the god of the sun and sky and the patron of the most elevated aspects of Greek civilization: music, poetry, and medicine, as well as various bucolic arts. By the early fifth century, the dawn of the Classical age, the sacred area inside the sanctuary walls was filled with objects and monuments consecrated to the Olympian deities. Some of these came from the Panhellenic victors, who were permitted to set up monuments thanking Apollo for help.

After ancient Greece's Classical period, Delphi also attracted the less pure of spirit, plunderers who made so many raids that few of the riches once there have survived into modern times. The Emperor Nero, for example, took more than nine hundred statues and had them carried off to Rome.

The monumental bronze image of a charioteer found at Delphi had been buried on the northern edge of Apollo's temple at some unknown date in antiquity. In Classical times Greeks often interred consecrated sculpture once it had suffered damage. A well-known example of the practice came to light when clearing operations uncovered a large number of Archaic statues broken up by the Persians in 480 B.C. and then buried on the Athenian Acropolis. Something similar must have happened to the *Delphi Charioteer*, severely damaged and then put to rest underground. Unfortunately, the scant archaeological evidence available to us fails to provide good clues about the nature, the cause, or the time of the events surrounding the injury and subsequent entombment of the beautiful *Delphi Charioteer*.

Owing to its great weight, the statue was probably buried near the place where it originally stood. This would have located the monument in the vicinity of the Temple of Apollo, high on the slopes of the sanctuary.

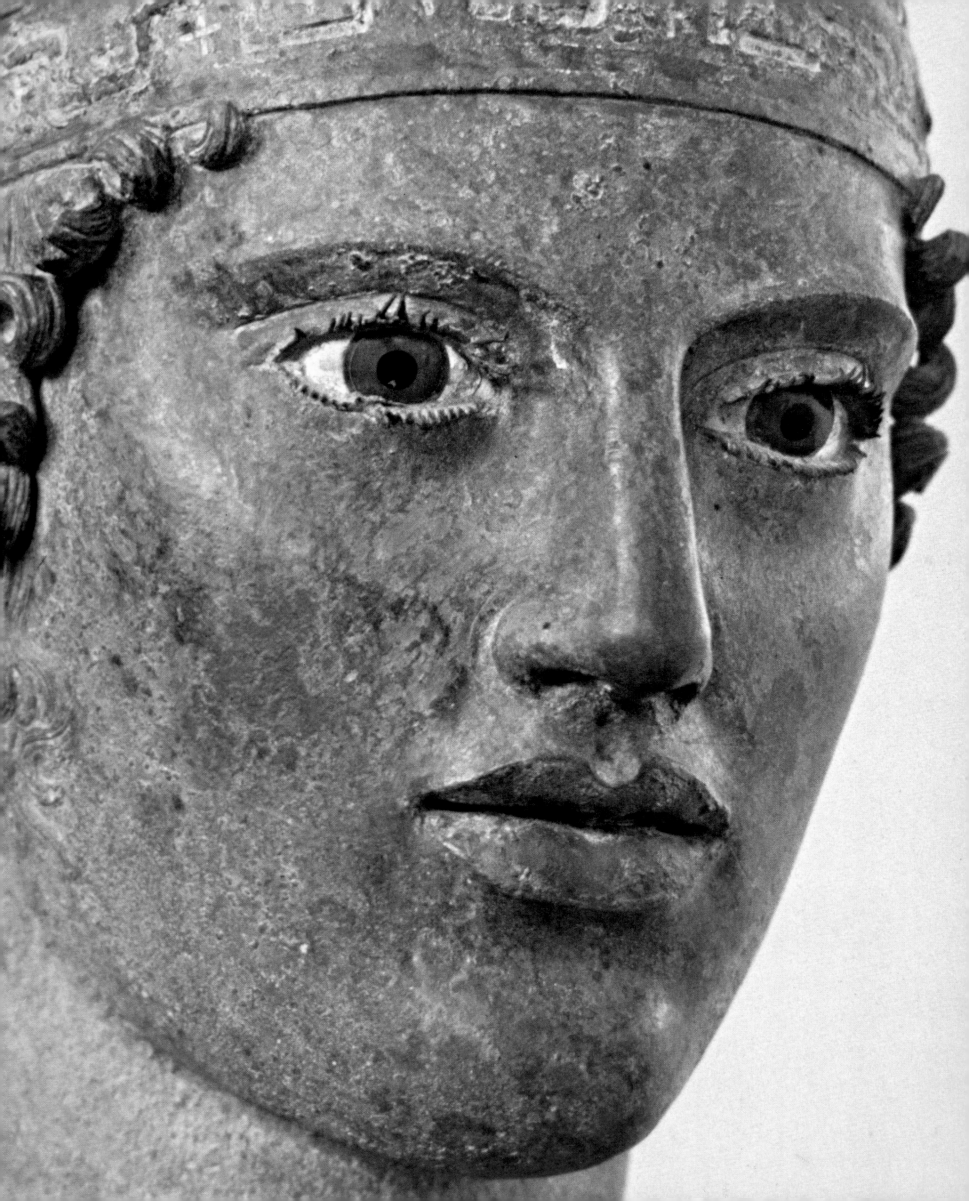

THE DELPHI CHARIOTEER

EARLY CLASSICAL, C. 477 B.C.

HEIGHT: 1.8 M.
EXCAVATED IN THE SANCTUARY OF APOLLO AT DELPHI, A.D. 1896
DELPHI MUSEUM

From the moment of its discovery by French archaeologists at the end of the nineteenth century, the *Delphi Charioteer* has been one of the most celebrated and beloved of all Greek statues. Moreover, the figure left little doubt as to its identity since pieces of two reins, now broken and bent, still cling to the statue's right palm. Although the missing left arm denies us the confirmation of the reins its hand would surely hold, the costume—a *chiton*—is clearly the long dress that charioteers customarily wore in fifth-century Greece. Additional clues came in the form of various broken fragments—representing a chariot, several horses, and a smaller person (a groom?)—found buried with the figure.

Today none of this accompanies the *Charioteer* at the Delphi Museum, where it stands alone in solitary splendor. The ancients, however, would have known the figure as one part of a large monument that included the chariot, the horses, and the attendant. Along with its remarkable beauty

and unequivocal identity, the *Delphi Charioteer* offers the added benefit—truly an incalculable value—of being the only Greek monumental bronze that can be dated by objective external factors to a relatively specific time in the fifth century B.C. The hard evidence appears on the statue base, the only base yet discovered with any of the large bronze statues made in pre-Christian Greece. There we find an incised label stating that the monument had been commissioned by Polyzalos, the ruler of Gela, to commemorate his victory in the chariot races. The dedication also records Polyzalos' request to Apollo for success.

Polyzalos was one of the Deinomenids who ruled various Greek cities on Sicily during the fifth century B.C. The period provided two occasions—478 and 474—when the tyrant could have participated in the Panhellenic chariot races at Delphi. But since his brief political power seems to have waned before the later date, the victory claimed by Polyzalos in the Pythian games at Delphi is more likely to

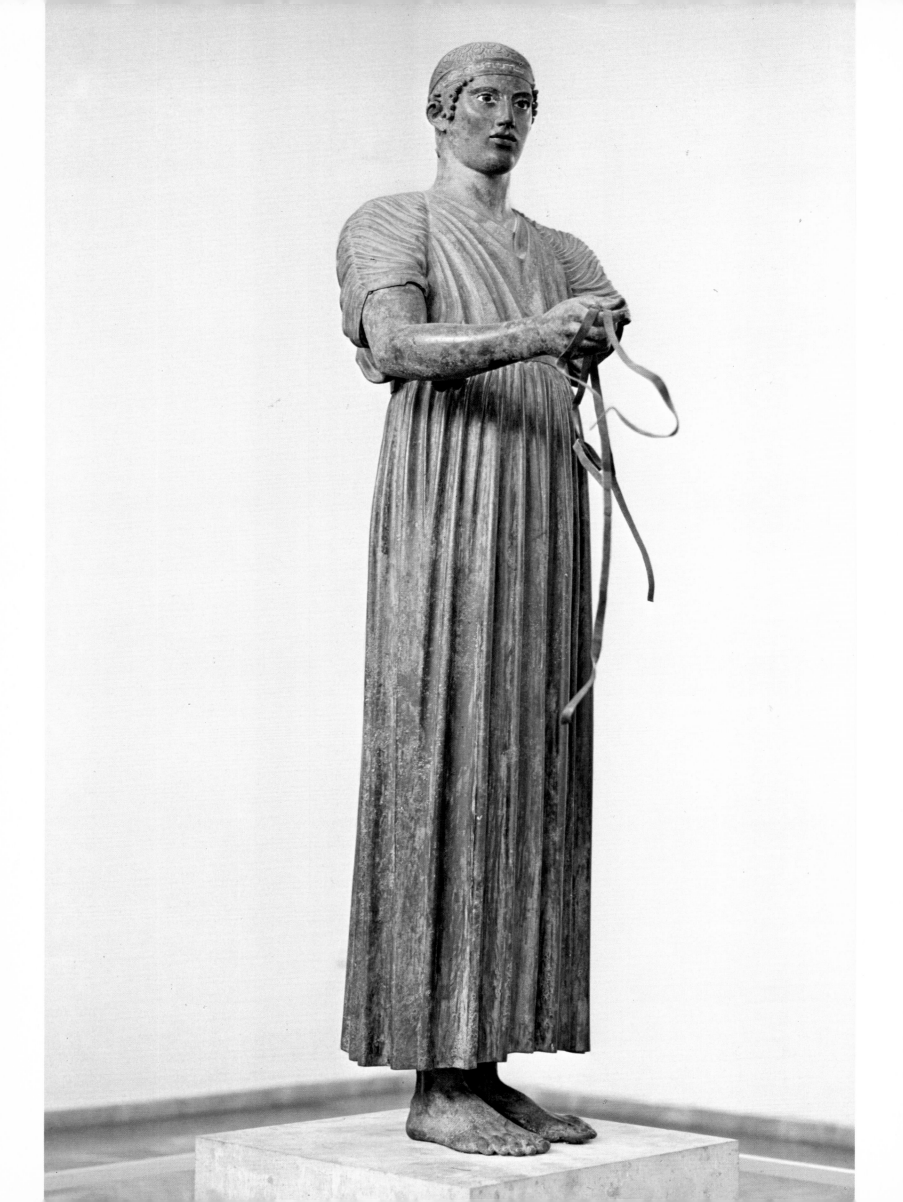

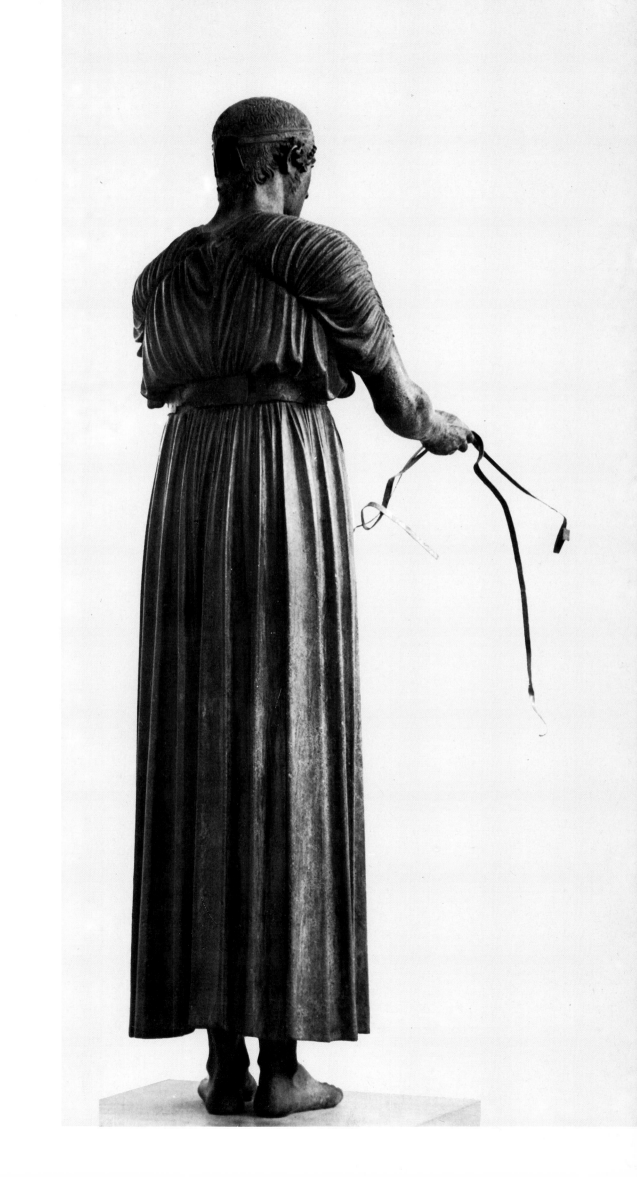

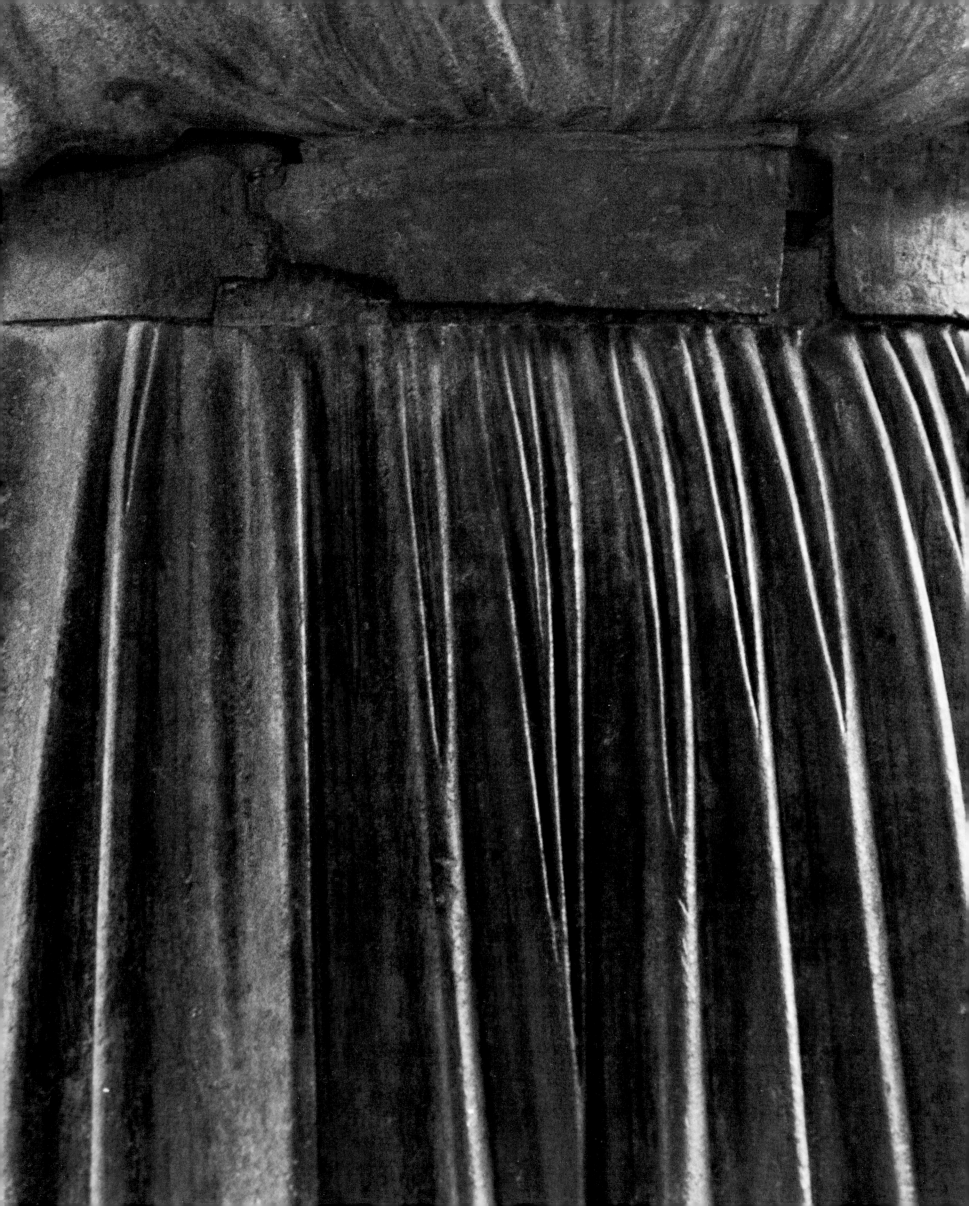

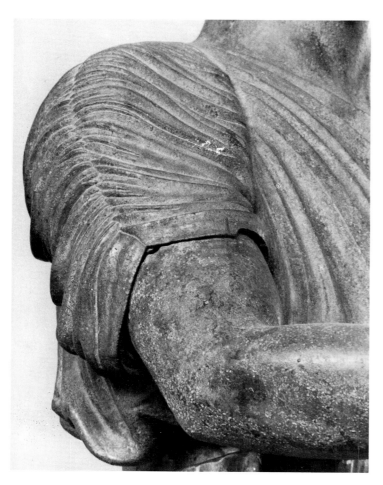

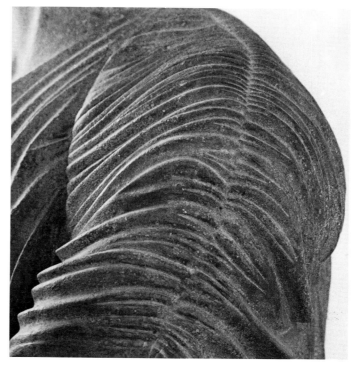

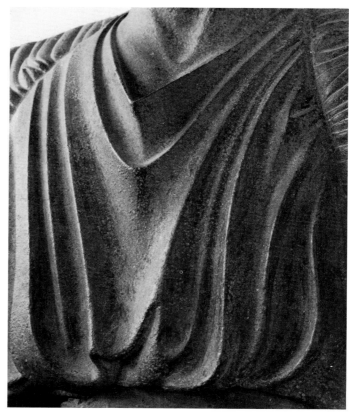

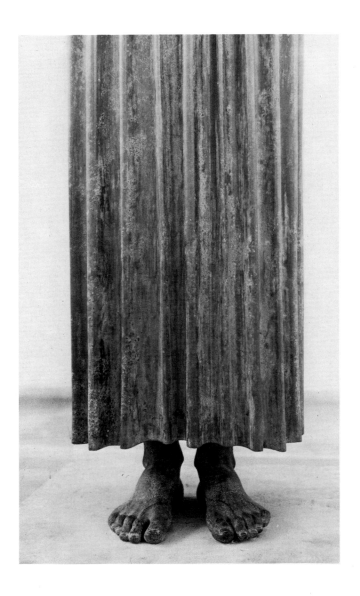

have occurred in 478 B.C. The sculptor probably received the commission for the monument immediately following his patron's moment of glory. Thus, the *Delphi Charioteer* may have been in place by the succeeding year, 477 B.C. A later date hardly seems possible, given the fact that Polyzalos came to political grief in 476, after which a costly monument would undoubtedly have been beyond his means.

The *Delphi Charioteer* has long been compared to a Doric column, ever since Théophile Homolle, the French archaeologist who directed the excavation of the sculpture, first noted the figure's cylindrical form and the somewhat regular, flutelike folds of its garment. Such an analogy, however, serves more to distinguish the differences, rather than the similarities, between the statue and an architectural member. Although the charioteer

stands perfectly erect, the axis of his body actually spirals. The head, for instance, turns almost thirty degrees to the right from the front plane of the body, while the left foot points leftward in a subtle countertwist to the direction of the head and its glance. This rotation of the figure's vertical axis— a gentle manifestation of dynamic life and movement—marks a dramatic departure from the strict frontality—the rigidity and stasis—so characteristic of Archaic Greek sculpture (see pp. 45–49, 52–57).

The sculptor of the Early Classical period—the time of the *Delphi Charioteer*—abandoned the Archaic practice of representing fabric folds by low relief and incised grooves in favor of modeling the material in the high relief of both negative and positive plastic volumes. The gathers in the charioteer's chiton appear to fall naturally, although arranged in a more balanced, careful composition

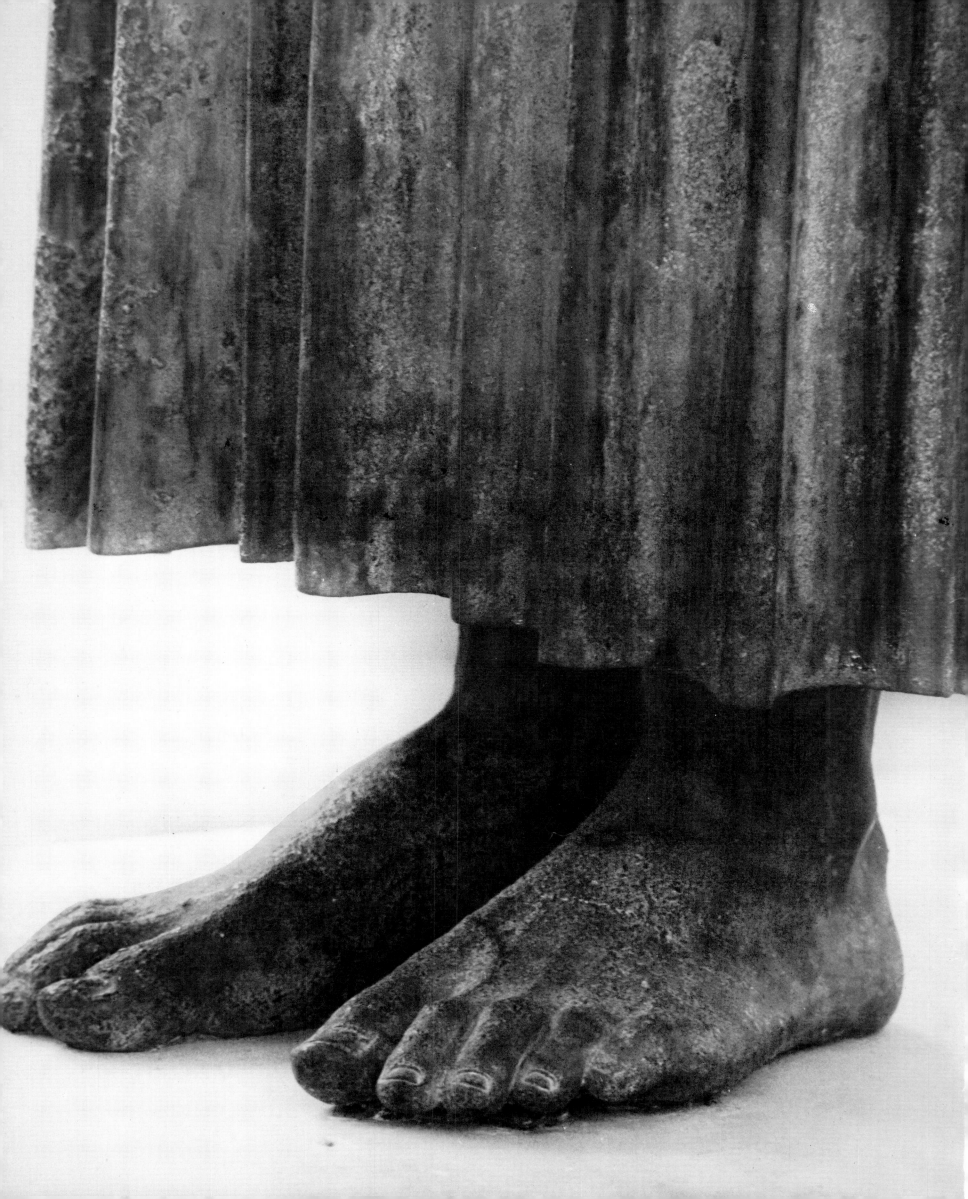

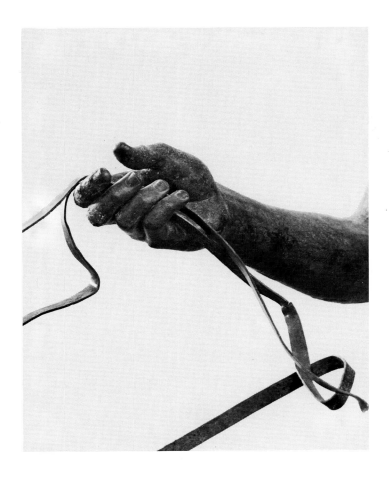

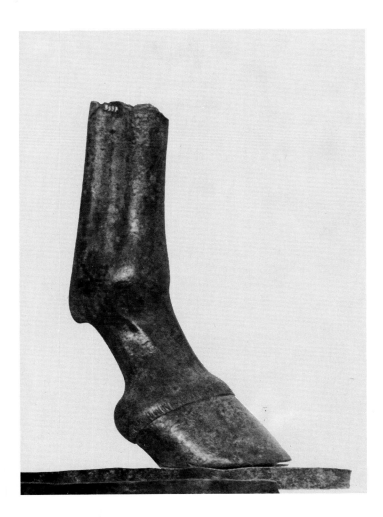

than would ever occur in actual life. Caught up by a belt, the soft, heavy drapery hangs from the shoulders in loops and blouses at the waist. The cord that wrapped around both shoulders and across the back in a figure 8—to keep the sleeves and bodice in place—was made separately and has now been lost, but the channels modeled to hold it remain an important part of the sculpture's overall design.

Thus, however much the charioteer's garment may, at first glance, evoke a Doric column, a less superficial examination reveals subtle but crucial differences. The rhythm of the skirt folds does indeed lend strength to the long vertical lines, since the cloth's every crest and trough forms part of a closely unified composition, but such is the variety within the unity of the design that no form repeats any other exactly.

Note, for instance, how closely the sculptor observed the way the bulk of the figure's torso lifted the hem of the skirt very slightly both fore and aft, thereby giving an organic, springing quality to material that would otherwise have appeared heavy and inert.

The elongated oval of the head has all the strength of simplicity, animated by slightly protruding ears and short, vigorous curls. In contrast to these richly modeled locks, whose realistic volumes simulate their counterparts in the three-dimensional world, the hair on top of the head has been formed as a series of flame-shaped tongues radiating from the crown, the products of a flatter, more abstract mode of sculptural representation.

Separating these two stylistic zones is a band circled about the head and tied at the back. Probably a victor's ribbon, the band has been decorated with a simple meander and Greek crosses, formed by grooves cut into the bronze and inlaid with silver strips.

The translucency of the stone and glass used for the chestnut-brown eyes endows the figure with a spiritual vitality and intensity that could never have been achieved by casting the eyes in bronze along with the rest of the head. Adding to the liveliness of the effect are lashes made of fringed copper no thicker than a sheet. Since they frame the eyes and have been set into the head with them, the lashes appear actually to grow from the lids.

A purer copper went into the full, slightly parted lips, which, in the sculpture's original state, would

have gained both color and articulation from their reddish hue set against the golden tonality of the polished bronze.

The quiet pose, as well as the victor's ribbon bound about the head, implies that we see the charioteer just as he has concluded his winning drive. Thus, the focus falls on victory rather than on the actual race, on the moment of calm and glorious recognition rather than on the time of tension and emotion.

The erect, columnar composition connotes patrician self-control, a characteristic that finds reinforcement in the delicately balanced design and a facial expression that is serious, intense, and alert without betraying the least passion. Aristocratic reserve perhaps, but it escapes all arrogance. By inclining the figure forward and directing the gaze downward, the artist created a certain intimacy of contact between his charioteer and the spectator both physically and psychologically. Meanwhile, the tectonic drapery fosters a sense of stability, just as the broad shoulders imply latent power.

The *Delphi Charioteer* embodies most of the stylistic qualities of the Early Classical period (c. 480–450 B.C.). Forms seem to be simplifications of those found in nature, all organized in a composition of clear and precise outlines. The design encompasses a mixture of the abstract patterning favored by Archaic artists and the heightened naturalism sought during the Classical period. Finally, the psychological expression, albeit grave, reflects nothing so much as stern emotional control.

In this erect and compact work, so full of variations within a magnificently unified whole, Greek sculpture has given us an unforgettable visual record of human strength, vitality, and composure.

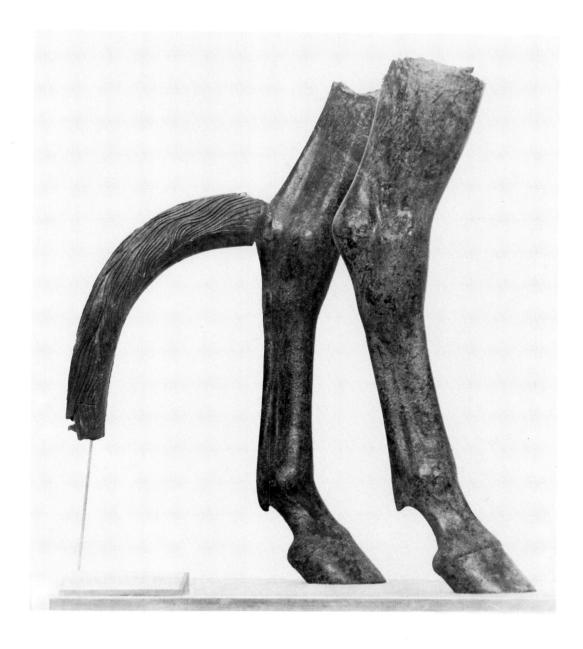

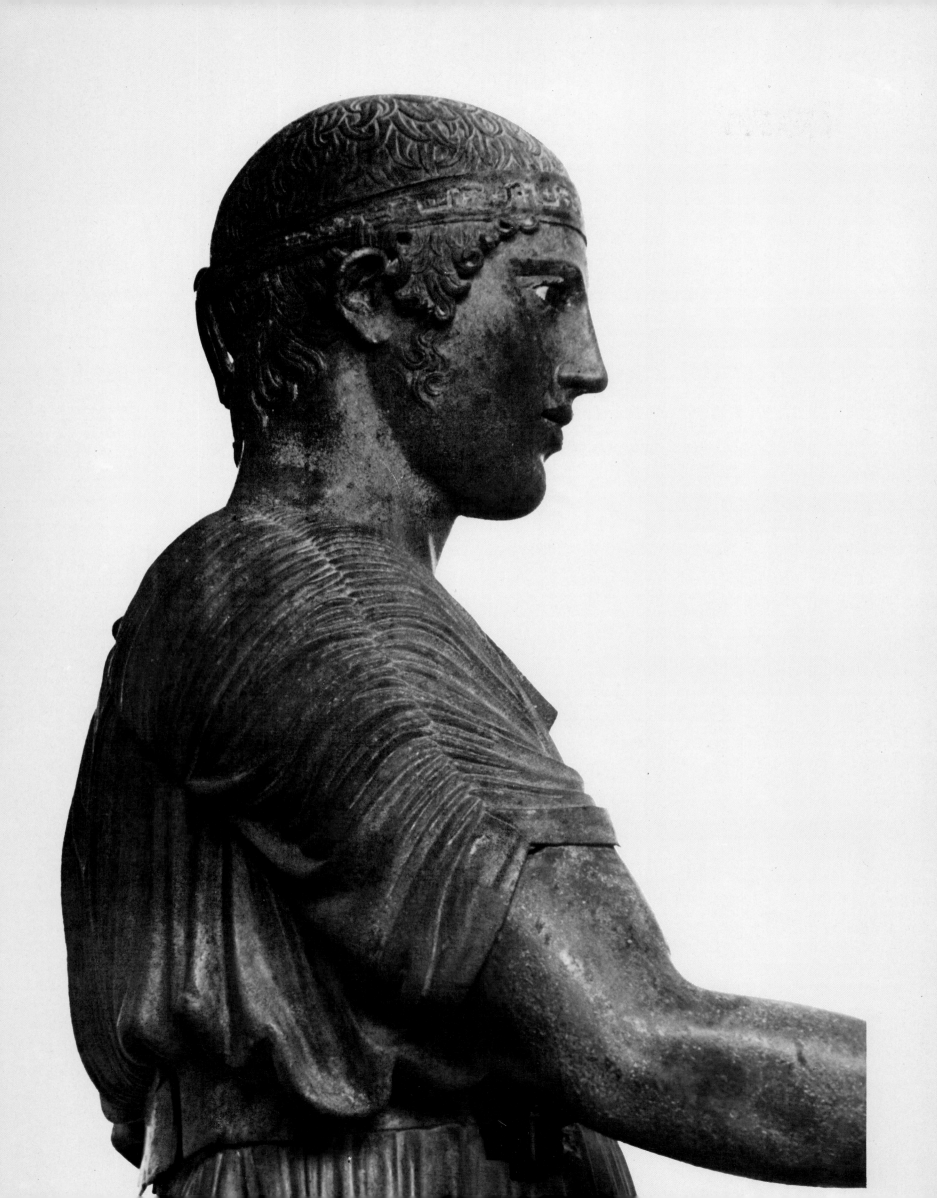

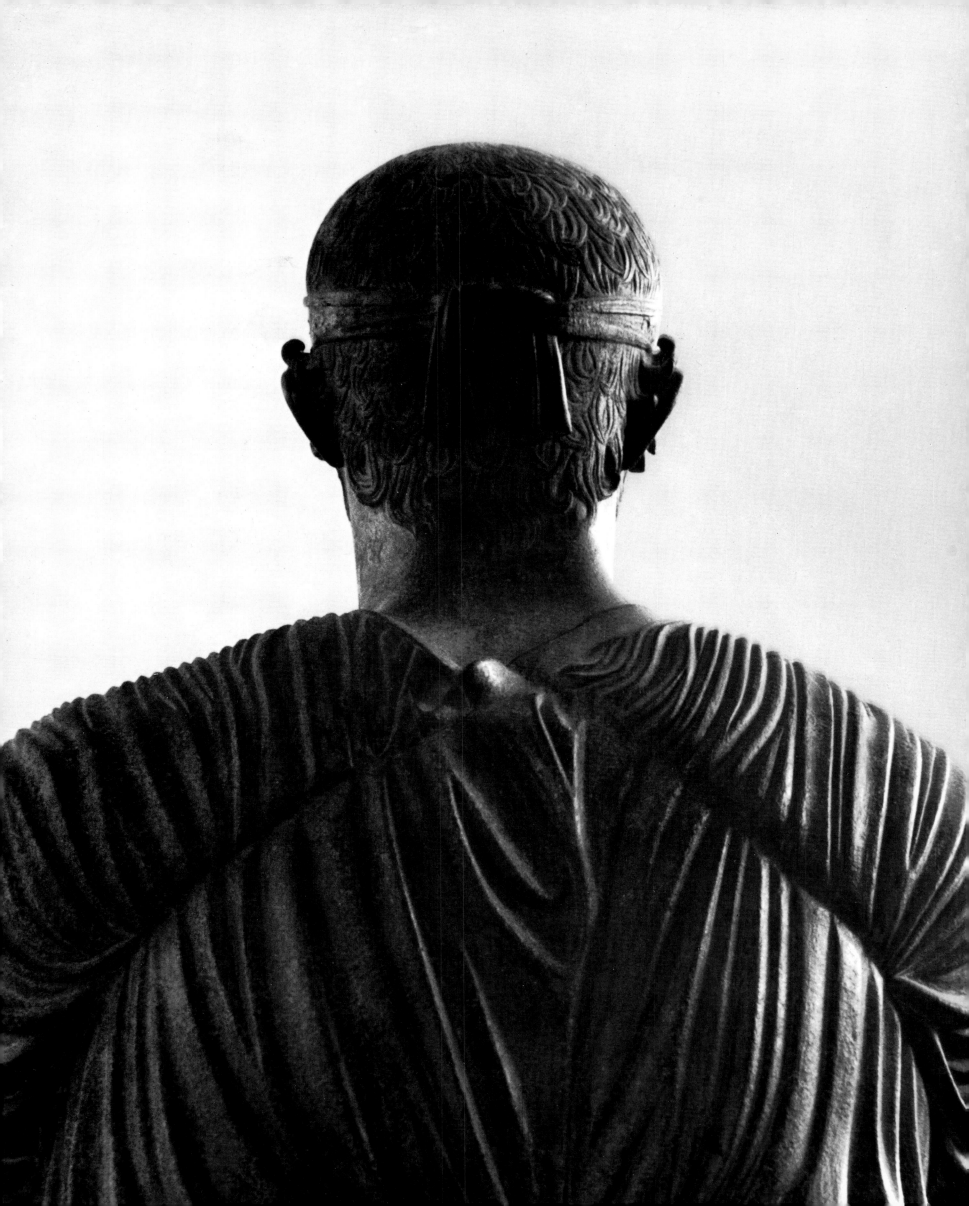

OLYMPIA

Olympia, a small plain set back eighteen kilometers (twelve miles) from the sea, nestles in a valley of breathtaking beauty, surrounded on three sides by low, rolling hills. Evergreen oak, olive, pine, plane, and poplar trees grow tall on a verdant land watered by the Alphaios River and its tributary, the Kladeos.

The first people to settle at Olympia arrived there nearly forty-eight centuries ago, at which time the area served as a religious site for the worship of the Titan gods. After the Olympian deities appeared in Greece and overthrew the Titans, Zeus and Hera assumed the leading religious roles at Olympia. From that time on, Olympia was a sanctuary rather than a city. Then, as Hera's influence gradually declined, Zeus became the dominant god, to such a degree that the sanctuary remained a major one until the rise of Christianity as a powerful and popular force.

In A.D. 393 Olympia lost considerable status when Emperor Theodosius I outlawed worship in pagan sanctuaries. A little more than three decades later, in A.D. 426, Olympia suffered a fatal blow, as a consequence of a decree issued by Theodosius II ordering the destruction of the monuments in the sanctuary. What hostile hands left undone, natural disasters completed, as earthquakes in A.D. 522 and 551 tumbled every structure and the rivers flooded the scattered ruins.

At a very early time the Greeks established physical excellence as an important aspect of religious observance at Olympia. Athletic games began there in prehistory, perhaps as early as the twelfth century B.C. The trials became Panhellenic in 776 B.C., and with this the Hellenic world entered its historic era, for Greeks would henceforth calculate dates in Olympiads. So important were the Olympics to the Hellenes that the games went on every four years for more than a millennium. The ancient series ended only when outlawed by Emperor Theodosius I in A.D. 393.

Being an important sanctuary, Olympia was also rich, and statues dedicated there accumulated into one of the greatest art collections in all of history. Statuettes representing horses, bulls, and human forms appeared in the sanctuary as early as the eleventh and tenth centuries B.C., joined by large statues no later than the seventh century B.C. In subsequent centuries the devout erected hundreds of statues portraying Olympic winners. Even athletes and judges caught cheating added to the collection after the 98th Olympiad (approximately 388 B.C.), when fines for dishonesty were first used to pay for *Zanes,* bronze statues of Zeus.

The most widely acclaimed statue in the entire Greek world may well have been the spectacular chryselephantine image of Zeus that Pheidias made in the fifth century B.C. for the Temple of Zeus at Olympia. So great was the fame of this work that it persists even today, some sixteen centuries after the figure's destruction. The colossal gold and ivory image, nearly as tall as the temple despite the sitting pose, dwarfed human viewers. Like all the other major representations of Zeus, Pheidias' statue portrayed the Olympian god as a mature, bearded man with a serious expression and a powerful, athletically conditioned body.

The surviving statue bases and ancient literary accounts of the sanctuary indicate that more bronze statues stood at Olympia than at any other site in the Hellenic world. Bronze became an important medium at Olympia in the eighth and seventh centuries B.C., a period of Geometric statuettes cast in solid bronze. As elsewhere, Olympia yields only rare evidence of large bronze figures made before the fifth century B.C. After the sixth century, however, the great statues of athletes fashioned at Olympia were hollow-cast in bronze.

Olympia lost almost all its monumental bronze statues to looters once the sanctuary and Greece had been rendered powerless. Rome and Constantinople probably absorbed much of the sculpture, which then succumbed to one destructive force or another. Three heads cast in bronze did survive at Olympia, albeit severed from their bodies. One is a Late Archaic bearded image that probably represents Zeus; the second, a Late Classical work, depicts a boxer; and the third provides a Late Hellenistic portrayal (badly battered) of a child. The Archaic *Zeus* and the Classical *Boxer,* both nineteenth-century finds made inside the sanctuary, come to us in relatively good condition and have been included here. They are the best survivors of the thousands of images of men and gods that comprised one of the finest, and most important, ensembles of sculpture the world has ever known.

THE OLYMPIAN ZEUS

LATE ARCHAIC, END OF THE SIXTH OR BEGINNING OF THE FIFTH CENTURY B.C.

PRESERVED HEIGHT: 0.17 M.

FOUND IN THE SANCTUARY AT OLYMPIA, A.D. 1877

NATIONAL MUSEUM, ATHENS

A surprising mystery surrounds the bearded head found near the Temple of Zeus at Olympia. Although discovered in the sanctuary just southwest of the Early Classical temple, the piece has defied all attempts to explain why or when it became separated from its body and exactly where the statue stood in the sanctuary.

No inscription or attribute remains to prove that the image represents Zeus, the great god of the skies, but such an identity has been traditional and continues to offer the most likely possibility. Statues of Zeus filled Olympia, which the Greeks regarded as his major sanctuary. Normally the deity was portrayed as a solemn, mature man with long hair and a full, short beard. Here, most of the long tresses have been tied at the back with a ribbon. Several wavy locks, which had been cast separately, remain in Olympia. The tubular diadem may refer to the god's kingly role in the pantheon.

Gouges around the right socket indicate someone's attempt to pry out that eye, which would have been made of colored stone, glass, or perhaps rock crystal. Defacing the image of a god or any figure dedicated to a god smacks of the sacrilegious, if not by one standard, then by some other. It would be difficult to imagine that such a desecration could have occurred while the Olympian gods held their lofty position in Greek spiritual and cultural life. Still, evidence exists to suggest that the statue may have been broken and buried before the second century, A.D. Pausanias, whose writings provide an invaluable contemporary source for the topography, monuments, and legends of ancient Greece, noted the statues of Zeus that he saw during his visit to Olympia during the second century, A.D. However, none of his descriptions quite fits this head, and so it may already have been damaged and disposed of.

If we assume that the head was one-seventh the height of the whole figure, the statue would have been a little over a meter tall, or just under lifesize. The strict symmetry of the design and the straight line of the neck permit one to visualize a body in a stiffly frontal pose, either standing or seated.

Although the artist based his design on natural form, he controlled it with geometric order. Snail-shaped curls, aligned in a double row forming an arc about the forehead, are uniform in diameter, a measure that provided a modular unit for the remainder of the composition. The mouth, for example, is three units wide, and each eye two units long. By their placement, moreover, the eyes bisect the face horizontally; they also mirror one another exactly, since the head is bilaterally symmetrical.

In the head of the *Olympian Zeus*, clear, rational order takes precedence over natural form, reflecting an intellectual concept of art altogether characteristic of the Archaic style.

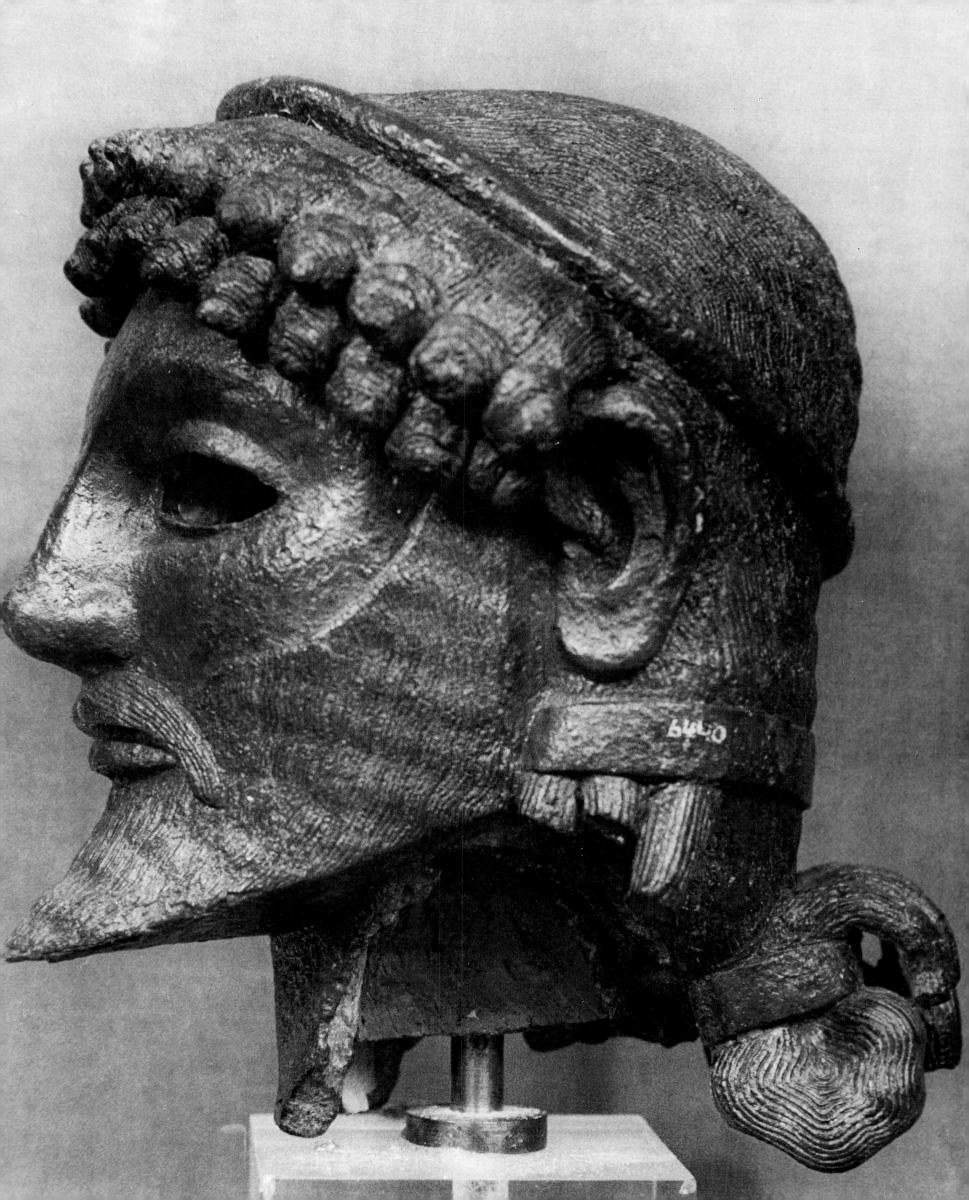

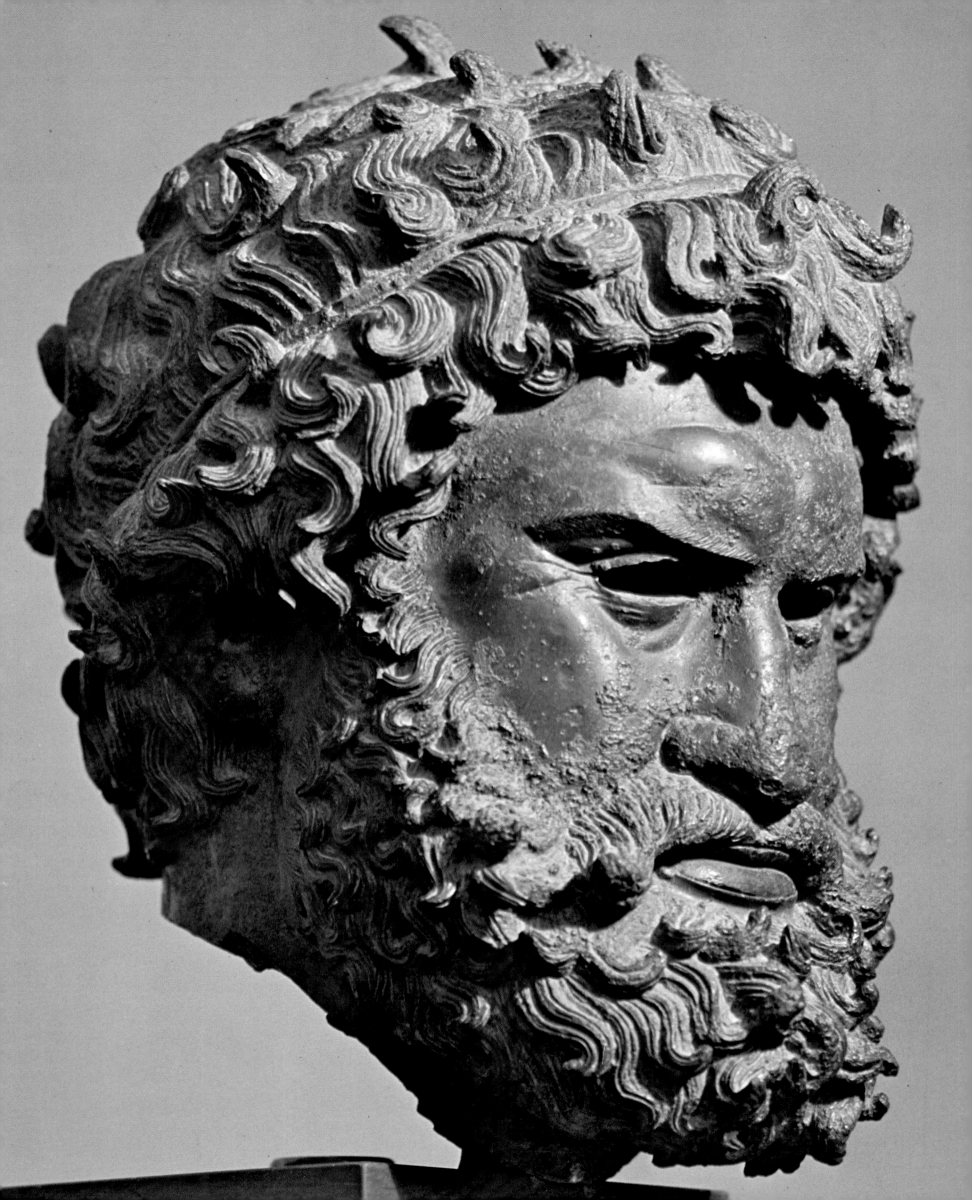

THE OLYMPIC BOXER

LATE CLASSICAL, SECOND HALF OF THE FOURTH CENTURY B.C.

PRESERVED HEIGHT: 0.28 M.
FOUND IN THE SANCTUARY AT OLYMPIA, A.D. 1880
NATIONAL MUSEUM, ATHENS

Hundreds of bronze statues portraying victorious athletes stood in the sanctuary at Olympia, but of this sculptural population, only fragments have survived, among which the *Boxer*—actually a bodyless head—constitutes the most monumental piece.

As their coveted prize, the Olympic victors wore a wreath of olive leaves. In the instance of this winner, the cord serving as the base of the wreath remains set in the unkempt hair, with nothing but stumps of branches and the stubs of a few leaves still attached to it.

We know the man portrayed to have been a boxer from his cauliflowered ears and battered forehead. Bags under the half-closed eyes and loose flesh on the cheeks tell us that the athlete had passed beyond his prime. Suffering and concentration would seem to be implied by the puffy, wrinkled brow.

The sole clue by which we could imagine the boxer's missing body are the slight leftward inclination of the head and the downward cast of the eyelids, which together suggest that the statue may have been designed in a quiet, introspective pose.

Despite the decapitation, the head retains its shape in good condition. The main damage to the piece is in its color and eyes. The reddish copper of the lips would have made their firm, straight set appear even more pronounced when seen in clear definition against the polished bronze. And eyes made of colored glass or stone, or even crystal, would have enlivened a visage now blinded by its empty sockets.

Stylistically, the *Olympic Boxer* announces an artist ready to turn away from the simple geometric organization of features espoused by earlier Greek masters in such works as the *Olympian Zeus* and the *Delphi Charioteer.* For his *Boxer,* the sculptor avoided idealization or generalization in favor of more irregular, naturalistic forms, which in fact became typical of portraits made in the last half of the fourth century B.C.

By treating the athlete's brutalized features and other imperfections with candor, the artist expressed some of the pain and problems his subject had suffered. This Late Classical view of an Olympic victor sees the hero not in his triumphant state, but as a vulnerable mortal worthy of compassion, just as much as the admiration he once inspired.

Thanks to the individualization of the face, its subject could probably have been recognized by anyone who knew him. According to reported custom, the artists at Olympia modeled the victory statues in exact personal likeness only for those who had been Olympic winners three times. Thus, we may assume that the head seen here represents a well-established champion.

We know that the Athenian sculptor Silanion modeled a portrait statue of an Olympic champion fighter named Satyros in the last half of the fourth century B.C., which makes it tempting to identify the *Olympic Boxer* as Satyros and to attribute the work to Silanion. However, inadequate evidence of Silanion's sculptural style prevents our doing this with certainty.

THE ATHENIAN ACROPOLIS

Athens has known human habitation for seven thousand years, its population, large or small, clustered on and around the Athenian Acropolis (the high city), a flat-topped rocky hill set in the midst of the Attic plain.

During the Stone Age and even in the early Bronze Age, Athens did not rank significantly above any of the surrounding towns. Then, about the middle of the second millennium B.C., the hero Theseus, a Bronze Age King of Athens, unified all the little Attic kingdoms into a single city-state under Athenian leadership. From that time on, Athens constituted one of the most important political entities in all of Greece.

Geography contributed to the power of Athens, which as a united city-state had access to fine agricultural land and good natural resources, as well as important harbors. Topography, moreover, made the city defensible. The Acropolis, which for all practical purposes could be entered only at its western end, provided a splendid fortress. To reinforce the natural stronghold, the Athenians in the thirteenth century B.C. built a wall of stones so gigantic that the masonry is called "Cyclopian," for the legendary one-eyed giants colossal enough to handle such massive boulders. That stout wall, part of which stands today, partially accounts for the fact that the Athenian Acropolis was the only fortress in Greece capable of withstanding the Dorian invasion in the last half of the second millennium B.C.

Other city-states, however, often surpassed Athens in both wealth and military power. A clue to Athens' leadership role in ancient Greece may lie in a story told during the fifth and fourth centuries. According to that legend, the city owed its survival against the Dorians to the wit and bravery of Kodros, King of Athens. After the Delphi oracle told the Dorians they would be victorious provided they spared Kodros' life, the Athenian leader proceeded to disguise himself as a woodcutter, went as such to the Dorians, and provoked a quarrel that brought on his death at the hands of enemies who would have wished to spare him for the sake of their own triumph. This made Kodros the savior of Athens, a hero personifying ideals of rational analysis, courageous self-sacrifice for the good of the state, and respect for supernatural forces. Whatever its historical accuracy, the story is important as an illustration of fifth-century Athenian values.

As Athens entered the period of its greatest political power, the city-state also became Greece's foremost patron of art, from the mid-sixth through the mid-fourth centuries B.C. The city itself grew into a major artistic capital, serving as a magnet for talented individuals from all over the Greek world. The sculpture and architecture created during that Archaic and Classical time expressed belief in the rational aspect of the cosmos; it also paid tribute both to the great capacities of mortals and to the awesome power of divinities. In their sculptural figures artists stressed idealized forms, producing generalized images that present individuals as embodiments of universal and affirmative qualities, qualities thought to be desirable goals for all people.

Even after Athens outgrew the urban perimeters of its Acropolis, the hilltop remained the religious center of the city, a place filled with sculpture dedicated to the gods. By the end of the sixth century B.C., the Athenian Acropolis served primarily as a religious sanctuary. Thanks to the integration of religion and politics in ancient Greece, the Acropolis also continued to function as a civic symbol and as the locus of ceremonies both religious and secular.

In 480 B.C. the Persians sacked Athens, demolishing buildings and shattering sculpture. Soon, however, the Greeks mustered their smaller forces and managed to defeat the mighty Persians in the Battle of Salamis. As the Athenians moved back into their city, they began the process of cleaning up the debris of war. This meant burying the mutilated sculptures, presumably like valiant soldiers, near where they fell. Much of the broken art rested there until the second half of the nineteenth century, when systematic exploration of the Acropolis first got underway.

Most of the sculpture found buried on the Athenian Acropolis lay there as a result of Persian destruction, which dates it before 480 B.C. No one kept detailed records of the various clearing campaigns that took place on the Acropolis in the nineteenth century; thus, we have virtually no precise archaeological context for the sculpture uncovered at that time. According to hearsay, the bronze head of a youth was discovered in 1866 by workers digging foundations for the Acropolis Museum. Other sculpture supposedly found in the same place at the same time is clearly Archaic in style, unlike the *Acropolis Youth,* but we lack proof that the deposit consisted of sculpture damaged by the Persians.

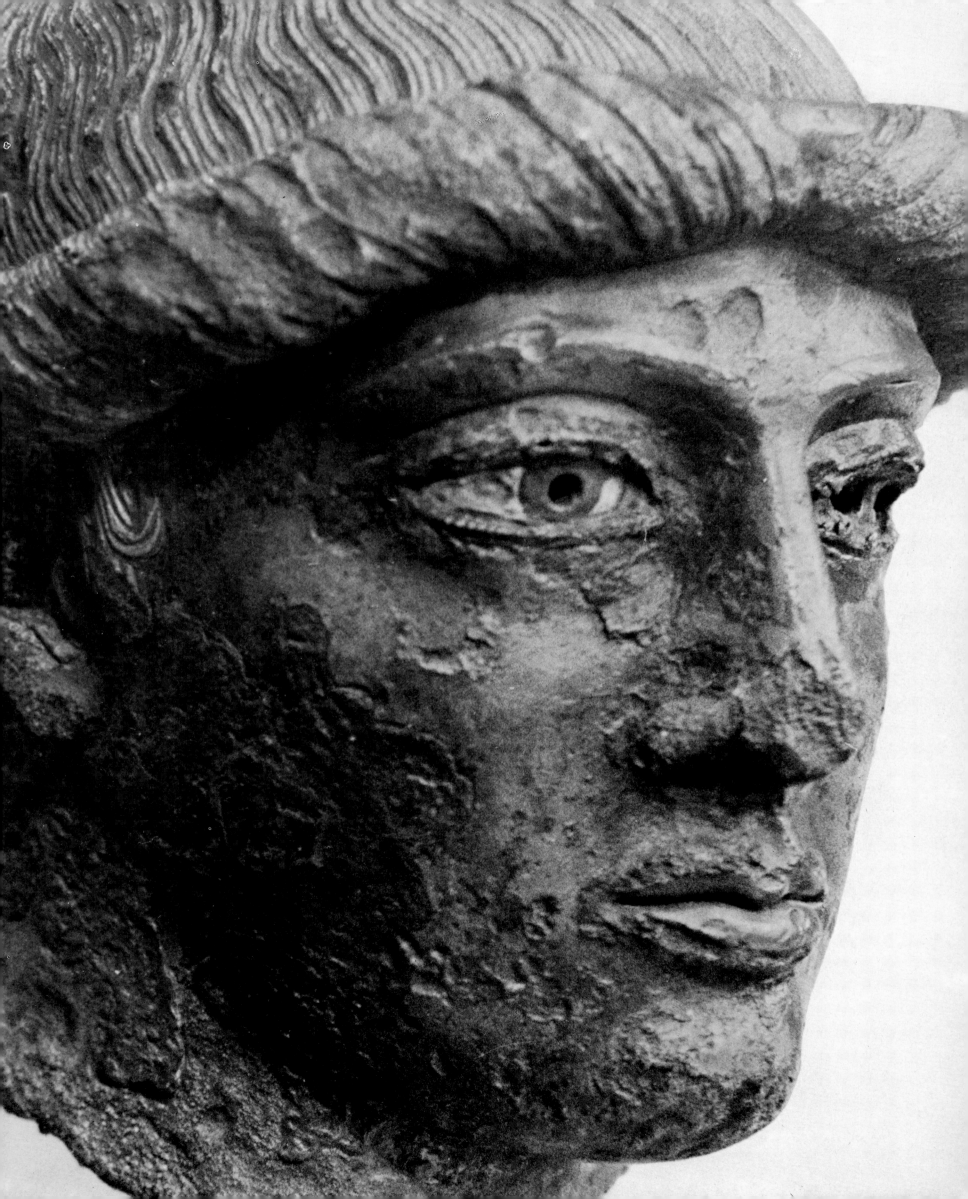

THE ACROPOLIS YOUTH

EARLY CLASSICAL, EARLY FIFTH CENTURY B.C.

PRESERVED HEIGHT: 0.13 M.
FOUND ON THE ATHENIAN ACROPOLIS, C. A.D. 1866
NATIONAL MUSEUM, ATHENS

The so-called *Acropolis Youth*—actually the half-lifesize head of a young man—counts among the first large Greek bronzes to be found since antiquity. Like so many other treasures from that moment of cultural triumph, it had been buried on the Athenian Acropolis. The beauty of the work never fails to impress, but the piece has seldom been published, owing to certain factors that persist in puzzling its admirers.

Whatever the event that caused the head to become separated from the body, it occurred prior to the form's burial in antiquity. But despite the violence done to the total work, the existing fragment has come down to us in remarkably good condition. The nose, however, is somewhat flat-tened, rather like that of a pugilist, and possibly for the same reason—a powerful blow to the face. Most of the right eye survives, albeit minus the pupil and with some damage to both the white and the iris. Worse befell the left eye, since the socket contains only pasty material that must have been inserted in the nineteenth century before records were kept of such "restorations."

Clearly the creator of the *Acropolis Youth* had a taste for naturalistic appearances, but he was also capable of carefully planned design based on a firm sense of geometric order. This can be seen in the vertical division that endows the left and right sides of the head with mirror-image symmetry, as well as in the placement of the eyes, so precise that it

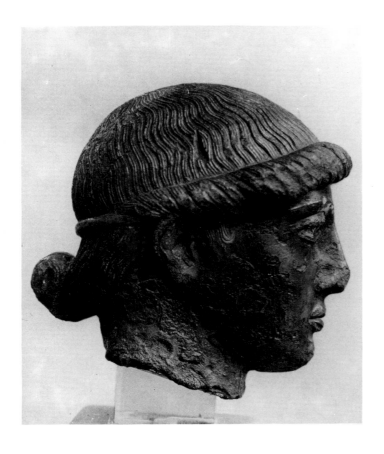 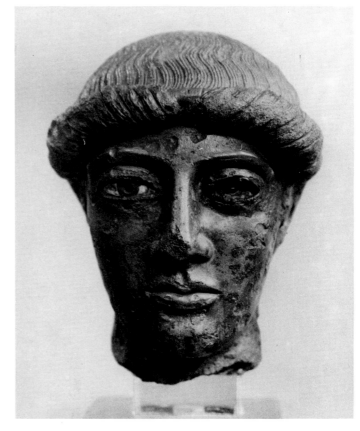

separates the head horizontally into two equal parts. Not a hair escapes its assigned place in a coiffure that combs the tresses forward, winds them around the cord crowning the head, or, at the back, gathers the long strands into a tidy bun. The arc of the lower lip, meanwhile, finds a corresponding shape in the upper eyelid and the eyebrows. What emerges from such balanced composition would seem to be a personality characterized by self-control and emotional stability.

The *Acropolis Youth* belongs to the same stylistic group as the pedimental sculpture from the Temple of Zeus at Olympia, which dates to the second quarter of the fifth century and embodies the essence of Greece's Early Classical sculpture. Artists working in the older Archaic manner allowed stylization to take precedence over natural shape (see pp. 45–49, 52–57). Once this ratio has been re-versed, as in the Olympia pediments and the *Acropolis Youth*, we know that we are in the presence of a work whose creator had advanced into the Early Classical period, when the illusion of realistic form received greater emphasis than the abstract patterns of design.

Most of the sculpture found buried on the Acropolis evinces the Archaic style that prevailed when the vandalizing Persians stormed Athens in 480 B.C. How, therefore, are we to account for the *Acropolis Youth,* whose Early Classical qualities conform to a manner generally thought to have evolved only by 479 B.C.? Until it can be determined either that the *Acropolis Youth* never fell victim to the Persians or that the date now used to separate the Archaic period from the Early Classical, should be revised, the beautiful head seen here will remain a tantalizing enigma.

LIVADHOSTRO BAY

Most sculpture recovered from the sea had gone down with a foundering ship, but this would not appear to be true of the bronze statue spotted by local peasants in Livadhostro Bay. The figure lay not far from the shore in water less than a meter deep. The sea level in this area has risen since ancient times; thus, the site where the peasants discovered the statue would have been too shallow ever to allow for shipping. The villagers saw some large stones, which could have been part of the figure's base, but searches carried out so far have failed to discern any trace of debris from a shipwreck.

Since the large sculpture taken from Livadhostro Bay seems not to have been on a ship in transit, it was probably thrown into the sea from some near point on the shore. And the bay, which opens into the Gulf of Corinth from the south coast of Boeotia, does in fact have along its edge two notable antique sites. Kreusis (modern Livadhostro) served as the port for Thespiai, and a settlement at or near modern Agios Basileios was the port for Platea. When found, the statue rested close to a chapel of Agios Basileios, which was most likely built on top of one of Poseidon's ancient shrines. The figure might well have come from the promontory sacred to the Olympian lord of the seas and now a holy place of Agios Basileios.

No clues have yet turned up to reveal whether men or natural forces deposited the statue in the Boeotian bay. Any group eager to overthrow the Olympian pantheon could have dumped a pagan image into the water, but no record survives of such an action near Agios Basileios. One natural disaster strong enough to have wrecked the sanctuary and wash a large bronze figure into the sea occurred in 373 B.C. This was an earthquake, which unleashed a tidal wave that drowned the ancient city of Helike just across the Gulf of Corinth from Livadhostro Bay. The quake also ruined the Temple of Apollo at Delphi, not far to the northwest of the bay. Perhaps that upheaval or one like it gave the statue to the sea.

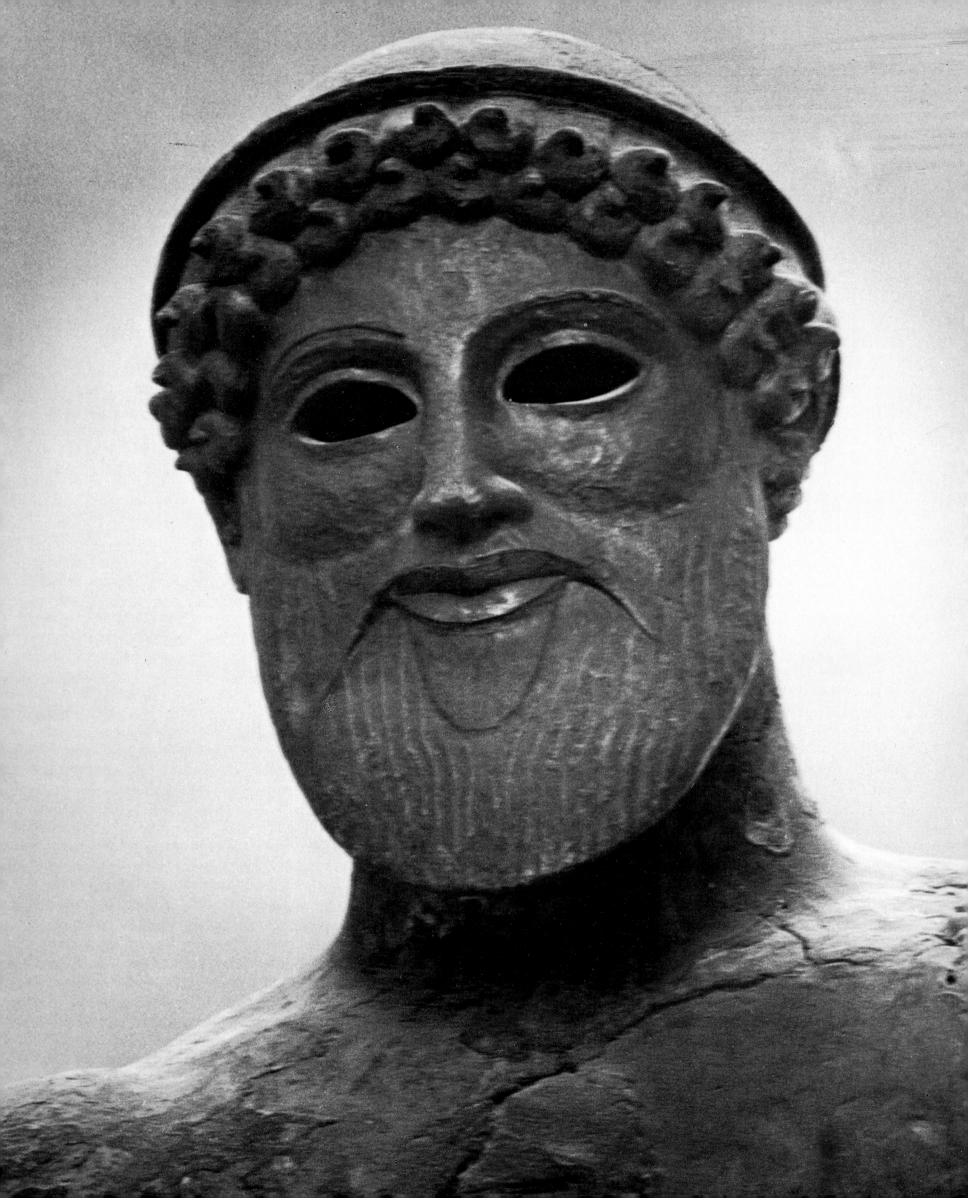

THE LIVADHOSTRO POSEIDON

ARCHAIC, C. 500 B.C.

HEIGHT: 1.18 M.
FOUND IN LIVADHOSTRO BAY, C. A.D. 1897
NATIONAL MUSEUM, ATHENS

When villagers discovered this statue in the late nineteenth century it was lying in pieces at the bottom of shallow waters in Livadhostro Bay on the southern coast of Boeotia. One of the pieces, a bronze tablet on which the figure originally stood, makes the sculpture unique among the monumental bronzes surviving from Greek antiquity. Not only has none of the other statues been based in this fashion, but the base seen here bears an inscription. Cut into the tablet at the viewer's right-hand corner, it reads "sacred to Poseidon."

The sculpture had suffered severe damage. A crack around the neck shows where the head had been broken off and then reset in ancient times. Further mischief left it in the shattered condition found by the peasants, and the numerous missing parts make it difficult to restore and display the statue. Still, the curators and conservators rose to the challenge and assembled the surviving fragments in an exemplary way. To distinguish the reconstructed passages, they have made them smoother but less light-reflecting than the original surface.

The image is of a mature human male, his dignified expression, direct confrontation of the viewer, and firm body consistent with the way the Greeks represented both Poseidon and Zeus, those fra-ternal deities of, respectively, the sea and the sky. A tubular circlet on the head may be a diadem, signifying divine sovereignty. From the time of its discovery, the tablet assured that the figure would be considered the image of Poseidon, an identification supported as well by all other available evidence.

The *Livadhostro Poseidon* is just over three-quarters lifesize, a scale favored by other sculptors who pioneered the use of bronze as a medium for large statuary. In this instance, however, the creator combined techniques that would become standard for monumental sculpture with a practice normal in the production of statuettes. As for the former, he hollow-cast the figure and then articulated its features by means of different materials and their colors. Thus, a nearly pure copper served for lips, nipples, and eyebrows, lending them a mineral-red blush. Originally, eyes of translucent glass or colored stone set into the bronze head would have given the face a look of intense vitality it has now lost. Meanwhile, the heroic figure stands on a thin bronze plate just as many Archaic statuettes do. In no other known Greek figure do we find such a mixture of elements typical of large sculpture on the one hand and of small works on the other.

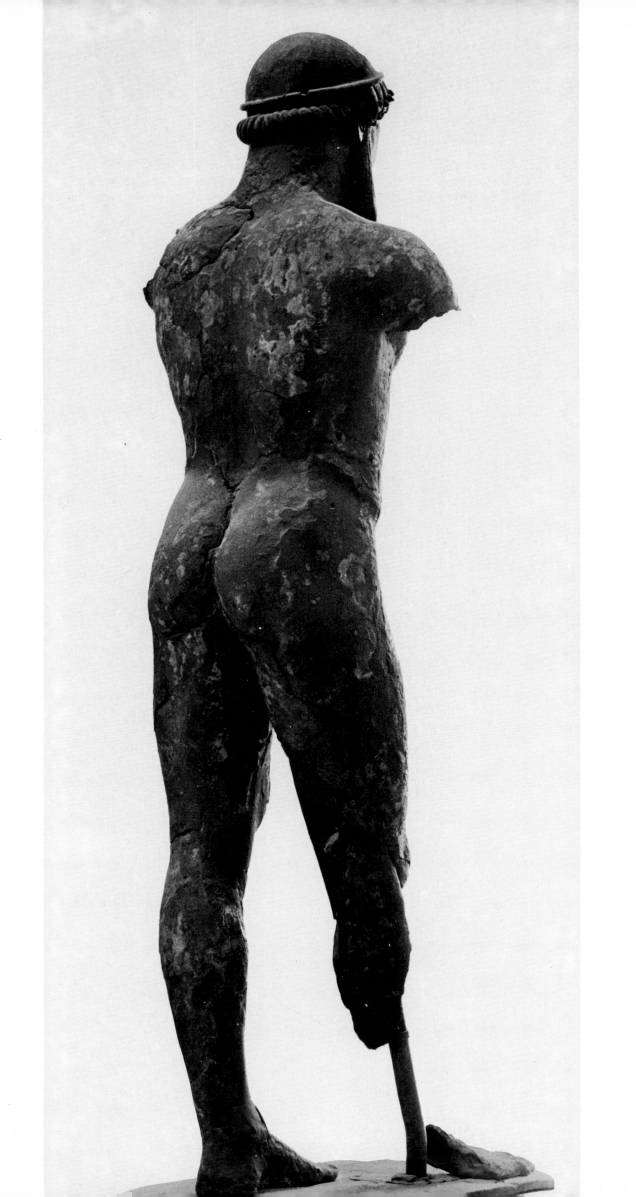

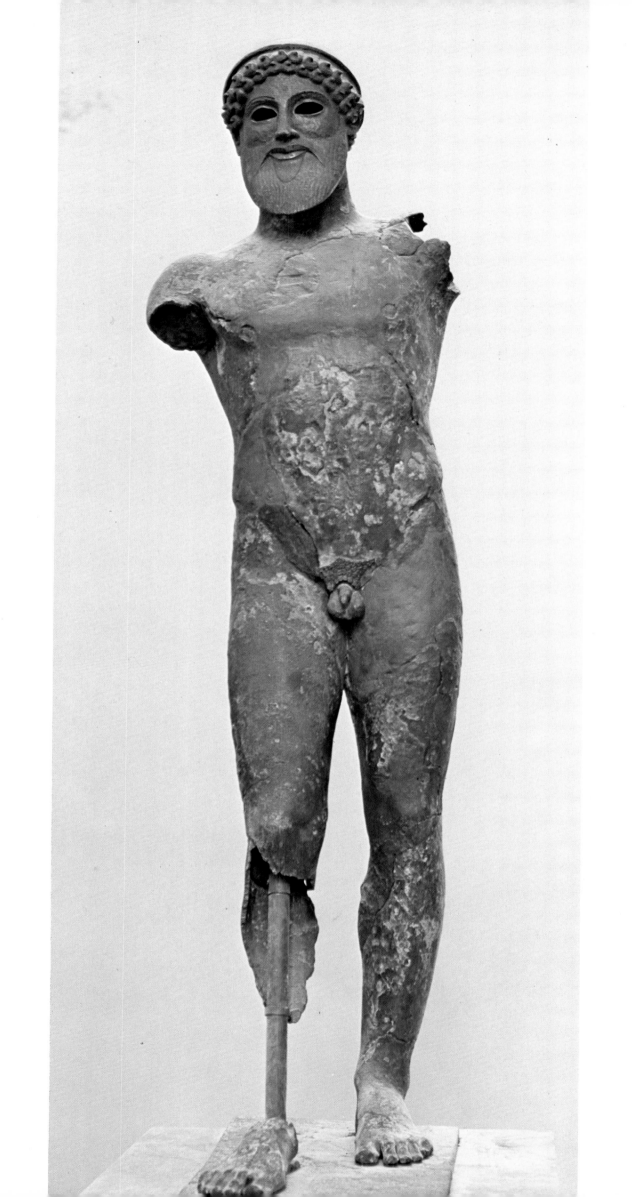

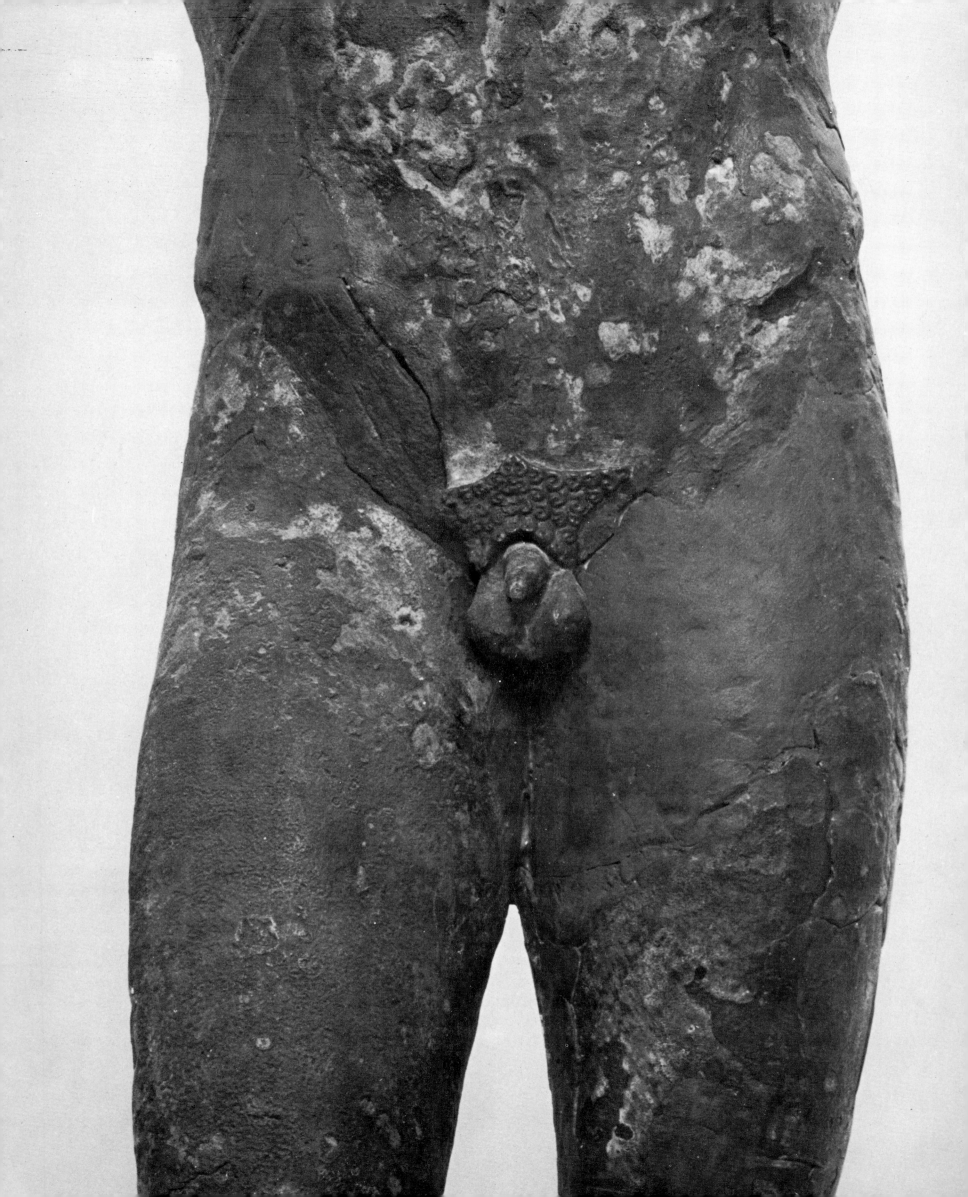

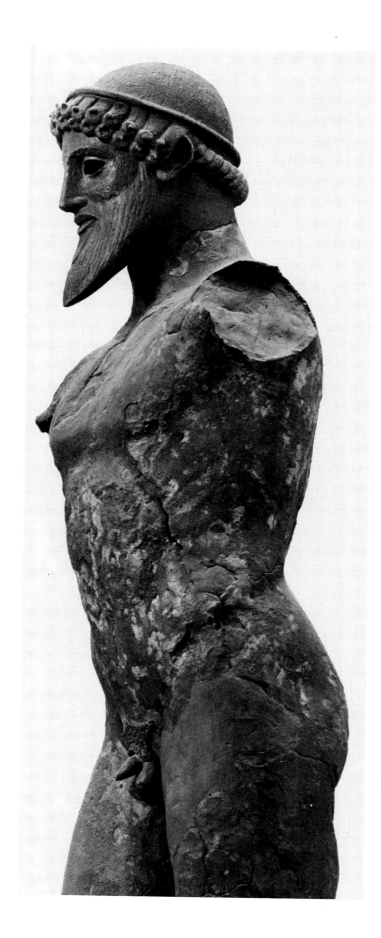

The *Livadhostro Poseidon* displays the stepping pose that Archaic Greek artists inherited from Egypt as the essential convention for portraying full-length standing male figures. It can also be seen in the *Piraeus Apollo* (pp. 52–57), the only other large Archaic bronze statue whose body has survived, and like the creator of that work, the *Poseidon* sculptor modified the tradition by setting the figure's right, rather than its left, leg forward. And whereas most sixth-century freestanding statues are in repose, except for their step forward, the *Poseidon* deviates from the norm by its engagement in action. The missing left arm appears to have been raised, probably to wield a trident, since the left side of the figure stretches and the body leans to its right, as if responding to the pull of that arm. Moreover, the right arm reached forward, a gesture reflected in the slight twist of the torso about its axis.

The head, which is better preserved than the body, exhibits a similar mixture of Archaic and Early Classical traits. Note, for example, the bangs framing the forehead, where the artist appears to have been more interested in finding a pattern in the double row of curls than in creating an illusion of reality. The ears, however, provided an occasion for naturalistic representation.

Such stylistic blending affected other Greek sculpture made around 500 B.C., most remarkably in the famous pedimental figures from Aegina (now in Munich; see p. 134), which are formally very close to the *Livadhostro Poseidon*.

The inscription, as we have seen, associates the figure with Poseidon in the surest way possible. And since it is written in the Boeotian dialect, the inscription joins other clues to indicate that our statue stood in a local Boeotian shrine set near the modern chapel of Agios Basileios and dedicated to the Olympian sea god. But even though the *Livadhostro Poseidon* can be assigned to a local sanctuary, the sculpture itself does not, unlike the inscription, demand identification with the region. The eclectic elements that distinguish the statue found in Livadhostro Bay—the mixture of techniques drawn from large and small statuary and the blending of Archaic and Early Classical styles—are also common to monumental sculpture made throughout the Greek world at the beginning of the fifth century B.C.

PIRAEUS

In 1959, during construction of a new sewer line beneath the streets of Piraeus, Athens' port city, workmen found the largest cache of Greek monumental bronze statues to be recovered in modern times.

The deposit contained three statues of superhuman scale representing Apollo, Artemis, and Athena. It also yielded another Artemis, a statue slightly smaller than lifesize. A large dramatic mask brought the number of bronze sculptures discovered at the site to five. Along with these artistic finds came fragments of two bronze shields, one plain and one decorated with repoussé relief.

Stacked with the bronze treasure were three pieces of marble sculpture. Two of them are herms, so similar to one another that they probably came from the same workshop. The still-crisp carving on these works suggests that they must have been made shortly before their burial. The third marble statue represents the figure of a woman with arms hidden under a strange sleeveless tunic bound about the figure like a strait-jacket. This too may be an image of Artemis, an obscure form of the goddess from one of the sanctuaries dedicated to her in Asia Minor.

The particular deities in the collection cause us to believe that their home sanctuary was sacred to the twins Apollo and Artemis. The statue of Athena would be especially appropriate in a place closely connected with Athens during the mid-fourth century. The freshly made herms probably issued from an area where a workshop producing herms thrived during the first century B.C. The peculiar small statue with its implications of an oriental Artemis points to a Panhellenic sanctuary in which Artemis was revered. The only site comfortable with all these qualifications is Delos, a major religious and trading center whose fortunes were entwined with Athenian politics.

Delos was caught in the conflict between Rome and Pontus in the early first century B.C. Romans occupied the island in the course of their eastward expansion, which

brought an attack by Mithradates' men sent from Pontus to Athens. When the Pontic forces reached Athens, they reported having killed twenty thousand Romans as well as having knocked Roman statues off their pedestals or thrown them into the sea. No record survives to tell us that the Pontic commanders "rescued" images of Olympian deities, whom they honored, but it would be surprising if they did not. Certainly their interest in sculpture and its political symbolism is documented. If the Piraeus Cache arrived at Athens' seaport on board Pontic ships, it remained stored in a harbor warehouse only a brief time before the Roman General Sulla began his merciless destruction of people and buildings in Athens and Piraeus.

When found, all the sculpture remained in neat order, stacked flat and parallel like cordwood, side by side or on top of each other. Traces of burned wood covered the collection, and a coin of Mithradates the Great (120–63 B.C.) lay with the sculpture. Such archaeological evidence suggests that the statues and the shields may have been stored in a warehouse at the port when a fire swept the area during the first century before Christ. As the warehouse collapsed, its contents fell into the ooze below, where it lay forgotten until dug up by twentieth-century construction workers.

Why these particular pieces came to be warehoused together presents a puzzle. The statue of Apollo belongs to the Late Archaic period (the late sixth century B.C.), but the large images of Artemis and Athena conform to the Late Classical style of the mid-fourth century B.C. The smaller bronze statue of Artemis, somewhat later in date, was probably made at the end of the fourth century or even in the third century B.C. Still more recent are the two herms, which appear to derive from the first century B.C. Since the Piraeus Cache ranges stylistically over a period of about five centuries, it cannot be seen as the product of a single commission, awaiting shipment from Athens to some distant patron.

A more logical explanation is that the sculpture originated at one sanctuary, where it had been dedicated, piece by piece, over the centuries before someone removed the collection in the first century B.C. Since Piraeus was a major Greek seaport, the cache could have been transported there from almost anywhere in the eastern Mediterranean.

All the bronze sculpture from the Piraeus deposit is religious. Not only do the statues represent the Olympian deities Apollo, Artemis, and Athena, but, in addition, the mask symbolizes the Olympian god of the theatre, Dionysos.

The greatest Greek sanctuaries honored more than one divinity, providing each with his or her own special space. At Delos, for example, the devout could find separate areas sacred to Apollo, to Artemis, and to Dionysos established near one another along the Sacred Way. Each space consecrated to a deity within the sanctuary usually contained at least one (and often many) statue of the god or goddess.

The Greeks dedicated their most important sculpture to one of the Olympian gods. It filled the sanctuaries until looted or destroyed by wars or later civilizations. Today the best collection of bronze sculpture made by Greek artists over a period of several centuries for a particular sanctuary is that found stored in Piraeus.

THE PIRAEUS APOLLO

LATE ARCHAIC, C. 520-510 B.C.

HEIGHT: 1.91 M.
FOUND IN PIRAEUS, A.D. 1959
PIRAEUS MUSEUM

The oldest monumental bronze statue to survive from Greek antiquity is an image of the god Apollo made during the late sixth century B.C. In it the sculptor followed an artistic convention, adopted from Egypt by Early Archaic Greece (see p. 134), wherein the human figure should be represented standing frontally with one foot stepped forward. Egyptian art, with its timeless style, had left the pose largely unchanged for thousands of years, but the more dynamic, progressive Greeks modified it immediately, doing so in a distinctive manner. From the start they adhered to the prototype only for statues of *kouroi*, young men, and always portrayed the subject nude.

Little survives of the objects once held by the *Piraeus Apollo*, but enough remains to tell us what they were. A portion of the circular ring in the right hand must be from the base of a phiale or offering bowl, and the cylindrical fragment still clutched in the left hand is surely the remnant of

a bow. Since the bow happens to be the attribute of Apollo, it provides a telling clue to the identity of the personage represented. Originally, when still brightly polished and in possession of its phiale and bow, the statue looked much like a figure of Apollo painted on a Greek vase now in Amsterdam's Allard Pierson Museum.

The "kouroi" pose served for a large number of Greek statues made during the sixth century B.C. The *Piraeus Apollo* belongs to this line of development, at the same time that it violates several aspects of the convention as we know it from earlier statues. Marble was the material traditionally used for large sculpture; in the instance of the *Piraeus Apollo*, however, the sculptor chose bronze. This medium set the piece apart not only by its higher cost and technical complexity but also by its golden color and gleaming surface. Moreover, since bronze possesses greater tensile strength than marble, the arms and hands of the statue could be designed

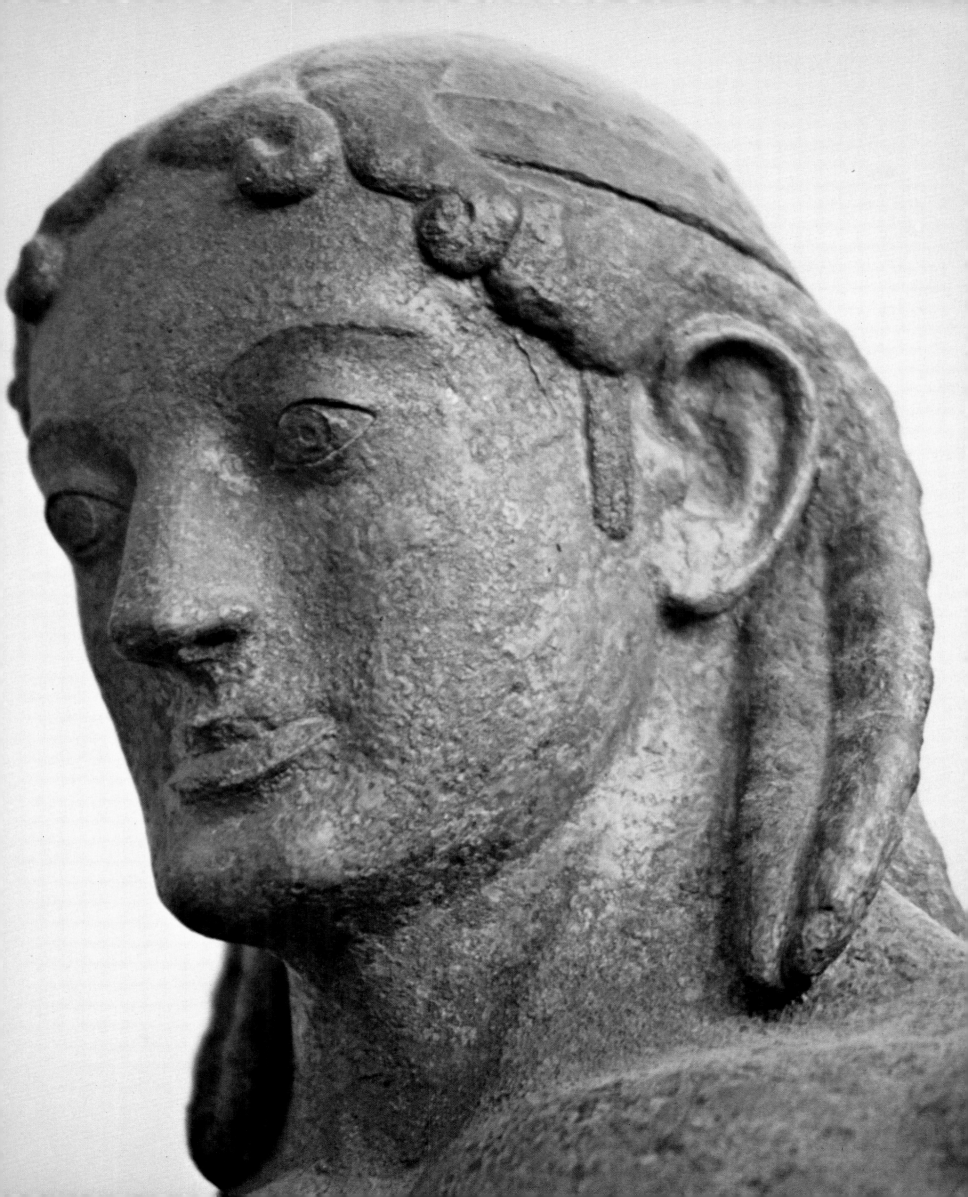

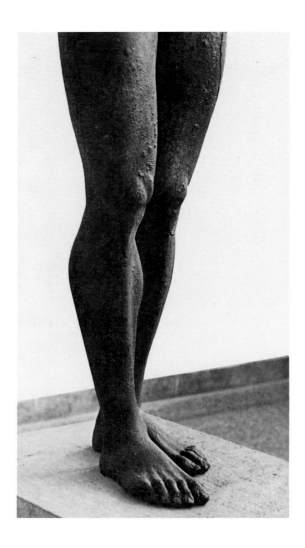

free of the thighs. As if to draw attention to his innovations, the Master of the Piraeus Apollo brought the figure's left foot forward, not the right one dictated by precedent.

The deity's thick, shoulder-length hair has been caught up in a tidy coiffure, with bangs parted at the center to form two locks on either side of the face and the longer tresses arranged in ten fat, sausage-shaped curls. The hairdo implies an orderly and self-controlled personality, as would be expected of the god devoted to the worlds of music and reason.

With the *Piraeus Apollo* we find something new in Greek sculpture, a suggestion that the person represented is conscious of you, his audience. The Master of the Piraeus Apollo so composed his figure that its head inclines toward the viewer, who becomes the focus of its eyes, unlike the eyes of Egyptian and earlier Greek statues, which stare straight out, over the spectator's head. A further innovation occurred when the sculptor broke the traditional position of the arms, bending them at the elbows, as though in a gesture of welcome.

The lines of the form flow together smoothly to create a serene and gentle effect, while the buttocks and chest swell, like power in repose. The composition gains volume the higher it moves up from the ankles, so that the body seems almost to defy gravity as it hovers above those who approach. The impact would have been even greater in antiquity, when the figure stood on a base taller than the one now provided by the museum.

The artist who made the *Piraeus Apollo*, hardly more than a century after the kouroi pose had appeared in Greece, rang such radical changes on the basic formula that the self-contained, stiff-armed Egyptian model soon lost all appeal for subsequent Greek sculptors.

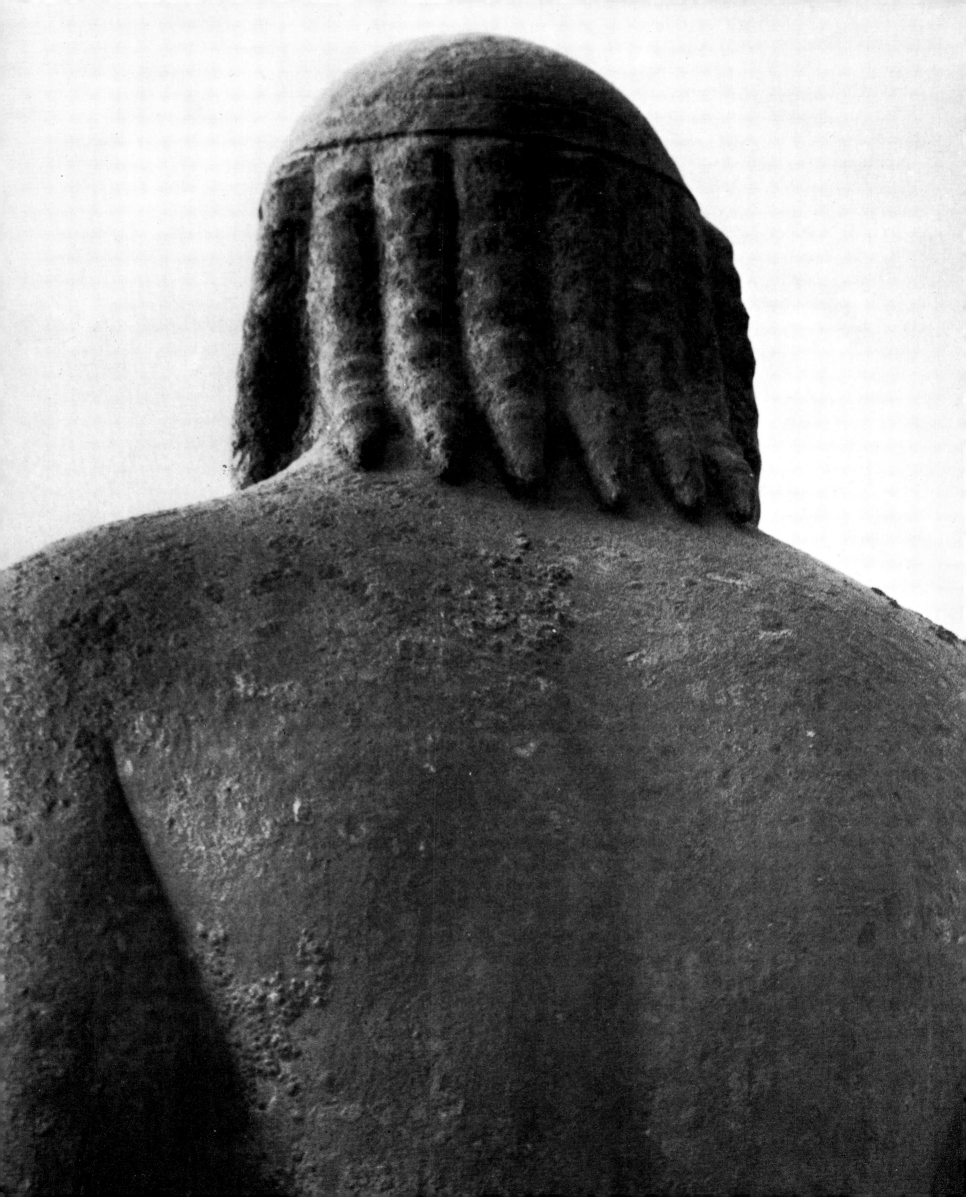

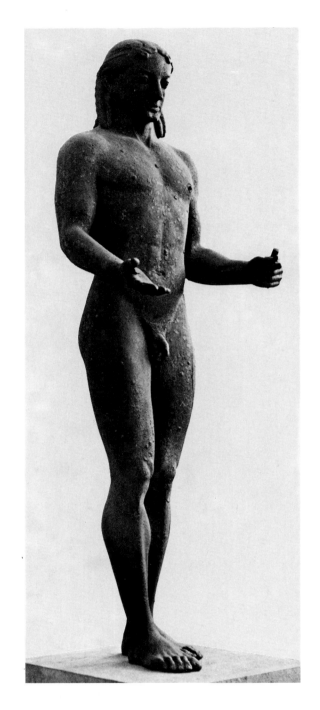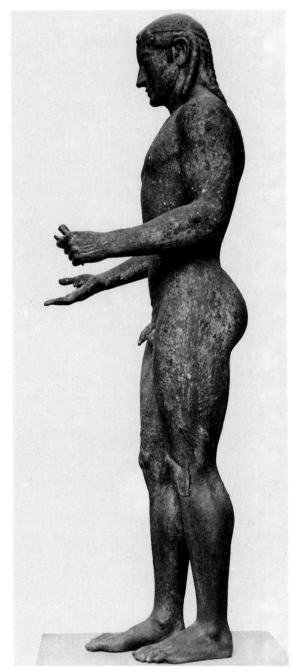

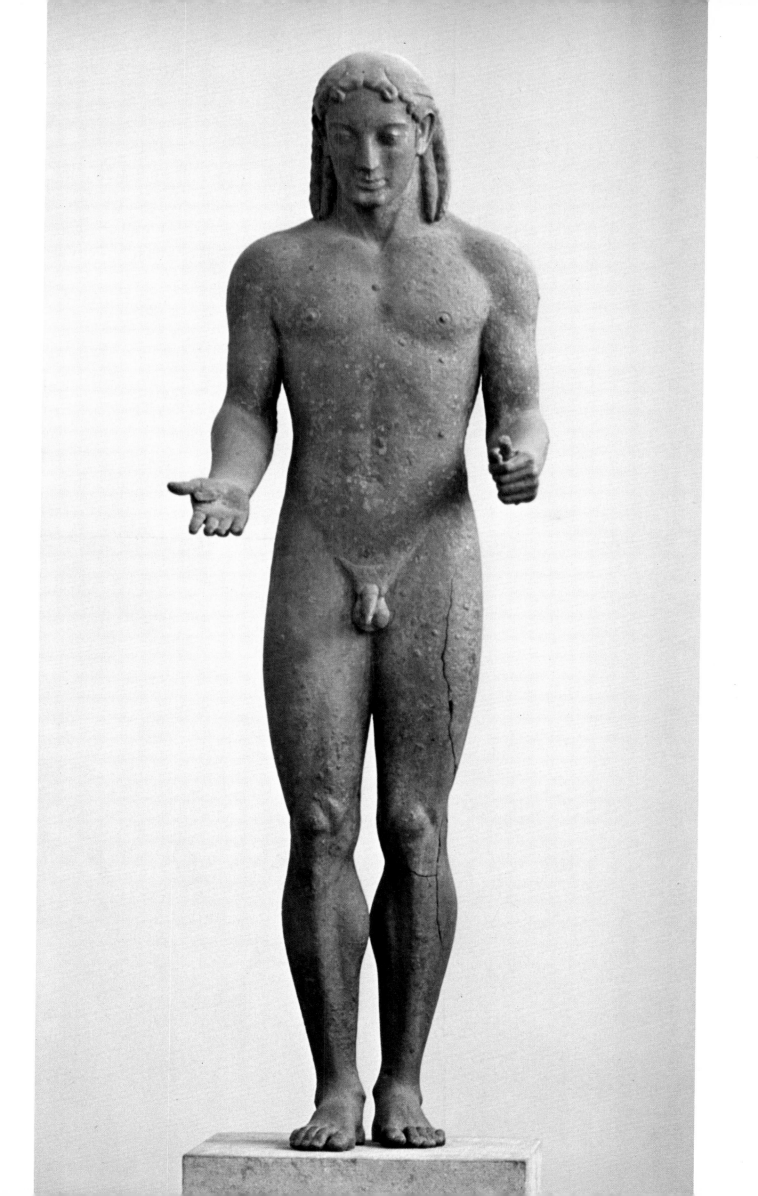

THE PIRAEUS ATHENA

LATE CLASSICAL, MID-FOURTH CENTURY B.C.

HEIGHT: 2.35 M.

FOUND IN PIRAEUS, A.D. 1959

PIRAEUS MUSEUM

The *Piraeus Athena* presents the patroness of Athens in a new role, that of a tender and nurturing deity, a personage of easy stance and gentle, quiet expression. The figure rotates to its right and leans forward as if listening to the viewer. A Late Classical image, this dulcet goddess differs considerably from the military Athena customary in Greece's Early and High Classical art, which we know through versions of the *Athena Promachos* (Athena the Defender) and of the *Athena Parthenos* (Athena the Virgin or Athena the Unviolated) by Pheidias (see p. 134).

The artist endowed the *Piraeus Athena* with a relaxed pose in which the left arm rested on a shield, the latter stood at the figure's side and balanced between its first two fingers on the interior and the thumb on the exterior. The left hand also steadied a standing spear. A mass of lead anchored both the shield and the spear to the goddess' hand, where it remains.

The object that this Athena cradled on her outstretched right hand was attached mechanically to a hole in her palm and thumb. The object has not come down to us, but the perforation suggests that it had a relatively irregular and small base, indicating a Nike, a Victory, or an owl, the bird sacred to the goddess.

In this image from Piraeus, Athena wears her helmet pushed back as though it were ceremonial regalia instead of battle armor. The long crest curves away from the crown in an arc that extends to the shoulders, where it terminates in a graceful arabesque. On either side of the crest a griffin stands guard, just as pairs of this mythical beast traditionally do on the goddess' helmet. Owls, however, replace the horned rams that usually claim the place of honor on Athena's visor.

Snakes and a gorgon's head, intimidations normal to Athena's aegis, assume a relatively amiable form in the Piraeus work. Instead of writhing serpents, they resemble decorative cording or piping tied in small knots, and the gorgon's head appears less monstrous than merely human. What the Piraeus sculptor designed was not so much martial

58

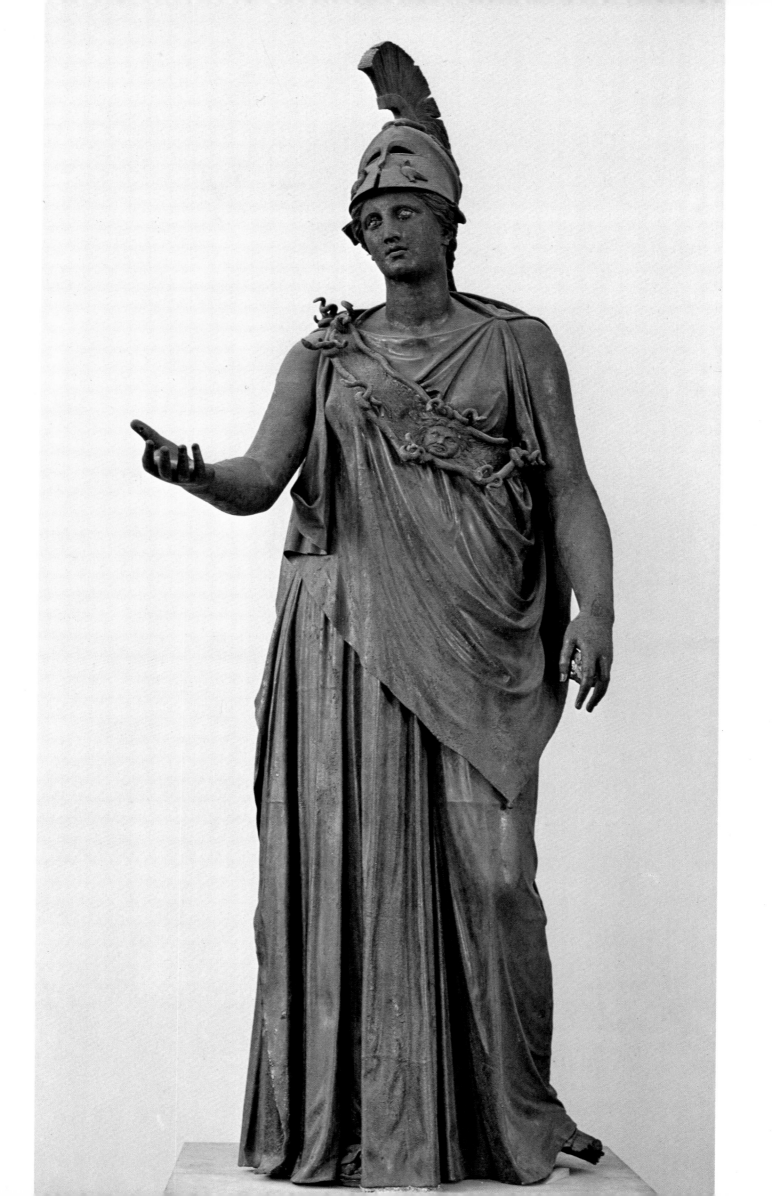

gear as a fancy diplomatic sash, with the gorgoneion serving as a jeweled medal.

Made of a single, large piece of cloth, the dress worn by Athena wraps around her left side so that two selvages meet on the right and fall in softly undulating folds. The cloth gathers at the shoulders, allowing the inner layer to drape to the floor and make a long skirt, while the overfold tumbles below the waist and hides the belt. The artist arranged the right side of the overfold to seem pulled over the shoulders at back, which would in turn draw the top front corner of the fabric across the goddess' body toward her left knee. Clearly, the sculptor used artistic license to exaggerate the length of the overfold and emphasize the strong diagonal line of the material's edge, as well as the curving, parallel folds of the garment, all manifestly designed to follow the direction of the diagonal aegis.

The voluminous skirt cascades heavily over the right leg, which bears most of the goddess' weight, visually reinforced and stabilized by the deep, vertical folds of the plunging fabric. Meanwhile, the smooth gathers of the skirt break over the left knee as Athena steps to the side, her action suggesting a moment of brief relaxation.

Sculpture of such high quality must have come from an artist whose name we know from Greek literature. Unfortunately, the paucity of work securely traceable to specific artists makes it impossible to identify the *Athena* sculptor with certainty. However, the stance and drapery rhythms of the *Piraeus Athena* are sufficiently similar to those of a marble statue found in the Athenian Agora and thought to be the *Apollo Patroos* of Euphranor that a good case has been made for attributing the *Piraeus Athena* to Euphranor as well.

Throughout generations the history of Classical Greek sculpture depended upon literary descriptions and Roman copies, for the simple reason that almost all monumental freestanding sculpture made in ancient Greece had been lost. Thanks to the discovery of the *Piraeus Athena*, we now have the means to compare an original Greek bronze with a later Hellenistic or Roman version and thus gain some understanding of the differences between the two. The Romans produced thousands of copies of monumental Greek bronze statues, but the only instance in which a bronze original can be matched to a complete antique copy involves the *Piraeus Athena* and a marble statute in the Louvre (see p. 134).

The Louvre marble, formerly in the Mattei Collection, follows the composition of the *Piraeus Athena* except in the lower right arm and hand, which the copyist made akimbo. Owing to the weakness of marble, an outstretched arm would have been difficult to achieve in that material. Furthermore, the shield and spear were basic attributes of the goddess that meant more to Greeks than to Romans. When the deity lost her symbolic import and the more versatile medium of bronze gave way to less costly marble, the deep religious and political significance of the original sculpture also vanished. Thus, while the Mattei copy quotes the original, it does so out of context, which makes it little more than a decoration attesting to the patron's learning and affluence. Compared with the *Piraeus Athena*, the Mattei marble copy appears vacant and insipid. Still, the importance of the comparison cannot be exaggerated, for it demonstrates some of the dangers fundamental to the long-established practice of accepting Roman copies as virtual replicas of the lost Greek originals.

The *Piraeus Athena*, with its gentle demeanor and quiet strength, constitutes a beautiful personification of a certain religious and political life that held profound meaning for a late-fourth-century Greek sculptor and his patrons, but a life utterly alien to Roman experience.

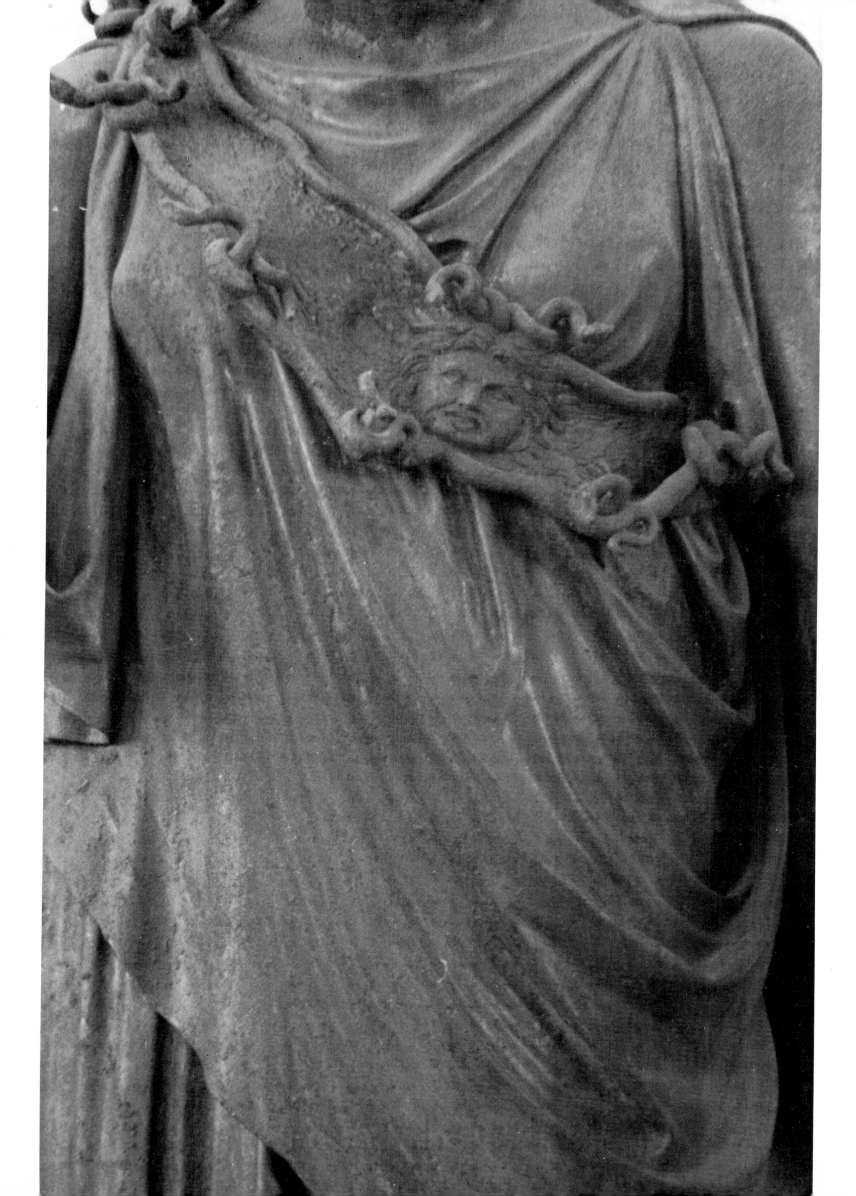

THE PIRAEUS ARTEMIS A

LATE CLASSICAL, SECOND HALF OF THE FOURTH CENTURY B.C.

HEIGHT: 1.94 M.
FOUND IN PIRAEUS, A.D. 1959
PIRAEUS MUSEUM

Artemis was the goddess of wild beasts and children, a deity acclaimed with high honors all over the Archaic and Classical Greek world. By those eras she had evolved from the deity considered in earlier times to be the essence of fecundity. But despite her concern for children and her continued interest in fertility, Artemis never became dependent on one man. Her epithet *parthenos* has been translated into English as "virgin," which may be nothing more than a poetic way of saying that the goddess remained unwed.

Born on the sacred island of Delos, Artemis received wide homage on the surrounding Aegean islands. The eastern Greeks of the Archaic period made her their favorite goddess, on whose fertility powers they placed great value. A resurgence of dedications in the fourth century before Christ, when oriental Greece was recovering from the Persian destructions, confirms the continuing strength of her popularity. Needless to say, many of the most splendid sanctuaries in the Greek world rose in the name of Artemis. A leading city like Sardis chose to build a major temple for the Olympian patroness of animals, and her temple at Ephesos counted among the Seven Wonders of the Ancient World.

On the Greek mainland too, Artemis enjoyed special honor. In Attica she had her own sacred space on the Athenian Acropolis, in addition to the important sanctuary at Brauron, which offered refuge to children and to women in childbirth.

As a huntress, Artemis usually appears carrying her bow, arrows, and a quiver, attributes that with few exceptions identify only this goddess and her twin brother, Apollo. Here, a quiver strap runs diagonally over the figure's right shoulder and under the left arm. A trace of lead solder at the center of the strap on the figure's back discloses how and

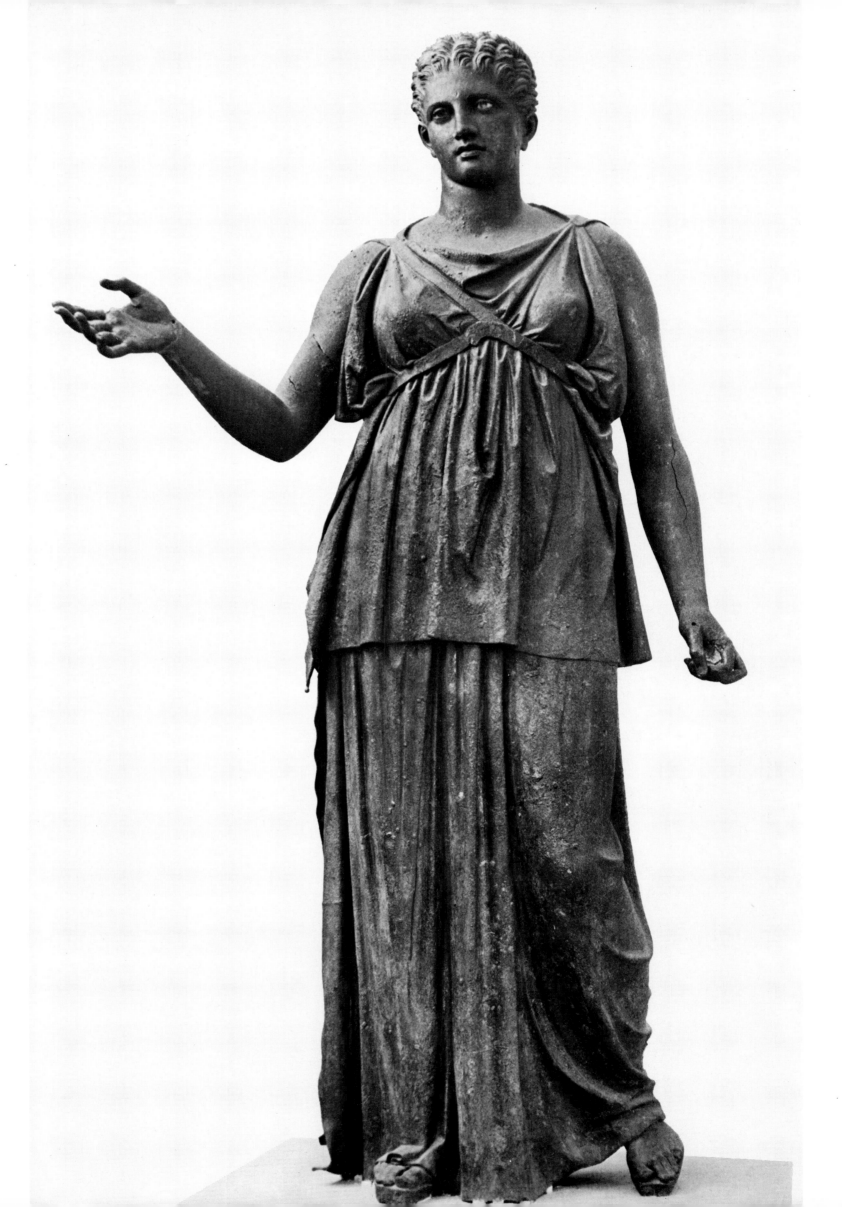

where the holder was attached. Nothing other than a quiver would fit on the strap and simultaneously make a logical addition to the cylindrical cavity in the left hand, which still clutches a lump of clay used to anchor the bow.

This full-bodied young Olympian also bore a phiale, or offering bowl, two small bronze remnants of which can still be seen in the right hand. Paintings and engraved gems show the pose seen here—an erect deity holding a bow and a phiale—to have been one of the ways by which Greek artists portrayed both Artemis and Apollo. And we find it again in the sixth-century image of Apollo (see pp. 52–57) recovered with this Artemis in Piraeus.

Although the Late Classical Master of Artemis A obviously derived his figure from the model established during Archaic times, he presented it in purely Classical terms. The weight of the figure, for instance, rests mainly on the right leg, which permits the "free" left leg to bend and step to the side. The arms, placed slightly away from the body, look as if they could move independently of the torso, action that seems implied in their asymmetrical positions, with the figure's right member reaching out at an oblique angle. Both the Archaic Apollo and the Late Classical Artemis have gently inclined heads, but the Artemis head also tilts to one side. Altogether, the devices just cited transform the traditional pose from an Archaic glyph or symbol of human form into a Classical image that creates the illusion of an animate being.

An unbroken line from forehead to straight nose gives *Artemis A* the quintessential Classical profile. Overall, the facial features are remarkably similar to those of the *Antikythera Youth* (pp. 92–99). The two statues also resemble one another in the complex arrangement of their hands as well as in their unusually wide torsos.

Artemis has often been represented with her skirts hiked up, the better to allow easier running in pursuit of wild animals, but the sculptor of *Artemis A* chose to clothe the goddess more formally. Thus, she wears a *peplos,* a dress made of a single piece of uncut fabric that falls in simple, dignified folds. No billowing here, for even the corners have been reinforced with small, round drapery weights. After the folding at the shoulders, about a third of the material's width hangs, doubled over, to the figure's hips.

The toes of the right foot, which carries most of the figure's weight, break the floor-length skirt in front. By its sideward step, the left leg raises the skirt and thus exposes most of that foot, whose sandal straps, cast separately from the foot and sandal sole, have disappeared.

Separate work also went into the facial features. Full, copper-rose lips part, revealing teeth carved of white marble. The effect thus created remains powerful and moving, despite the ravages wrought upon the material by time. Fringed bronze lashes frame chestnut-brown irises set into marble whites. Unfortunately, the damaged condition of the orbs makes the goddess look slightly cross-eyed, but even the present evidence permits one to imagine how breathtaking *Artemis A*'s original, intently focused appearance must have been.

The remarkably modern-, or even eighteenth-century-, looking coiffure is called the "melon" style because the segmental combing seems reminiscent of the ridged rind of a cantaloupe. After parting into equal sections, the wavy hair has been twisted and then pulled back to the crest of the head, where it is combed into two large tresses and coiled like a wreath about the top of the head. All this indicates just how completely the sculptor has described the coiffure, enabling us to understand its complications. Variations of the arrangement, usually modified by the relocation of the coil to the back of the head, continued to be fashionable throughout Hellenistic times and into the Roman era, but seldom would the hairdo be so re-created that a viewer could grasp its construction.

The gifted author of *Artemis A* had thoroughly mastered the forms he portrayed, and he knew how to articulate them, using a naturalistic vocabulary.

By choosing Artemis as their subject, the sculptor and patrons of the original Greek statue stored in Piraeus paid sincere homage to the Olympian deity. Consistent with this attitude, they interpreted her as a full-bodied woman whose physical strength would assure power of action and whose reflective nature would find expression in a calm, relaxed stance. By virtue of her carefully ordered and balanced forms, we know this goddess of wild animals to be a serene and pacific creature. The equilibrium of the concept is borne out in the serious but untroubled visage, as well as in the contemplative but animated mien.

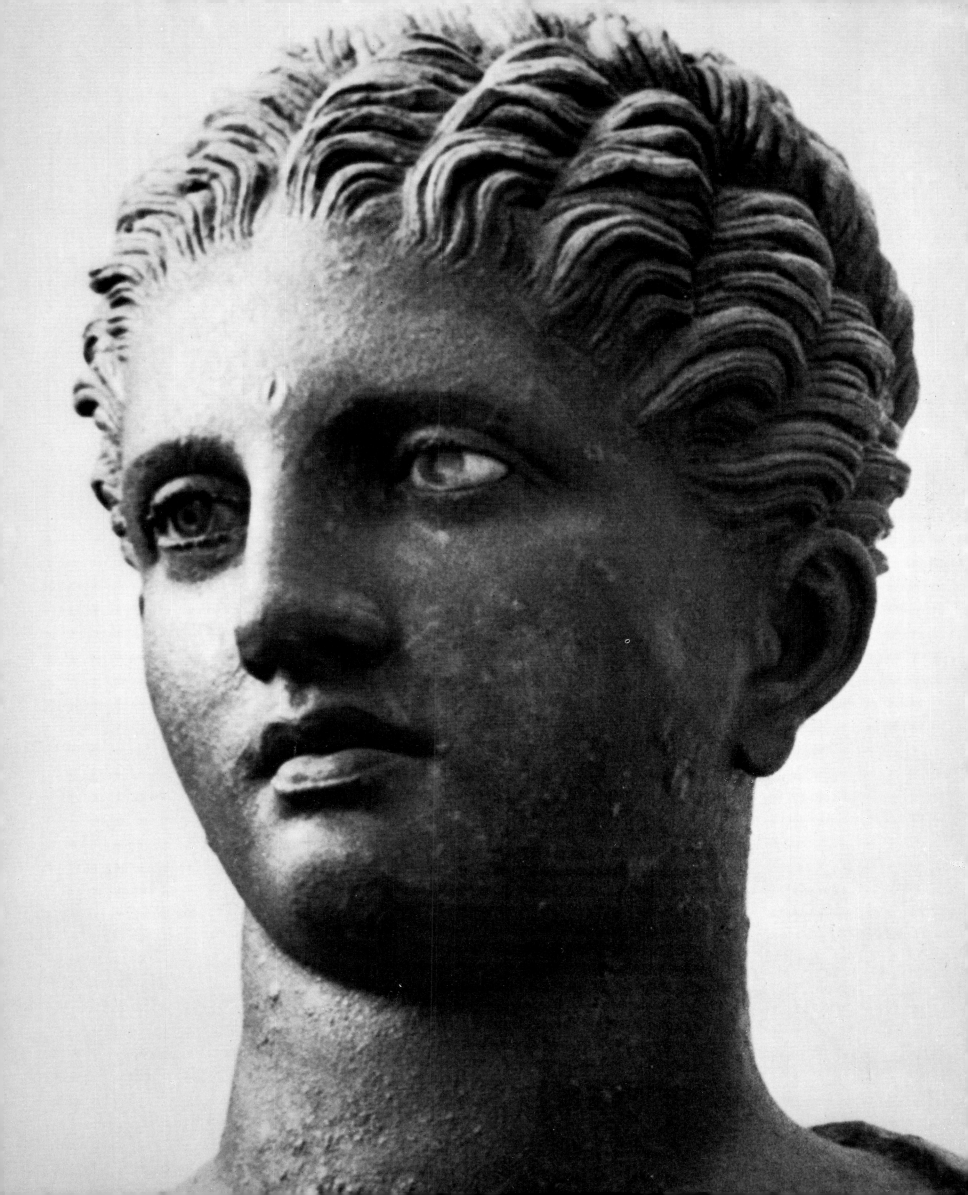

THE PIRAEUS ARTEMIS B

EARLY HELLENISTIC, PROBABLY THE FIRST PART OF THE THIRD CENTURY B.C.

HEIGHT: 1.55 M.
FOUND IN PIRAEUS, A.D. 1959
PIRAEUS MUSEUM

The smaller of the two bronze images of Artemis recovered from Piraeus, *Artemis B* stands slightly under lifesize. In a way typical of Greek artists, the Master of Artemis B employed a traditional repertoire of forms but recast them into a new format. The resulting pose corresponds to that of *Artemis A* (pp. 62–65), itself a version of the *Apollo* (pp. 52–57) found in the same cache, but with a new and different emphasis.

Both Piraeus Artemis bronzes have been fully modeled in the round and equally well detailed on all sides. But whereas near frontality governs the pose of *Artemis A,* so that one general position, slightly to the right of direct eye contact, yields the most satisfactory view, the pose of *Artemis B* presents a more complex situation.

To begin with, the figure of *Artemis B* turns more dramatically toward its right, with the head inclined and oriented in the direction of the outstretched right arm. Indeed, from every vantage point, *Ar-*temis B seems to be in rotation, as though urging the viewer to follow its head. But to see the spiraling S-curve of the form at its most graceful, the spectator should approach from the angle indicated by the statue's right hand. If the sculptor intended a principal viewing point, this may be it.

Both arms swing somewhat farther away from the body of *Artemis B* than those of the other statues found in the Piraeus storage area. The left hand, like that of *Artemis A,* is clearly poised to hold a bow, and this Artemis too grasped a phiale, evidence of which survives in the segment of a bronze circle still attached near the thumb. The offering bowl would have been emphasized by the gesture of the outstretched arm.

The strap crossed over the goddess' right shoulder and under her left arm supports a portion of the quiver. Cast separately from the figure, the quiver came off and had to be reattached in antiquity. The repair set the receptacle in a position

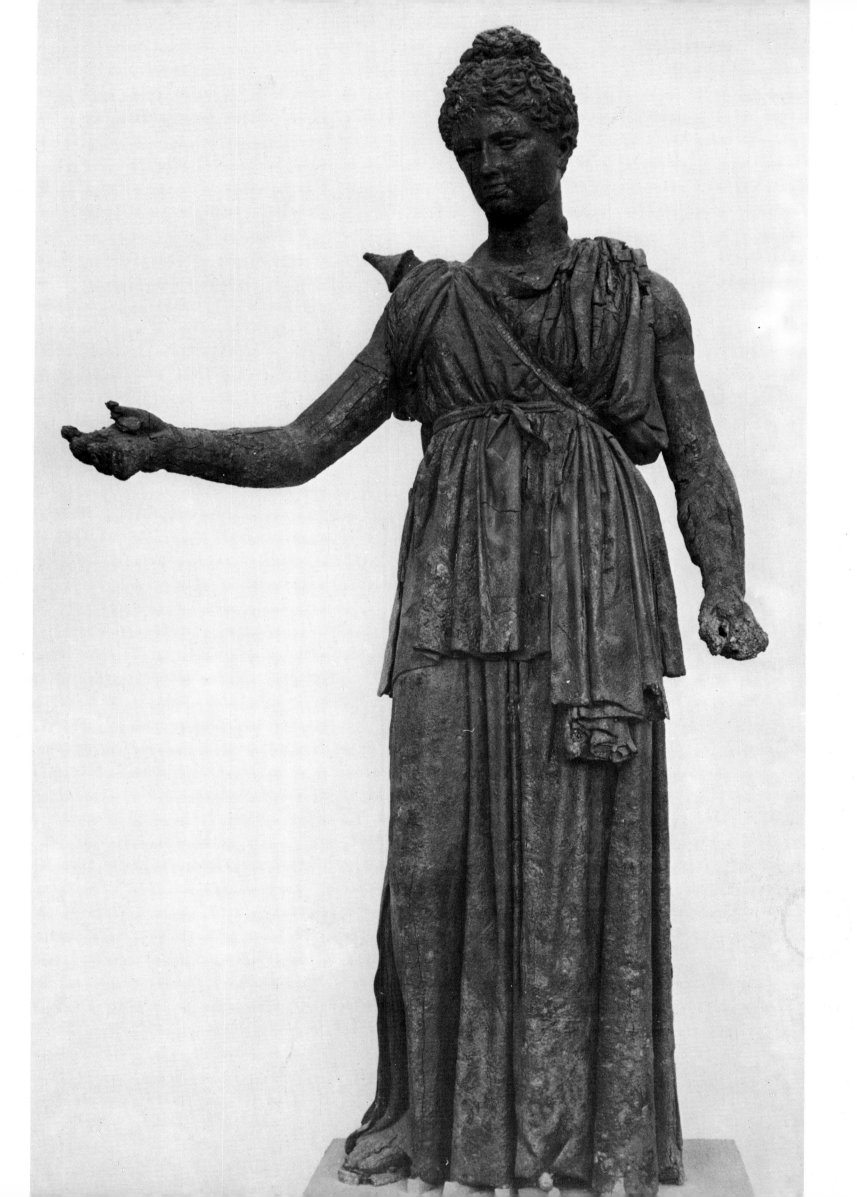

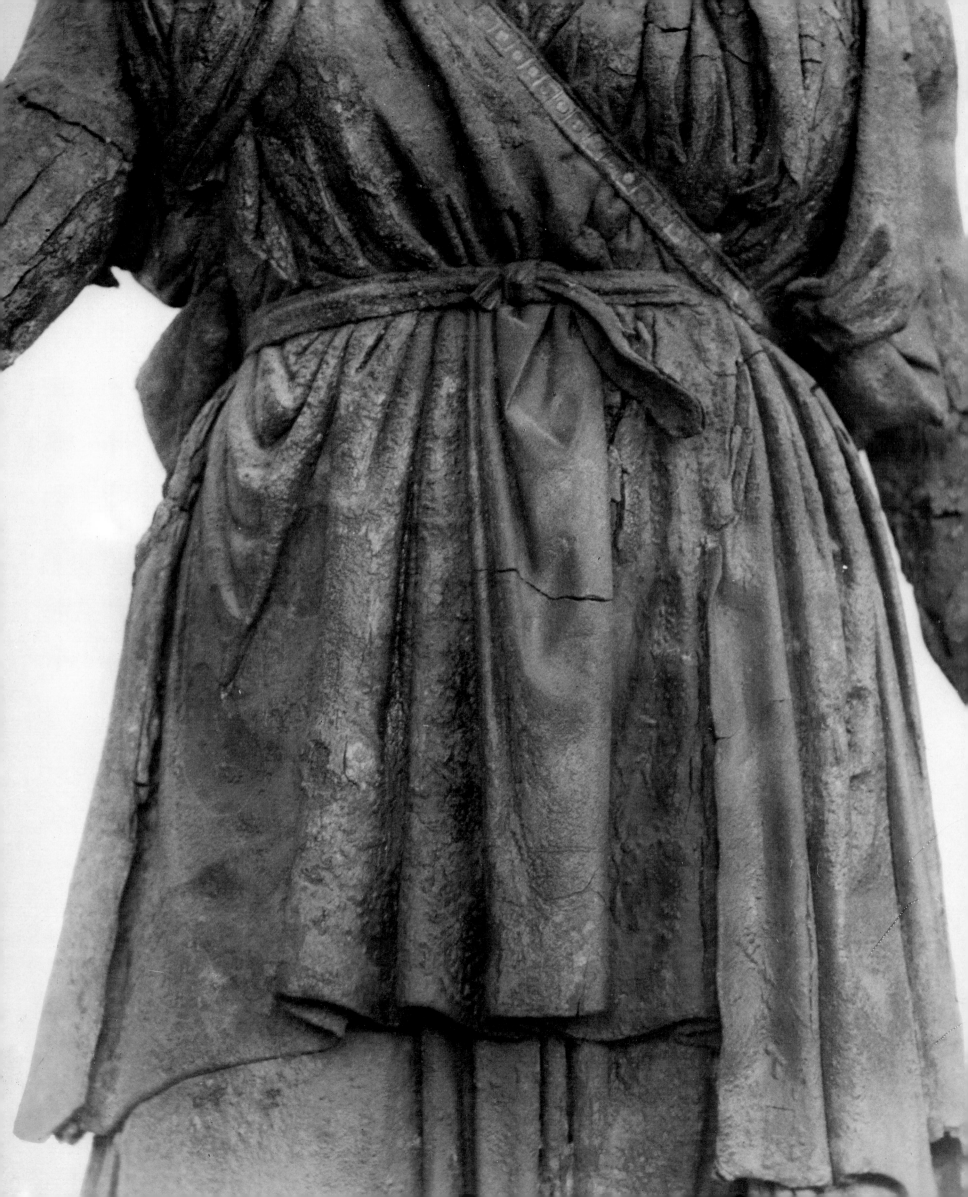

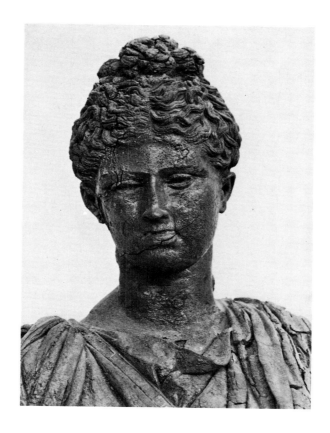

slightly different from the one it originally had, lower and at a flatter angle to the concave channel modeled in the drapery to cradle it.

The quiver strap is extraordinarily elaborate and beautiful, its decoration consisting of a meander and dot pattern inlaid with silver. Around her waist, the goddess wears a belt tied in a square knot at the front. The knot and the loose ends (perhaps the whole of the belt) were not cast with the torso but made in bronze by cutting and hammering. Such variations in technique help distinguish each and every band as a separate entity.

The rest of the costume reflects a similar respect for the unique character of each part. The overfold of the peplos, like that of the other bronze goddesses from Piraeus, was fashioned apart from the skirt beneath it. So too the cloak, which wraps about the right shoulder and across the back to hang past the figure's left hip. Cracks in the bronze of the outer garment disclose the peplos below.

Of all the bronze sculpture from the Piraeus find, *Artemis B* survives in the least good condition. Some of the bronze has crumbled, almost disintegrating into powder, and some has separated into layers, like a bar of soap left in water too long. Disfigurement caused by the swelling is particularly marked on the right side of the head.

While faithful to the traditions of Greek sculpture, the Master of Artemis B so modified them that he brought a new animation to inert form, producing a sense of motion more emphatic than anything seen before in Greek monumental art.

CYPRUS

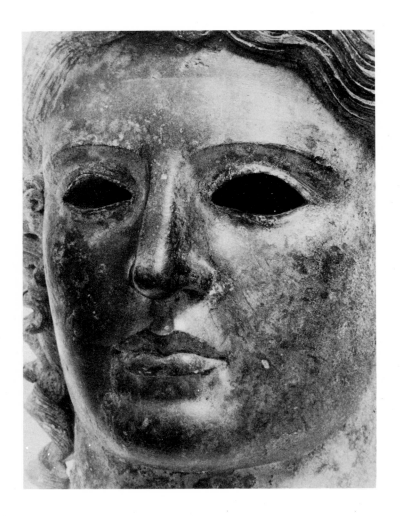

Cyprus, the birthplace of Aphrodite, goddess of love and beauty, has been linked to the Greek world since the Bronze Age. Named for the copper that made the island famous in antiquity, Cyprus possesses rich mineral resources, at the same time that it also occupies a strategic location in the eastern Mediterranean. So important were these assets that they brought ancient Cyprus neither prosperity nor peace but, rather, endless military conflict and frequent internal division.

During Archaic and Classical times, Cyprus found itself caught between the Greek world and the Persian Empire. Whereas the Cypriot kingdoms settled by Phoenicians identified with Persia, those of Hellenic heritage aligned themselves with the Greek city-states.

In the early fifth century B.C. Persia, under the leadership of Xerxes, dominated the island and obliged all the Cypriot kingdoms to join the Persians in their assault upon

the Greeks in 480 B.C. Soon after the latter proved victorious they sent an expedition to liberate Cyprus from Persian hegemony. For the next quarter of a century, the Athenians carried on active traffic with Cyprus, all the while that they and the Phoenicians competed for the loyalties of the Cypriot kingdoms, the ultimate goal being to gain access to the island's copper and harbors. Unable to cement widespread alliances, the Greeks signed away their claims to Cyprus in the 449 treaty negotiated to end the Greek and Persian war. This left Greek Cypriot colonies to struggle on their own. Once again, the Phoenicians came to the fore, holding sway in Cyprus for many years. But so firmly rooted were the Greek settlements that they managed to withstand Phoenician attempts to eradicate them.

A number of Cypriot kingdoms, such as Tamassos, appear to have been composed of elements from both Asia Minor (especially Phoenicia) and Greece. At present we know very little about Tamassos except that copper was discovered there in prehistoric times, perhaps as early as 4000 B.C. Archaeological exploration, however, indicates that Tamassos had a sanctuary to Apollo and that Astarte-Aphrodite could also claim devoted followers in the city. In view of Athenian activity on Cyprus between 480 and 450 B.C. and the importance of the Tamassos copper mines for the production of bronze, it should not surprise us that the large bronze statue accidentally discovered in 1836 in a river bed near the Sanctuary of Apollo at Tamassos is Greek in style, technique, and subject.

Historically, the statue could have been made at any time in the fifth century, inasmuch as Greek colonists continued to live on Cyprus throughout all the political changes, but the second quarter of the century, when the Athenians held the reins of power on the island, seems to have offered the greatest possibility for a major exchange of artistic ideas between Cyprus and Greece.

A river bed may not appear so strange a place to uncover a fifth-century Greek bronze statue, once we consider the intricate relationship of politics and religion in the ancient world, which often made it inevitable that invading forces would destroy religious images. The Persians, for example, thoroughly sacked the Athenian Acropolis when they stormed Athens in 479/480 B.C. The fact that Cyprus lay across the path of so many military moves made the sanctuaries there particularly vulnerable to enemy wrath. Hurling an image of the reigning deity into a river seems a typical act of war symbolizing the overthrow of the adversary himself. Since the sculpture found at Tamassos is indisputably Greek, the violence that struck it probably came from either the Persians or their local allies.

Every Greek sanctuary seems to have been a place suitable for the erection of a bronze statue. But Tamassos—with its copper reserves, which provided the Greeks with a primary source of ore, itself a primary ingredient of bronze—seems especially promising as a place where a dedication would have been in the form of a bronze statue.

More thorough exploration of the site may eventually resolve some of the uncertainties about the subject of the bronze statue from Tamassos and who threw the figure into the river bed.

THE TAMASSOS APOLLO

EARLY CLASSICAL, SECOND QUARTER OF THE FIFTH CENTURY B.C.

PRESERVED HEIGHT: 0.316 M.

FOUND ON CYPRUS AT OR NEAR THE ANCIENT SITE OF TAMASSOS, A.D. 1836

BRITISH MUSEUM, LONDON (FORMERLY AT CHATSWORTH HOUSE)

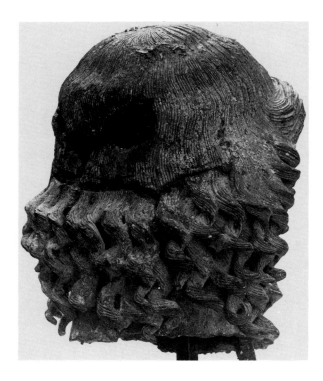

The *Tamassos Apollo*, so called for the site of its discovery, came to light in modern times when Cypriot peasants digging for water uncovered a large statue of a complete male figure from a dry river bed. In order to extract the piece, the peasants lashed a protruding part to their team of oxen. The technique freed the statue, only to shatter it in the process.

Nothing but the head survives, because the peasants, unaware of the value of their find and frightened of Turkish reaction, sold all the rest for scrap metal. The head meanwhile fell into the hands of a Smyrna (now Izmir) merchant, who sold it to the sixth Duke of Devonshire. This great collector installed it at Chatsworth House, where it remained until acquired by the British Museum. Owing to its provenance, the piece has been called the *Chatsworth Head* or the *Chatsworth Apollo*.

Such a large and impressive sculpture probably represents a deity, and since the temenos from which it came has been identified as Apollo's, the head would seem to be a representation of the sun god. Moreover, the Classical period generally portrayed the Olympian Apollo as a young, beardless man with shoulder-length hair and a beautiful, serene face, like that of the Tamassos head.

Simplified as the facial modeling may be, it has great strength, as well as animation gained from the thick, lively hair, formed in low furrows radiating from the back of the crown. Its neatly combed, parallel lines make a subtly irregular, wavy pattern. Corkscrew ringlets fall free from the

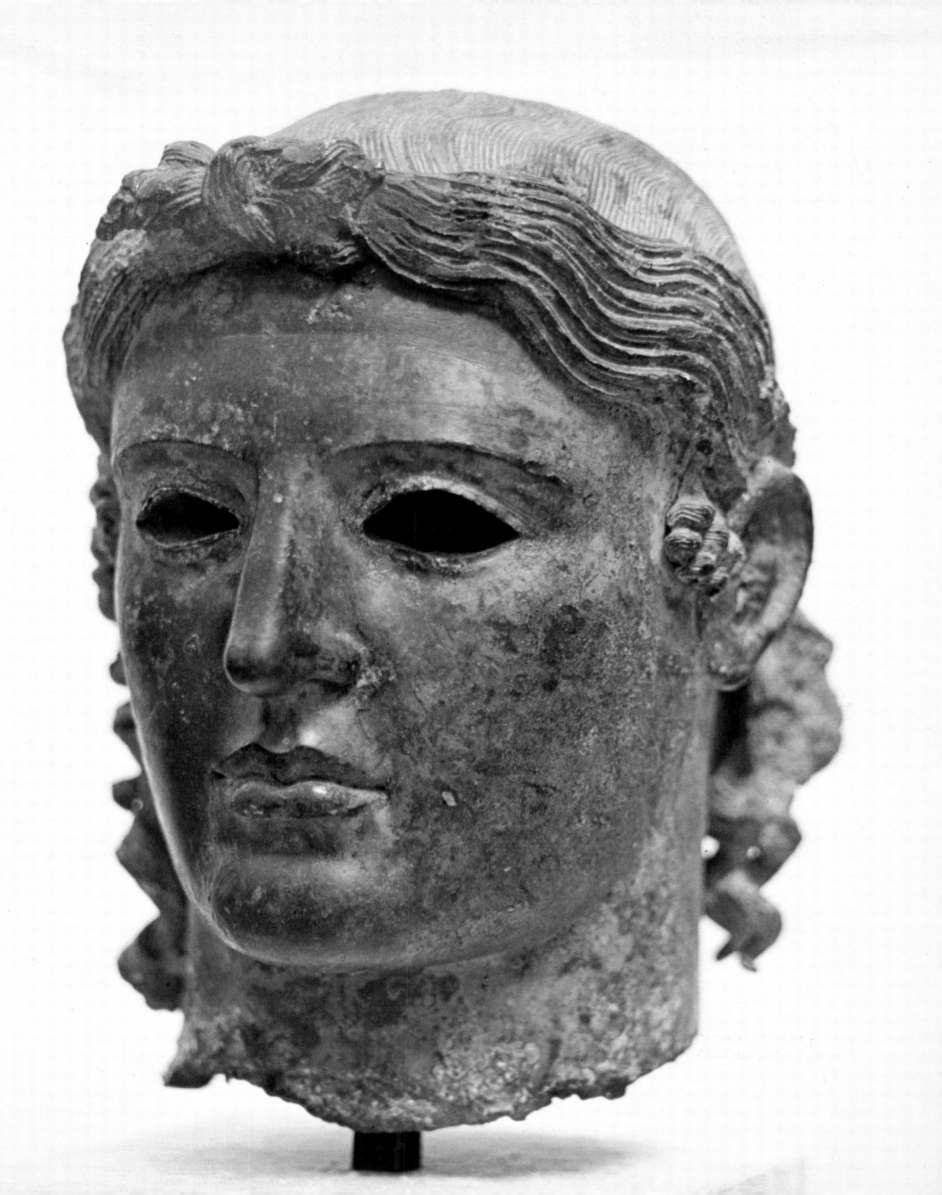

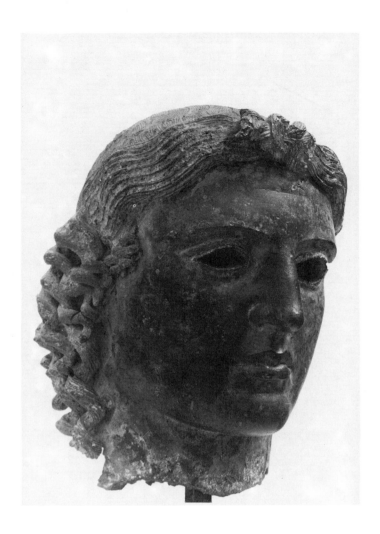

skull at the back of the head, their definite, three-dimensional appearance the product of their having been cast separately and then attached to the head. The independent, fully modeled head, with an ear, can be seen on the figure's right side, where the ringlets have broken off. That part of the hair combed to the front from either side is shown pulled into broad, undulating bands that frame the forehead and meet at the center in a square knot.

A concave indentation around the crown of the head suggests that this Apollo may have once worn a wreath of laurel.

Large eyes, no doubt fashioned of glass or stone, have disappeared, leaving blind sockets, the right one still fringed in the sheet metal that once surrounded the inset eye. A line contouring the lips indicates that they too were made of material different from that of the sculpture's main mass, surely an inlay of copper, whose reddish hue would have contrasted with the golden bronze.

The regular, symmetrical features, reinforced by the simplicity of the surface modeling, produce a face of serious mien and somber expression.

In both style and technique, the *Tamassos Apollo* belongs to the tradition of Early Classical Greek sculpture and seems related to some of the earlier works of Pheidias. Certainly the sculptor knew the mainstream of Greek art, and he surely traveled between Athens and Cyprus. But while the head displays a keen vigor and solid power, the execution of the design, especially in the modeling, lacks the subtlety and extreme sophistication evident in the *Delphi Charioteer* and the *Artemision Zeus* (pp. 20–31, 76–85). These differences, furthermore, are the very ones usually found in Greek Cypriot art, which often seems firm and vibrant but less refined than art from the great centers of the Greek world. Although no one can say whether the creator of the Tamassos head was a native Cypriot, we can be secure in calling him a Greek.

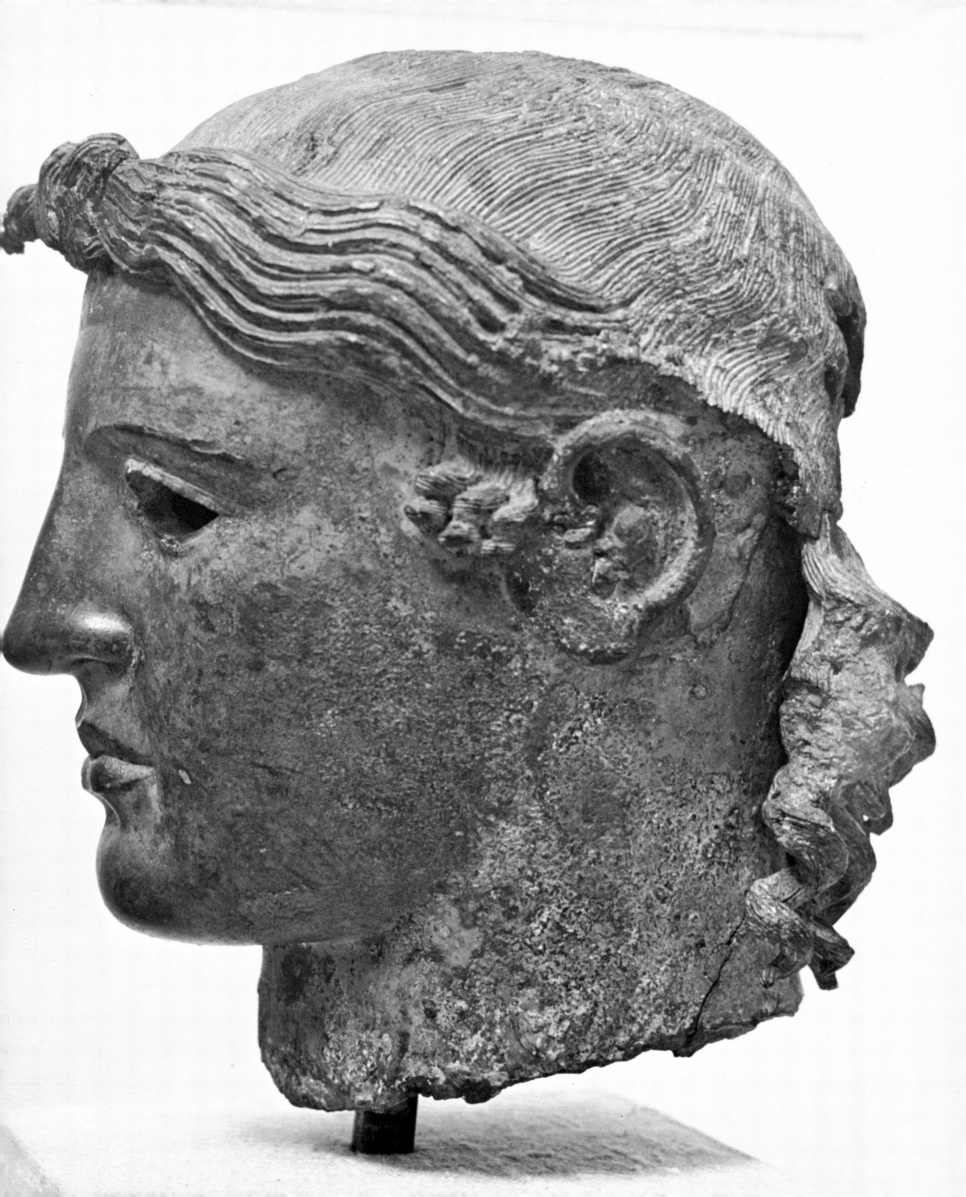

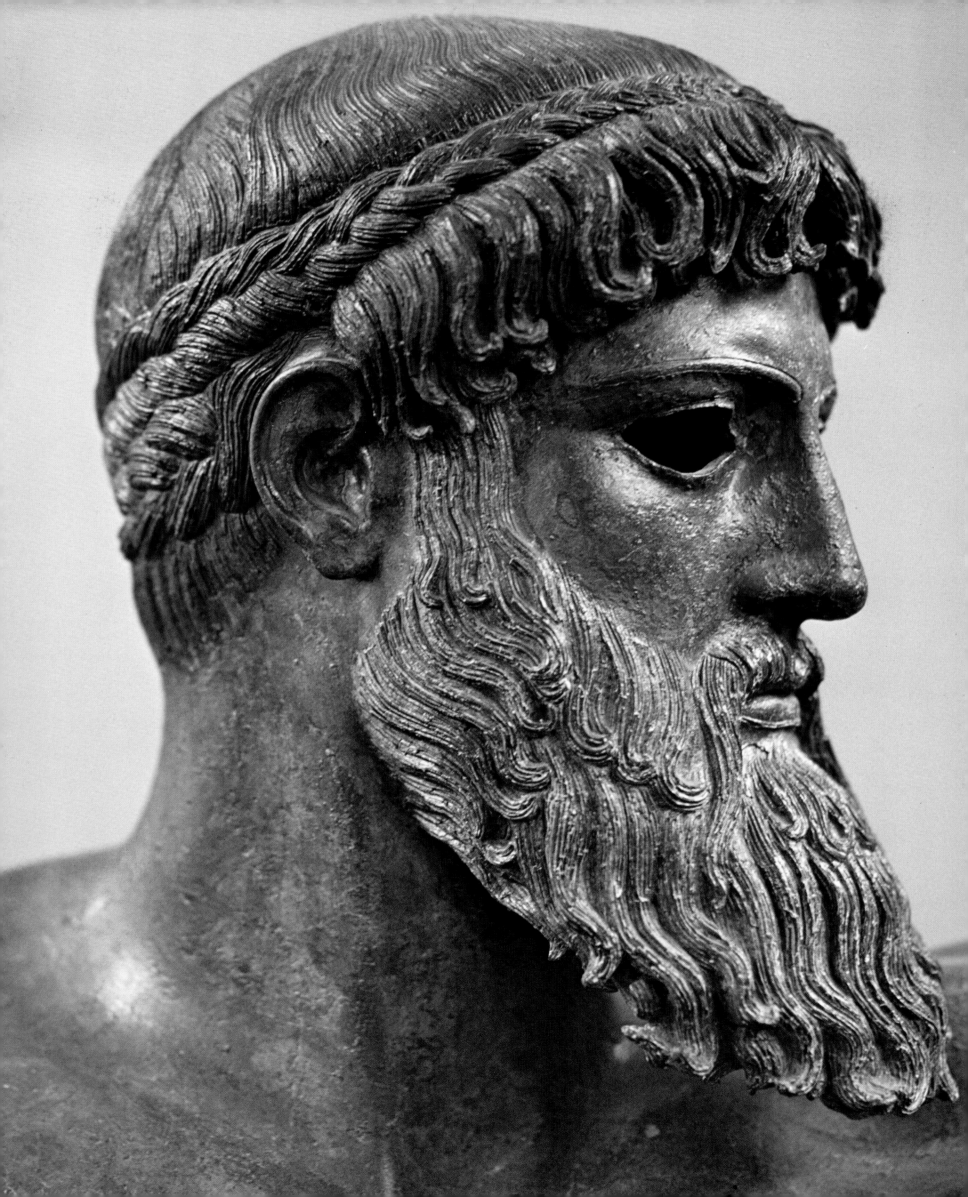

CAPE ARTEMISION

When the news broke in 1926 that Greek sponge divers had found a large bronze arm in the sea near Cape Artemision, robbers organized to loot the area. Fortunately, the unscrupulous plan came to grief, and in 1928 a legitimate archaeological expedition arrived on the site. There divers discovered the remains of an ancient shipwreck and from them recovered three large bronze figures, some pottery, and a portion of the ship's wooden hull.

The bronze sculpture forms part of two monuments made at different times. One statue (to which the large arm belongs) represents Zeus, and the other a boy jockey astride a racehorse. The Early Classical style of the *Zeus* dates this image to the second quarter of the fifth century B.C., while the Hellenistic horse and its jockey must have been modeled and cast two or three centuries later. Thus, the sculpture aboard the doomed vessel may have come from one city or sanctuary, but it cannot be considered the product of the same workshop.

Pottery brought up from the Artemision wreck appears to have been made around the beginning of our era, which means that the ship probably sank close to or during the lifetime of Christ and almost five centuries after someone had commissioned the figure of Zeus.

Such magnificent sculpture would be important cargo at any time, but who was sending it where and why remains a puzzle. No known shipping lane of major importance passed along the northern coast of Euboea. The sculpture could have been seized from a Greek city or sanctuary by Roman or Pontic forces, but the evidence now available leaves our questions without convincing answers.

The rest of the vessel and its cargo, which surely contain more clues, still lie at the bottom of the sea. The dangerous and difficult task of exploring the wreck 140 feet deep in the water had to be abandoned after one of the divers died in 1928, and no one has yet been able to finish the excavation.

THE ARTEMISION ZEUS

EARLY CLASSICAL, C. 460 B.C.

HEIGHT: 2.09 M.
FOUND IN A SHIPWRECK NEAR CAPE ARTEMISION, A.D. 1926–28
NATIONAL MUSEUM, ATHENS

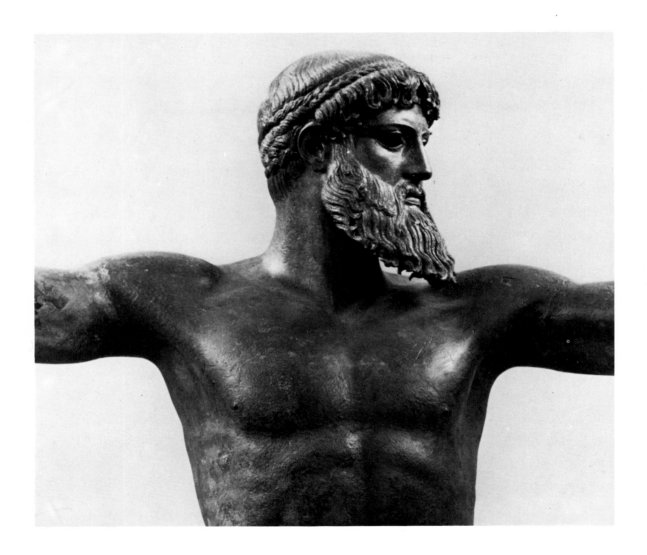

The action and power of the most mighty Olympian god could hardly be more manifest than in this sovereign image, discovered in the sea of Cape Artemision. Here Zeus has been revealed in full heroic nudity, a mature man with an exceptionally beautiful, well-developed physique. It is a body that fairly radiates strength and discipline, reinforced by stability gained from a simple, triangular design (the legs and torso) crowned by a strong horizontal line (the arms).

In a way symptomatic of the Early Classical period, the composition breaks the "law of frontality" generally observed by Archaic sculptors, whose freestanding statues represent the potential for movement without actually showing engagement in it (see pp. 45–49, 52–57). Unlike those older works, made in the seventh and sixth centuries B.C. and designed to stand at attention staring straight ahead, the fifth-century Zeus looks toward his left and extends his arms almost to their max-

imum reach on either side. Thus, the space occupied by the statue is wider than it is tall. When the figure still held a thunderbolt in its left hand, the lateral displacement would have been even greater.

Although handsome from every side, the nude figure appears so powerful from one vantage point that this surely must have been intended as the primary viewing angle. The silhouette thus perceived shows the torso nearly frontal and the arms at their fullest extension.

Despite its damaged condition, the face is intense, even riveting, in its expression. Originally, the vacant sockets would have been set with eyes made of glass or translucent stones. One can imagine their hypnotic effect, gazing as they did from under those firm brows, formed of silver or copper. Further colorism would have come from the ruddy hue of the lips inlaid with a purer grade of copper.

In this image the god sports a coiffure combed forward into bangs around his forehead, while the long hair at the back has been plaited into two braids wound about the head and knotted together above the center division of the bangs. Such a hair style conforms to the taste of the first half of the fifth century B.C., when men bound up their hair, provided they still followed the Archaic custom of letting it grow long.

As for the torso, it reveals the hand of a sculptor with a thorough knowledge of human anatomy. But while producing an illusion of reality, the artist also succeeded in making it seem a thing of utter perfection. The true anatomist's touch can be found in the smoothly modeled transitions between muscles, in the organic asymmetry of the `omphalos, and in the nipples, made veristically redder with inlays of copper. Still, for all its naturalism, the figure does not replicate nature. The abdominal muscles, for instance, have been simplified to two pairs, the pectorals depicted as nearly smooth, and the outline of the rib cage expanded into a high, wide, and handsome arch.

The left arm stretches out far to our right, extending a steady hand whose palm is turned down as though the god were using it to sight his aim. The right arm follows the same horizontal line as far as the elbow, where the arm turns upward, lifting a hand curved to hold the cylindrical shaft of a thunderbolt. The missile having been lost, we can see the concave channel on the palm made to

give the thunderbolt a more secure mooring.

The arms and feet display a network of veins modeled in a true-to-life pattern. Their distended, ramified forms suggest blood rushing under strong pressure, the perfect complement to a pose obviously meant to express vitality and the power of a body tensed for action.

The posture is unquestionably an aggressive one in which the subject prepares to hurl a weapon. The ancient Greeks used the pose to symbolize a militant protector. In most known instances by far, the subject represented in such a stance happens to be Zeus, but the design also served for images of *Athena Promachos* (Athena the Protectress). Occasionally Poseidon too became the subject, but his long trident created an artistic problem in that it would cut across the subject's face. The citizens of Poseidonia used the hurling pose for images of their patron god on coins, where they managed to sidestep the compositional difficulty by placing the trident behind the figure's head (see p. 134). This solution, however, is an awkward one that would not work for sculpture in the round.

Sometimes the Artemision protector is called "Poseidon." Those who would do so have been known to argue that the image must be that of the great sea god since the statue was found in the Mediterranean. But like other statues of totally different subjects, this one went into the sea simply because it was on board a ship that sank. Others cite the example of the Poseidonia coins, overlooking the much weightier evidence presented by the numerous surviving statuettes of Zeus launching his thunderbolt in a pose matching that of the Artemision figure.

After their repulse of the invading Persians, then masters of the world's largest and richest empire, the Greeks gave Zeus the highest honors among all the gods in the pantheon. At Olympia he received the tribute of the greatest temple built there during the Early Classical period. Contemporary with that masterpiece is the image of Zeus recovered from a shipwreck near Cape Artemision, another offering to the powerful deity who had saved his "chosen people."

So moving does this fully exposed image of a pagan god remain that an Orthodox priest recently assaulted a replica of it, seeing in the *Artemision Zeus* a threat to his Christian faith.

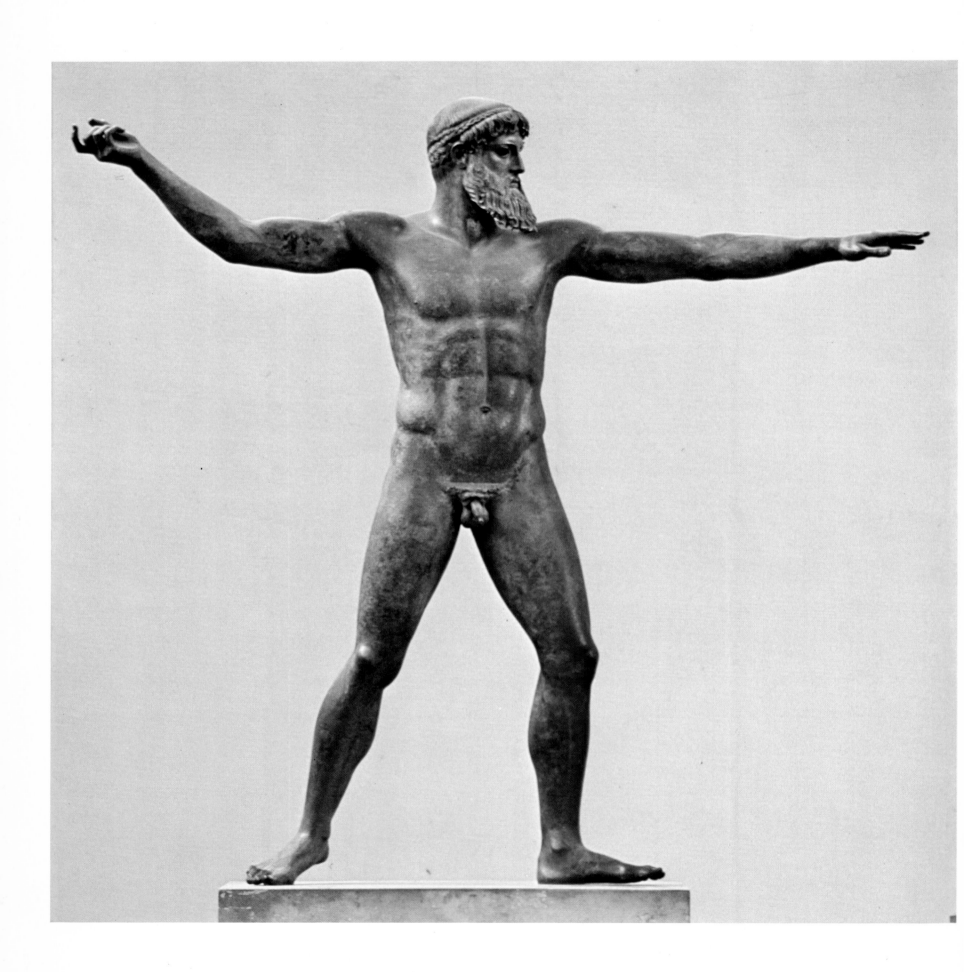

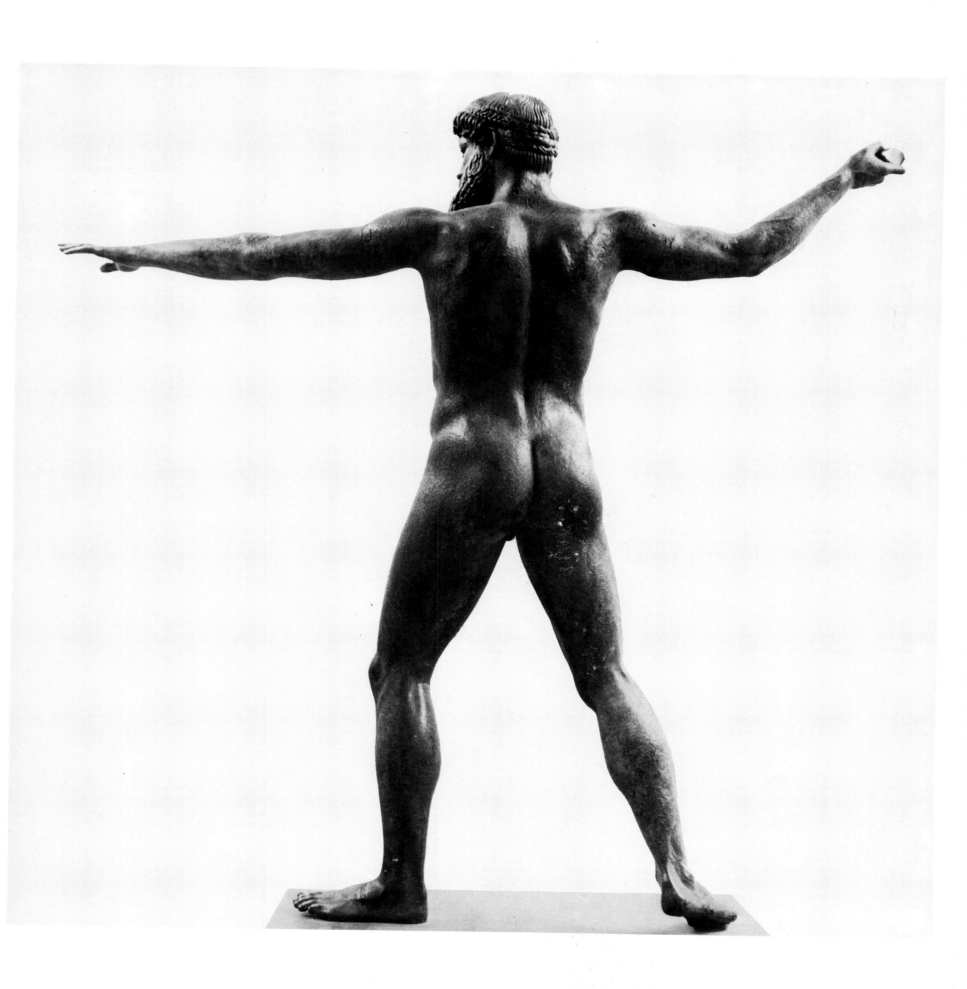

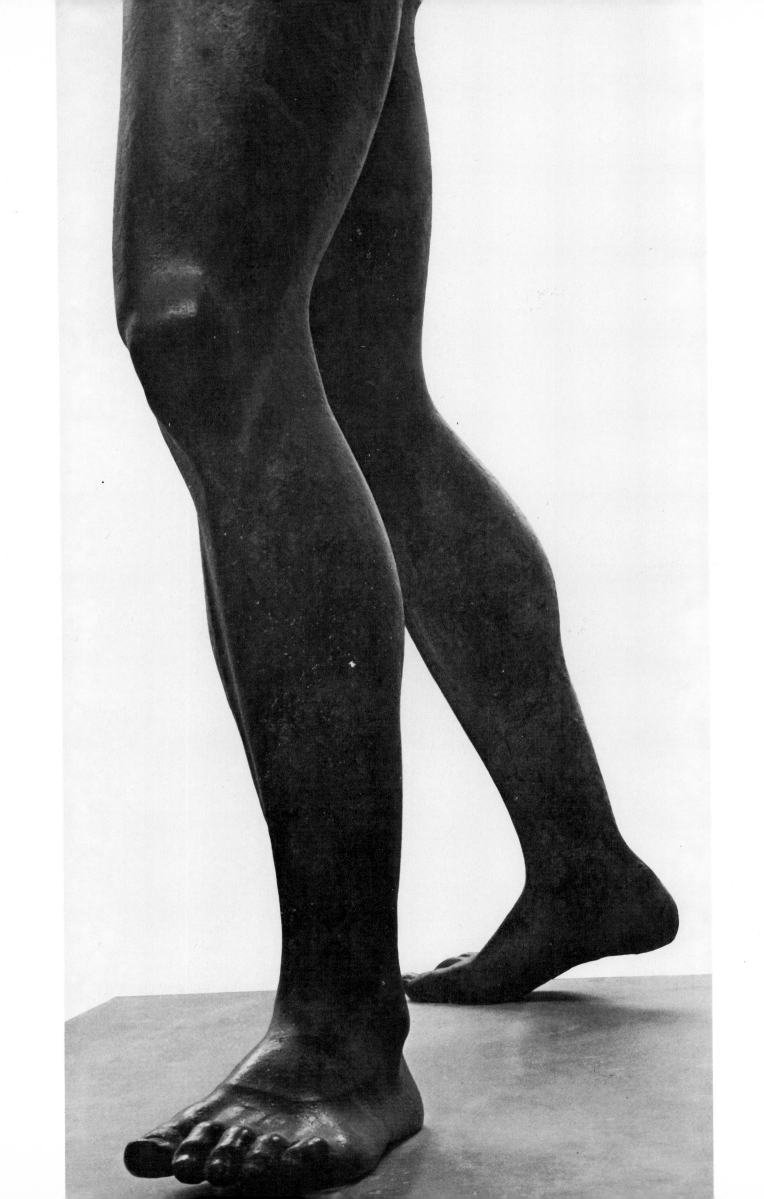

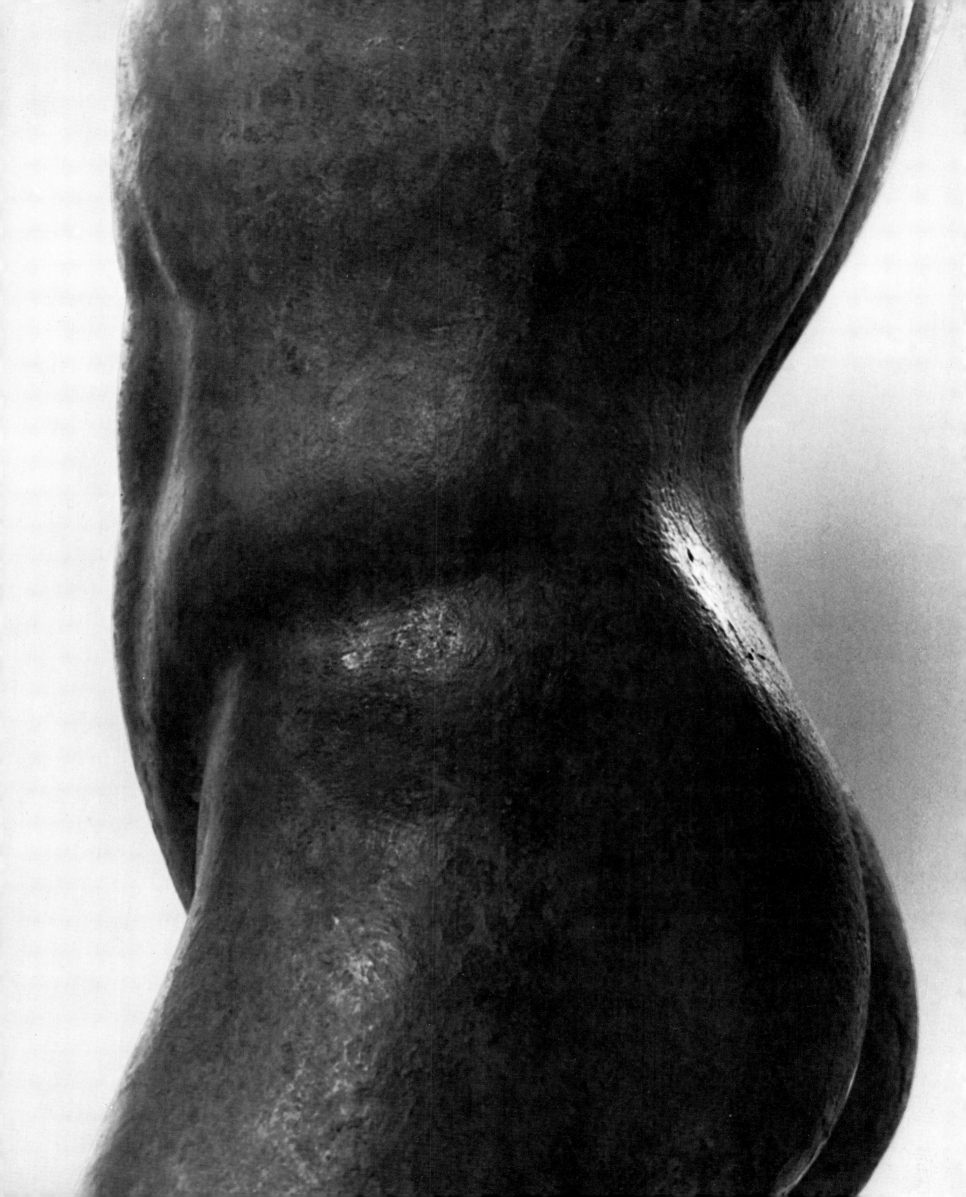

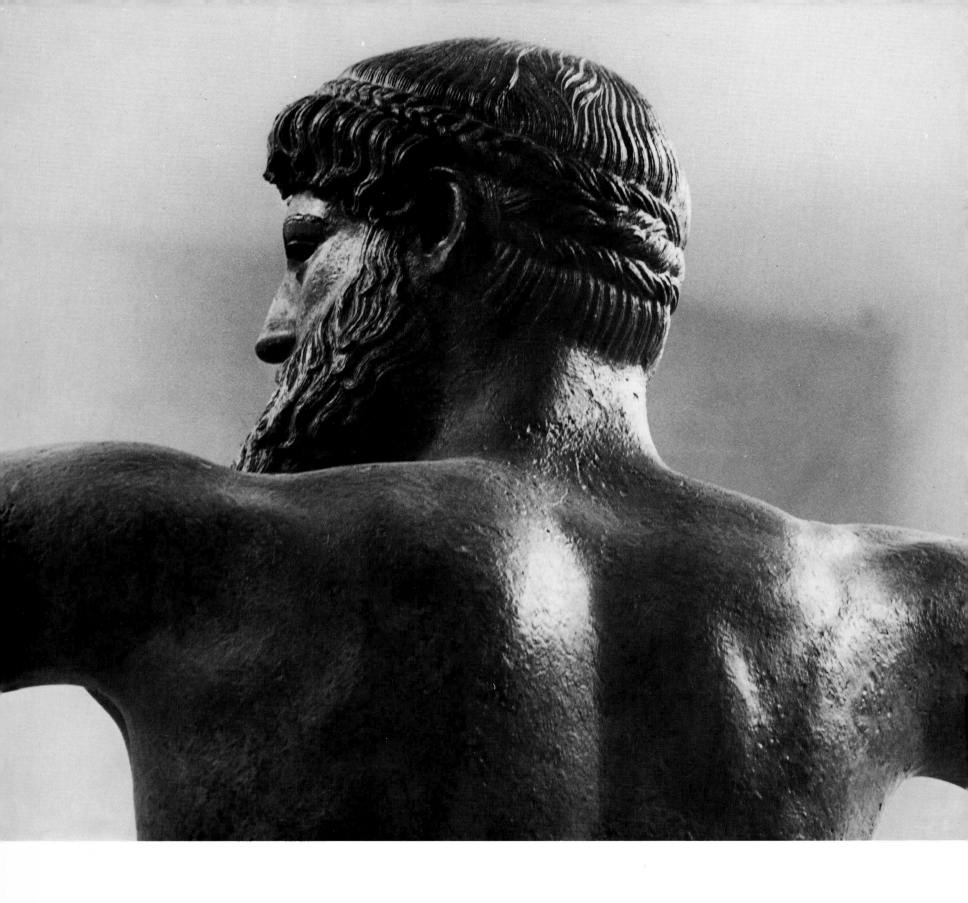

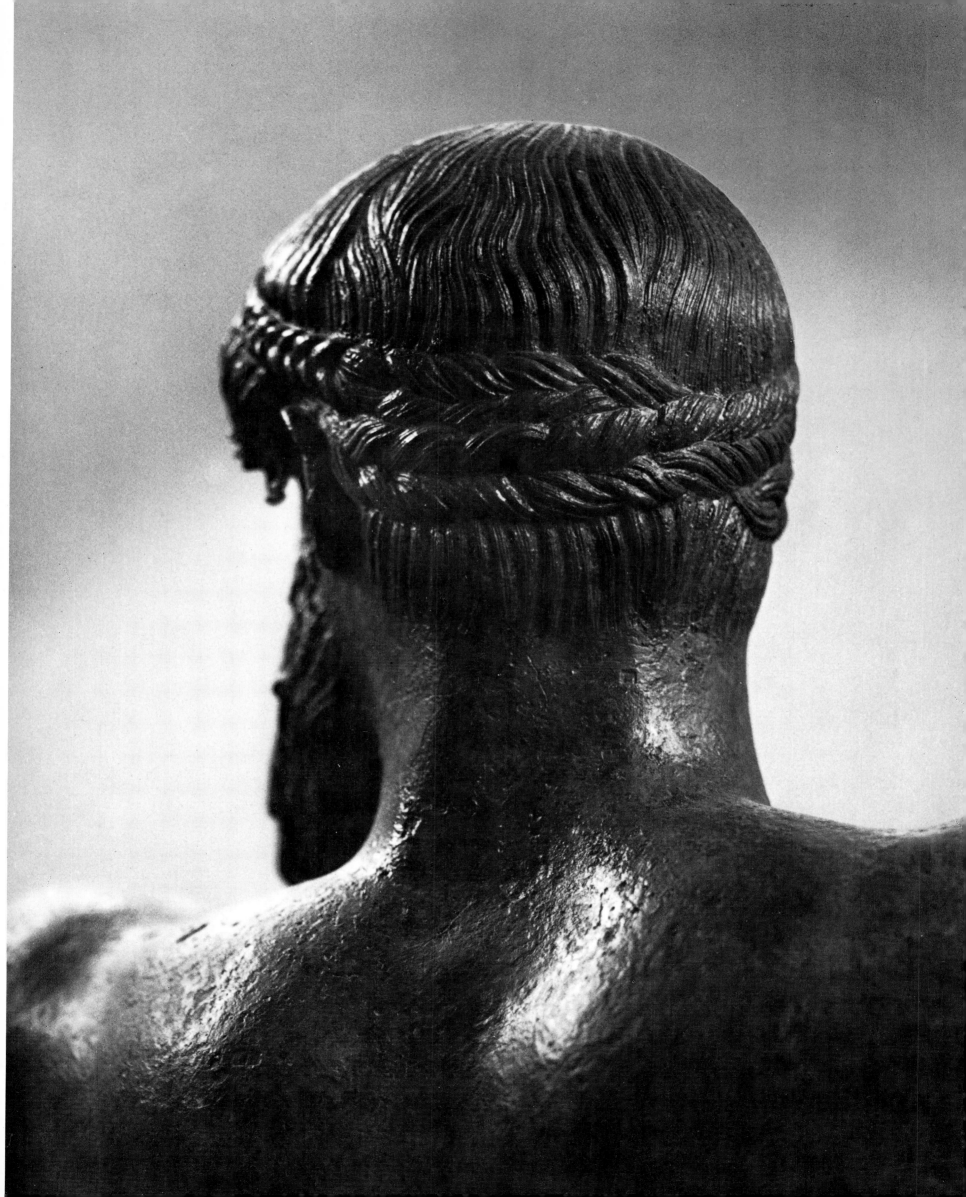

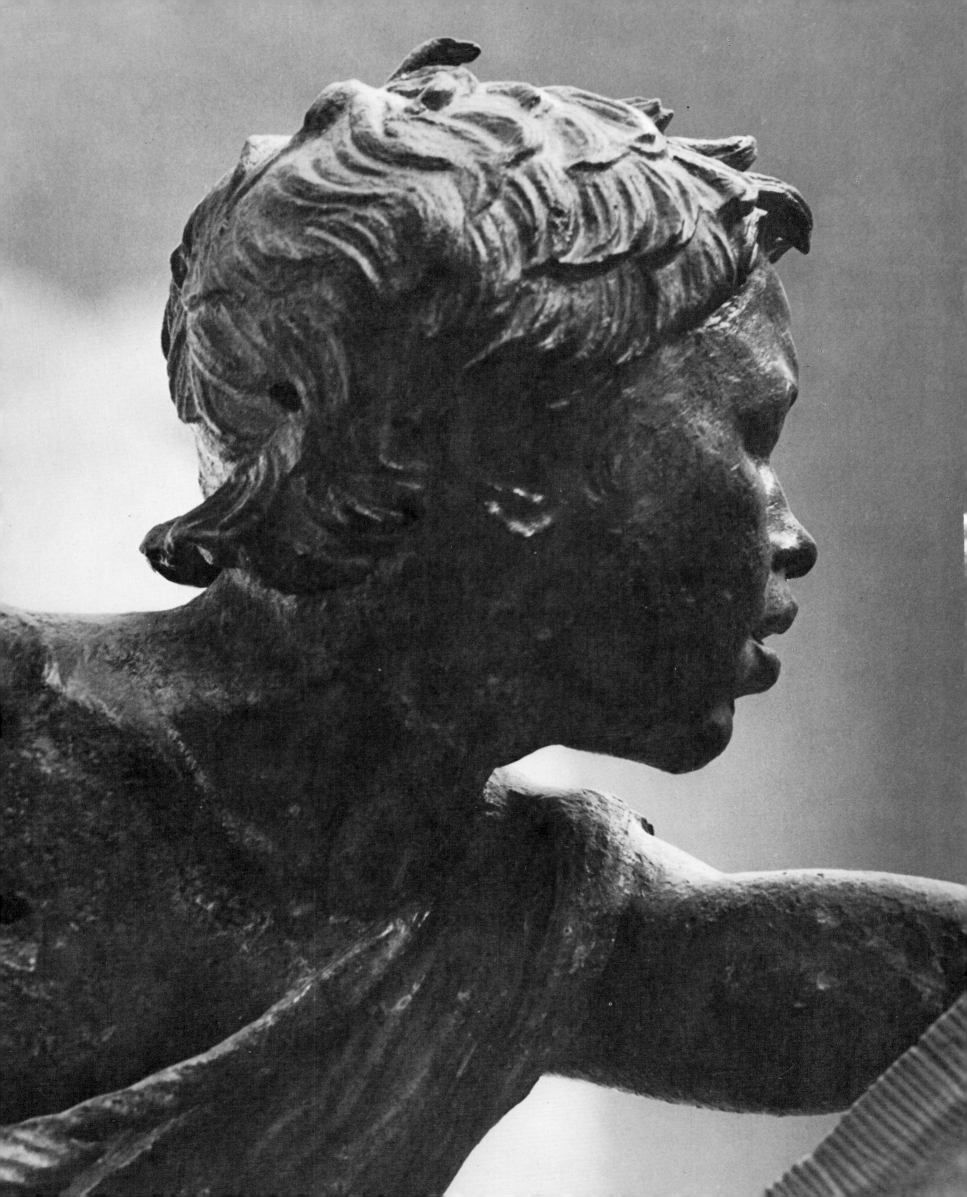

BOY JOCKEY AND HORSE

HELLENISTIC, THIRD OR SECOND CENTURY B.C.

HEIGHT OF THE BOY: 0.84 M.

FOUND IN A SHIPWRECK NEAR CAPE ARTEMISION, A.D. 1928

NATIONAL MUSEUM, ATHENS

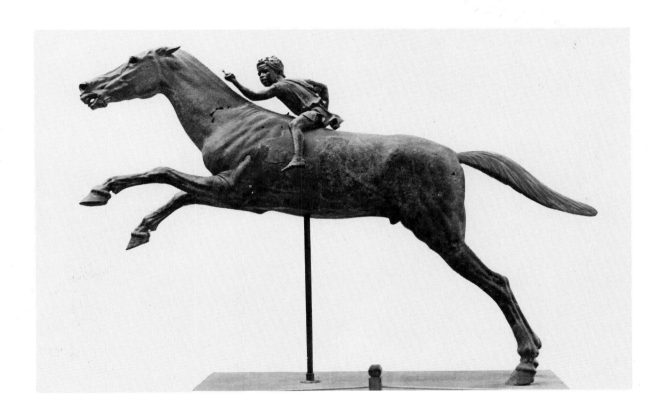

The galloping horse and its little rider had come apart by the time archaeologists recovered them in 1929 from the sea near Cape Artemision. The jockey went on display in Athens' National Museum almost immediately, where it remained without the horse until the beast underwent restoration in 1972.

The horse had been broken into numerous pieces. Nothing of the original tail, the middle part of the body, and the left hind foot survived, and so the restorers had to model new ones. The restoration of the rear half of the animal proved especially difficult, since its pieces do not match extant ones from the front half. But thanks to a bit of the jockey's dress still preserved on the horse's mane, we know that the rider and the mount belong together.

The monument gives the impression of being lifesize, but the boy is smaller and the horse bigger than they would most likely have been in real life. By thus manipulating the scale of his subjects, the sculptor expressed the immensity of the jockey's undertaking and the tremendous power of the horse.

The moment depicted catches the horse and rider in the heat of the race, when the outcome remained unknown. The unstable pose, showing the mount's forelegs off the ground, adds to the feeling of extreme tension. The horse seems the very image of swift forward motion, propelled by hind legs thrusting against the ground. Its nostrils flare as wide as the eyes, while the ears stream backward under the same onrushing force that blows the garment away from the jockey's body.

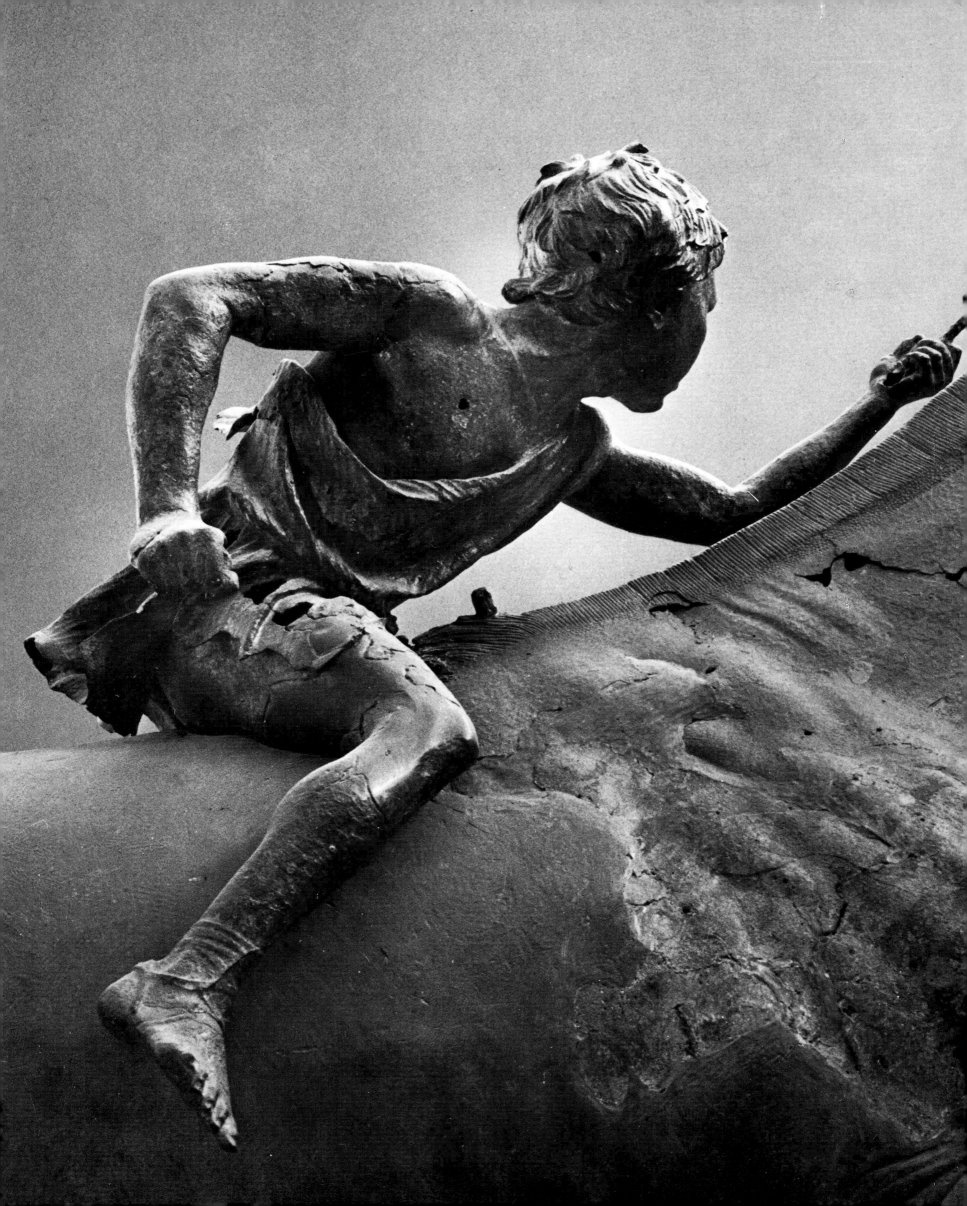

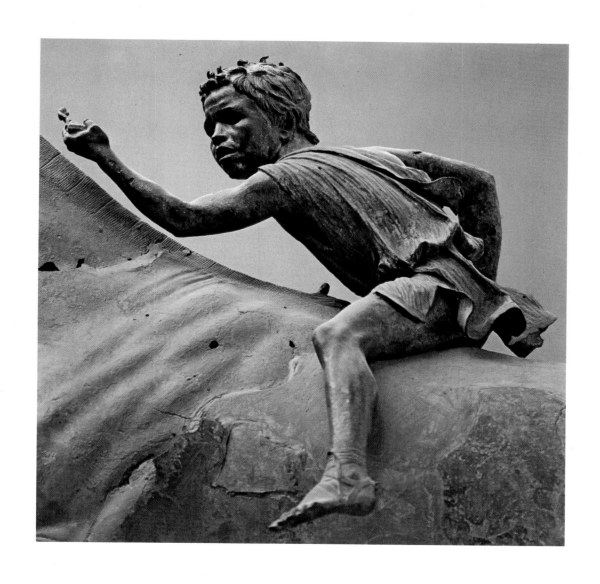

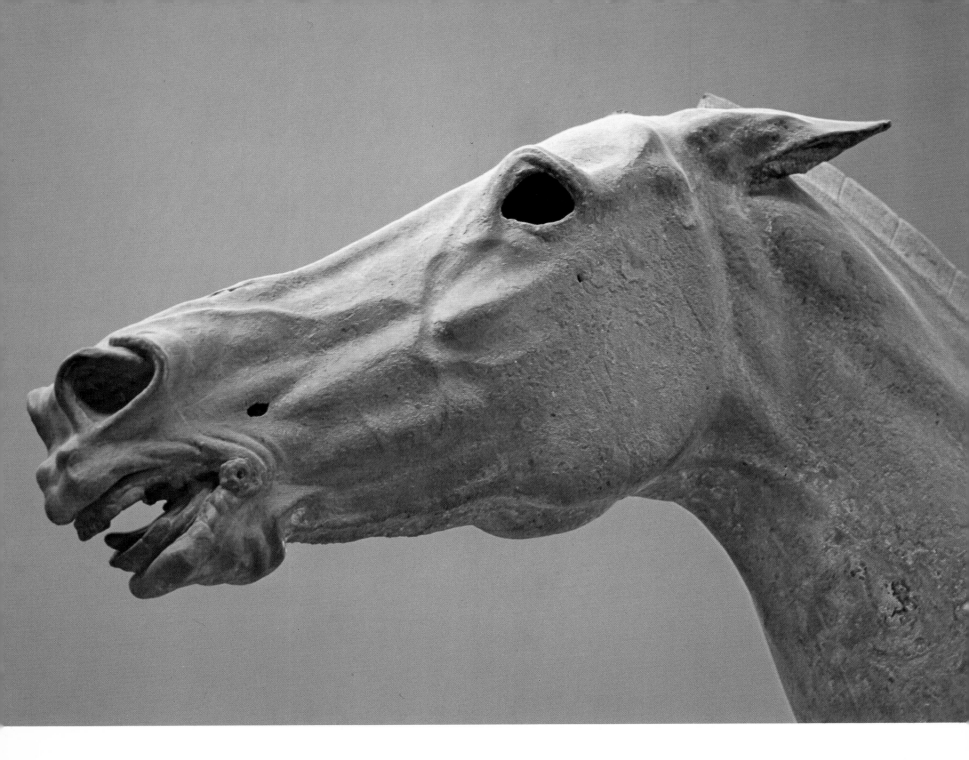

In his eager drive to win, the jockey, a small Negro boy, leans forward along the same diagonal established in the horse's neck and hind legs. Originally, he held the reins in his left hand and a whip or prod in his right hand. Additional goads can be found in the spurs that are still attached to the feet by straps tied at the ankles. In keeping with the violence of the scene, a strained look of desperate concentration distorts the rider's face beyond anything normal for a child. Blacks often arrived in Greece through Egypt, and portraits of them have turned up throughout the Hellenic world.

The horse and jockey have been modeled with equal sensitivity and attention to detail. Indeed, the very naturalism of their rendering makes the images seem almost real. The effect would have been even more uncanny when enhanced with eyes of colored glass or stones and with teeth set into copper-lined mouths. In the horse's mouth we can still see the tongue and part of the bit.

On the horse's rump, silver strips once filled the brand, an outline representation of a Nike, that winged female personification of victory. Shown in profile, she faces right and holds up a victor's wreath. Records of the Athenian cavalry cite the brand for several different men.

The overt emotionalism of the Artemision *Jockey and Horse,* albeit handled in a manner characteristic of Hellenistic art, stands in marked contrast to the monumental quietude of the *Delphi Charioteer* (pp. 20–31), which depicts not the heat of the race but the moment of calm immediately following victory, thereby stressing the reserve and self-control so typical of Early Classical art.

ANTIKYTHERA

In 1900 sponge divers made the first important underwater discovery of ancient Greek sculpture. It occurred between Crete and Kythera, near the small rocky island of Antikythera, when a sponge fisher returned to his ship with frightening tales of ghostly people and horses lying on the ocean floor, their flesh rotted by syphillis.

The story might have been dismissed as one of the hallucinations sometimes experienced by people who work underwater—but for the arm that the diver brought up with him. After investigating the site, the ship's captain realized that the "ghostly" figures were in fact statues from a wrecked vessel.

With assistance from the Greek Navy and from the Professor of Archaeology at the University of Athens, sponge divers worked under the auspices of the Greek government to recover the sculpture. The salvage crew operated for nearly a year, from November 1900 through September 1901.

The cargo included badly eroded marble sculpture, transport amphoras, pottery of Hellenistic and early Roman date, and glass, as well as a geared machine identified as a calendar computer. Study of the ship's freight shows that the most recent objects date from about 80–70 B.C. Carbon-14 analysis of the ship's own remains indicates that the wood used in the vessel's construction had been cut about a century earlier. So, the ship was probably an old freighter that capsized in the early part of the first century B.C.

Objects from the wreck can be identified with eastern Greek cities on Kos and Rhodes, as well as at Ephesos. Nothing in the cargo relates to Athens. The marble pieces, for the most part, appear to be copies made in the first century from earlier Greek masterpieces, the kind of sculpture produced in workshops on Delos and Rhodes during the first century B.C. Such evidence indicates that the wrecked vessel had begun its voyage in the eastern Sporades Islands and along the coast of Asia Minor. Since Antikythera lies at the western edge of the Aegean Sea, the freighter probably was headed to a western port, where wealthy collectors would have welcomed sculpture from eastern Greek sites. Rome seems a logical destination.

Bronze sculpture also formed part of the cargo. Stylistically it poses more problems in that the work ranges from the fourth to the first century B.C., with none of the pieces revealing any readily discernible connection. The group may be a random one, the sort of Greek art from the east that appealed or was available to a Roman merchant or collector.

THE ANTIKYTHERA YOUNG MAN

LATE CLASSICAL, SECOND HALF OF THE FOURTH CENTURY B.C.

HEIGHT: 1.94 M.

RECOVERED FROM A SHIPWRECK OFF THE COAST OF ANTIKYTHERA, A.D. 1901

NATIONAL MUSEUM, ATHENS

The statue of a young man recovered in 1901 from a shipwreck near Antikythera constitutes a monument to the skill of the National Museum restorers and curators as much as to the genius of the original sculptor. At the time of its discovery, the figure had been broken into many pieces. Dissatisfied with the repair made early in the century, the conservators undertook to reassemble the work in 1951–52.

The grooming evident in this figure reflects a fashion fostered by Alexander the Great, the beautiful face clean-shaven and the thick, wavy hair cut short and left tousled. But the connotation of adolescence inherent in the title *Antikythera Youth*, often applied to the statue, is belied by the well-developed nude physique, clearly that of a full-grown man. The body may be likened to the square-built Polykleitan form (see p. 135), for not only does it incorporate the canonical proportions introduced by Polykleitos but it also respects the compositional order favored by the fifth-century master. Nevertheless, the Antikythera artist was a man of his own time, the fourth century B.C.; thus, he espoused rhythms more complicated than those of the High Classical age. The head, for example, turns in a direction opposite that of the weight-bearing leg, and one leg extends directly out into space.

Still, the sculptor chose a quiet pose and gave his subject a gentle expression of wonderment. Deep-set eyes peer along the angles of the raised arm, suggesting that some great importance must attach to the action of the hand or to the object it once held.

Even today the statue seems lifelike, a powerful illusion of nature, produced in part by the technique of making distinctive elements separately and then fitting them into the bronze form. Fringed-metal eyelashes frame white orbs inlaid with brown corneas. Copper lips part slightly to reveal white

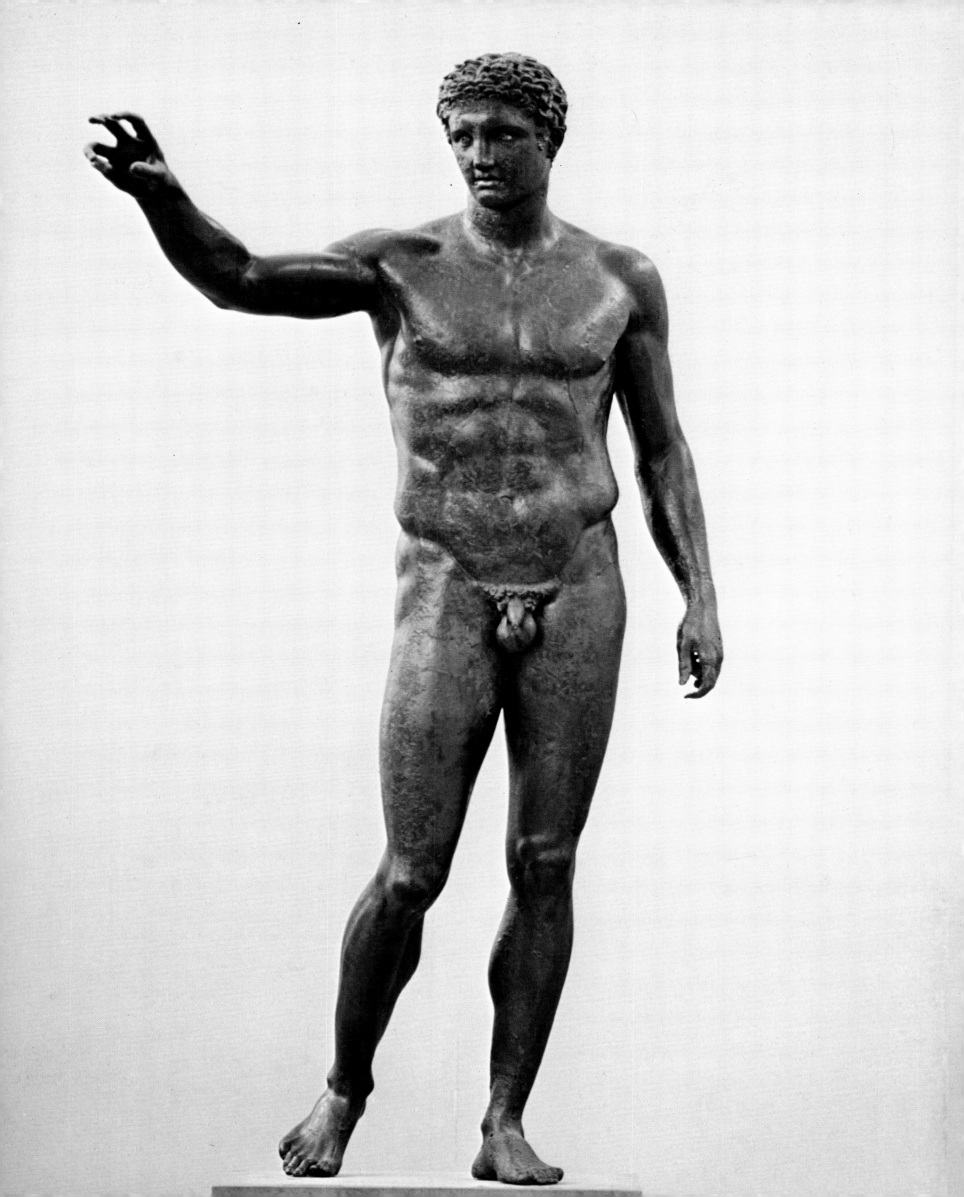

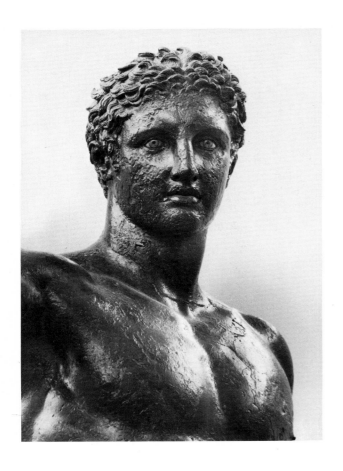

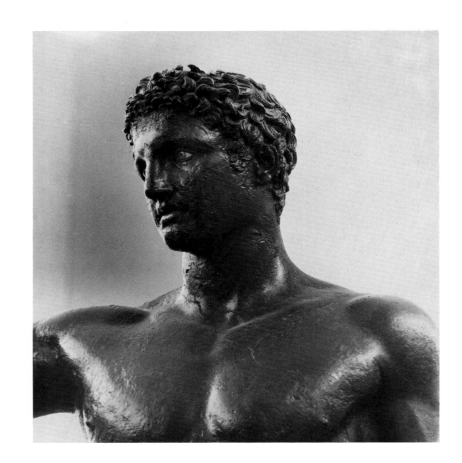

teeth set into the head by a method similar to that used in the nineteenth and early twentieth centuries for making high-quality dolls. When new, the *Antikythera Young Man* must have been truly arresting as an exercise in sculptural realism.

The figure's facial features closely resemble those of the *Piraeus Artemis A* (pp. 64–65). The profile, forehead, and hairlines of the two heads so reflect one another that the statues could be taken for twin brother and sister. Such morphological similarities surely could not come from different hands.

Clear as this may be, the statue poses a conundrum when it comes to identifying the subject and his action. And neither attributes nor inscriptions survive to help us resolve the mystery.

Clues to what the figure once loosely held in its left hand do exist, mainly in the cylindrical shape defined by the curve of the fingers and in the bit of lead still soldered to the palm near the little finger. The left arm, which hangs away from the torso unstrained by any great load, looks as though it rested slightly against whatever the hand grasped. Thus, the missing object must have had a polelike

shaft and been long enough to extend easily from the hand to the ground. A spear would seem to fulfill those requirements perfectly. A particularly long sword would also fit, but not the greater thickness of a club. So far so good, but then almost any Greek hero or warrior, as well as some athletes, might be furnished with a spear or even a sword.

The right arm presents us with a real enigma. Raised shoulder high, it stretches forward and to the figure's right, the fingers extended and arched as though grasping a small, rounded object. This pose recalls that of Cellini's *Perseus,* the Renaissance bronze that brings such drama to Florence's Loggia dei Lanzi (p. 135). Since the piece portrays the subject holding a sword in his left hand and Medusa's head in his right hand, a Perseus identification might seem in order for the *Antikythera Young Man.* But a close comparison of the two large sculptures reveals differences serious enough to defeat recognition of the Greek figure as a Perseus presenting the severed head of Medusa. While the right arm of the Cellini figure bends in order to remain close to the torso, that of the Antikythera statue extends almost horizontally. And whereas

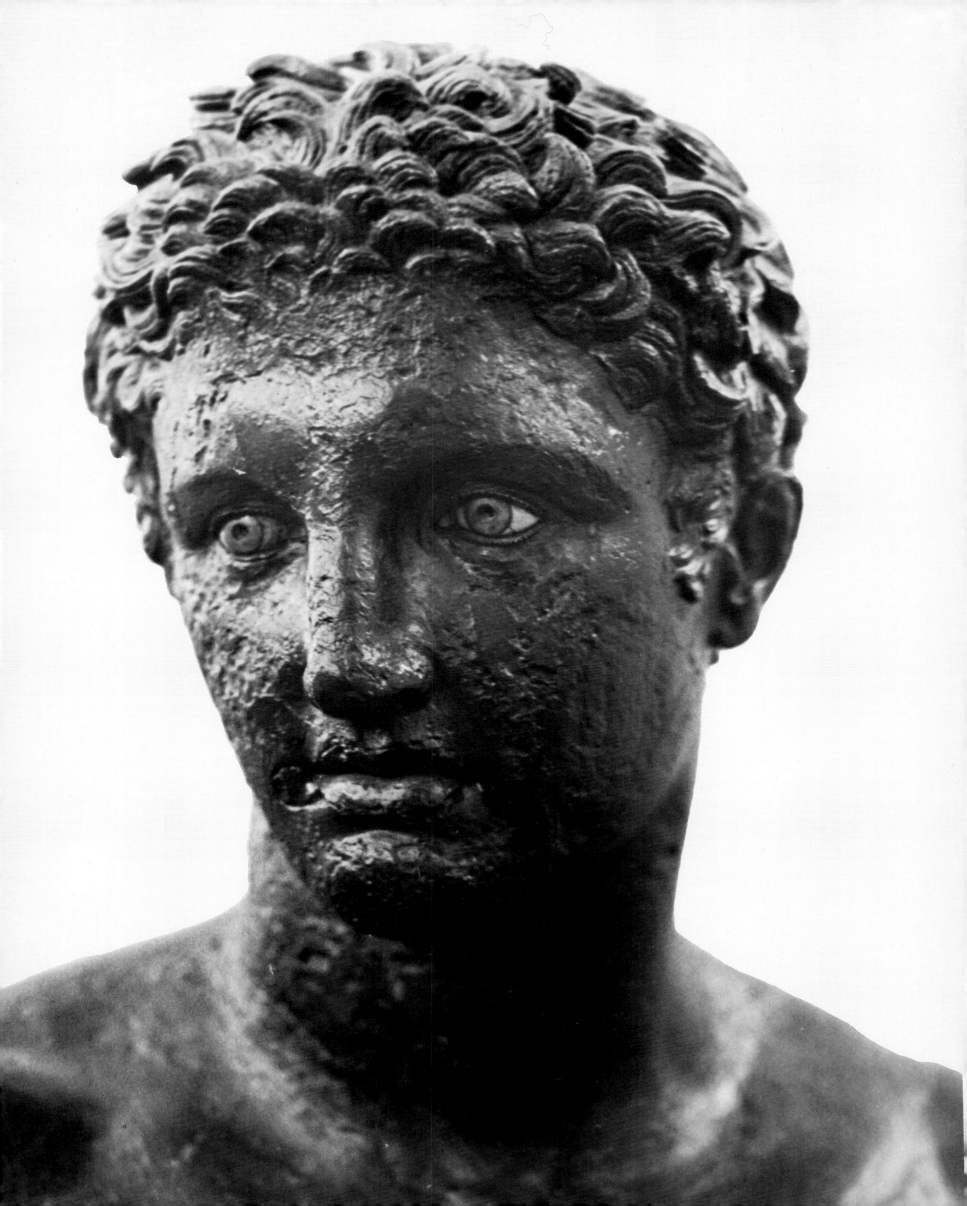

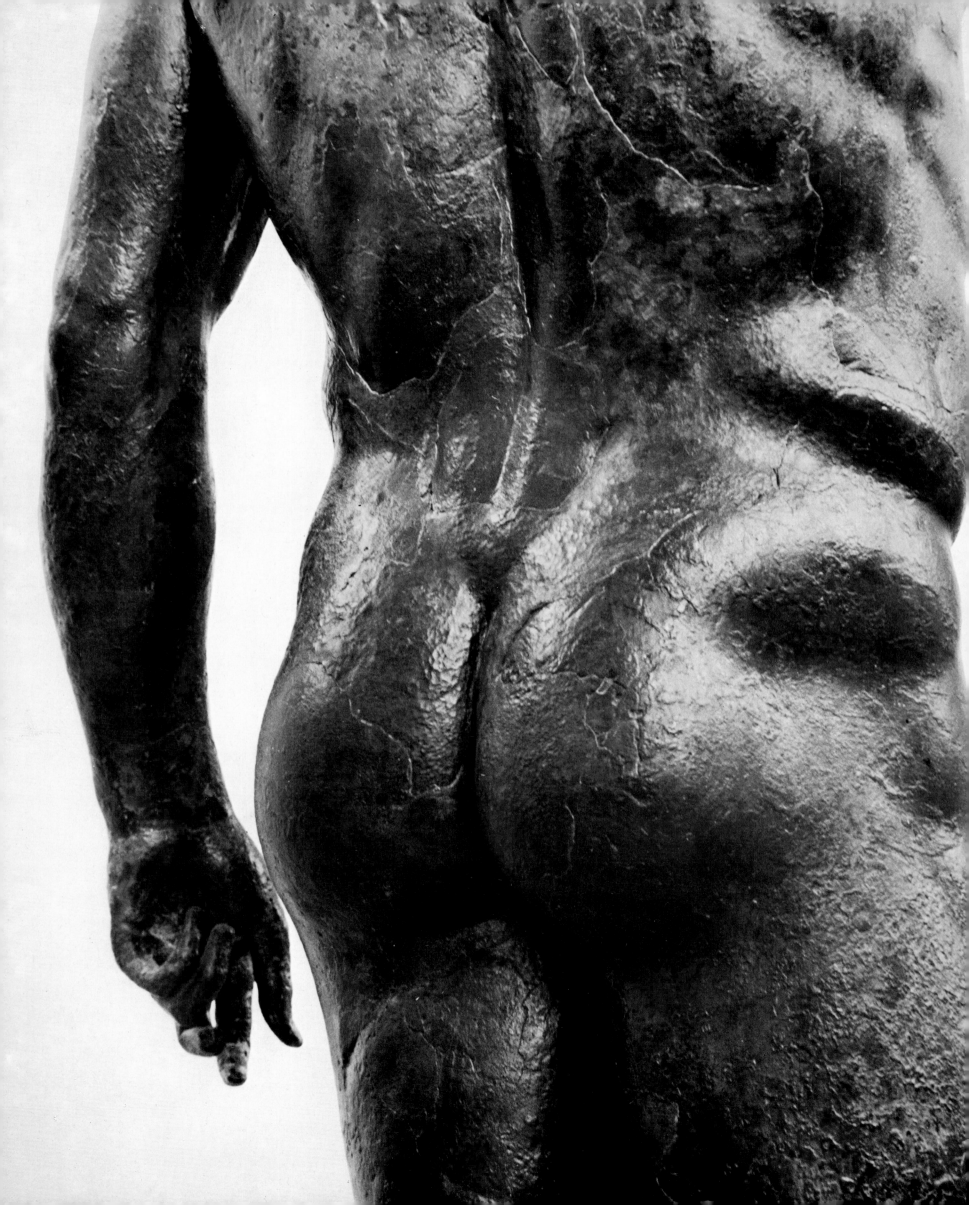

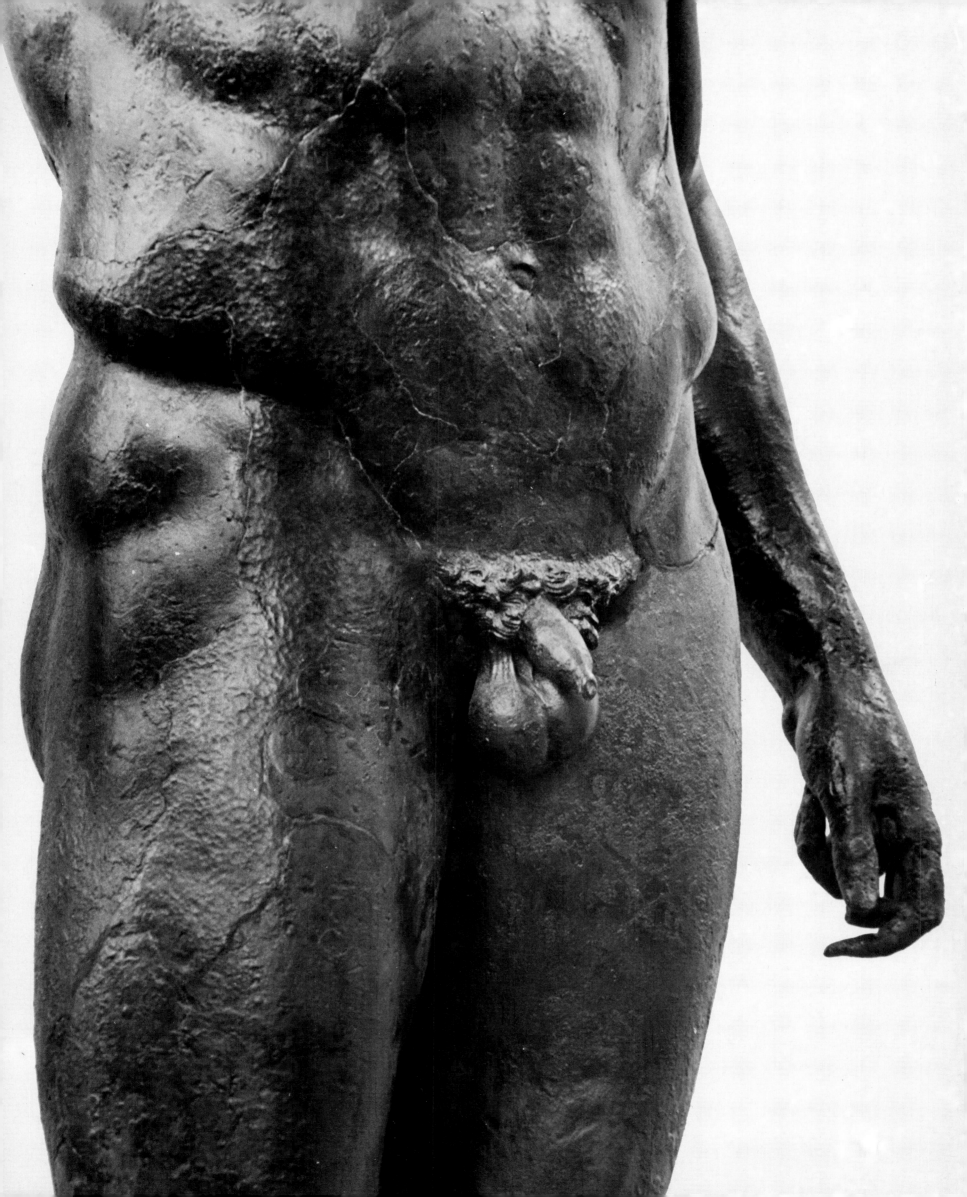

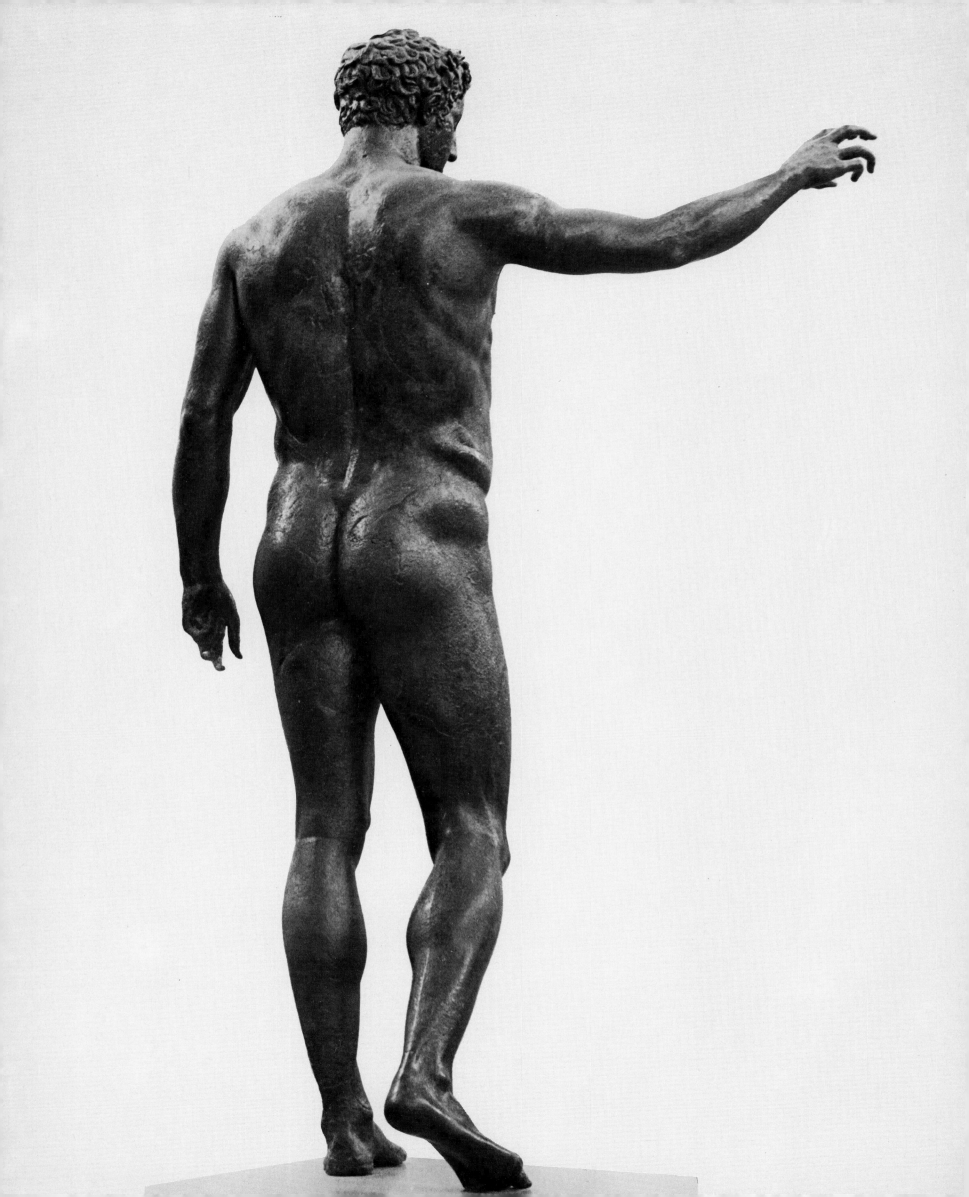

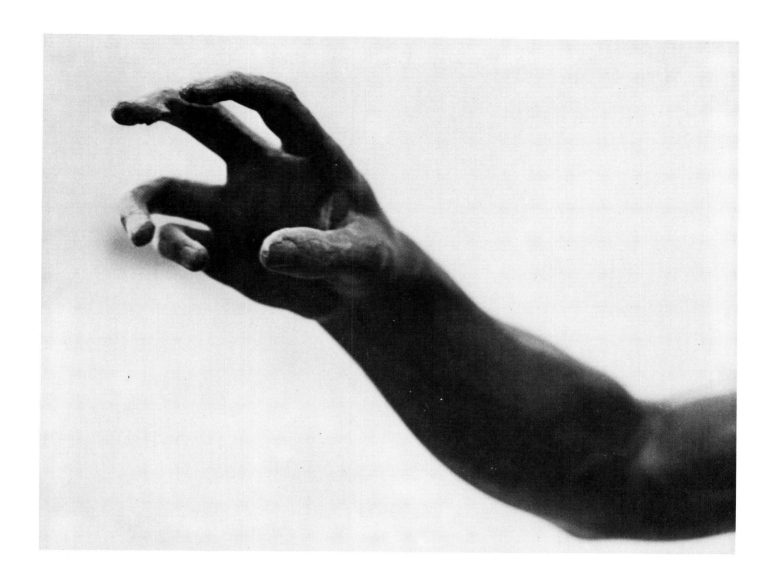

the design of the Italian work allows for the heavy load borne by the hero's right hand, the Antikythera figure appears not to have been planned to hold anything very substantial in its right hand.

The *Antikythera Young Man* has also been frequently called the *Ball Player,* since the spherical grip of the figure's right hand would be appropriate for a ball, which the arm might be poised to throw or display. But there is no trace of the wreath or fillet normally worn by victorious athletes, and no important ball-throwing contest is known to have been included in the Greek Games.

A more promising possibility lies in visualizing the right hand as clutching an apple. In one of his final Labors, Herakles gathered the Golden Apples of the Hesperides. But if meant to be Herakles, the figure should probably have the characteristics of an older man, at the end of his Labors. Moreover, we might expect to see some evidence of a lion skin and a club, the attributes of Herakles.

Greek legend also associated apples with Paris, who threw a golden apple "for the most beautiful" to Aphrodite, Hera, and Athena. Certainly the Antikythera figure portrays a young man handsome enough to be Paris. Should this identification be correct, then the Homeric prince, whose fascination with women, especially Helen of Troy, led to wholesale trouble, has been treated with an unwonted degree of sympathy and subtlety.

But whatever the subject's real name may have been, the *Antikythera Young Man* expresses the introspection and compassion typical of the Praxitelian school of Late Classical sculpture (see p. 135).

THE ANTIKYTHERA PHILOSOPHER

HELLENISTIC, THIRD OR SECOND CENTURY B.C.

PRESERVED HEIGHT: 0.29 M.

RECOVERED FROM A SHIPWRECK OFF THE COAST OF ANTIKYTHERA, A.D. 1900–19

NATIONAL MUSEUM, ATHENS

The ship that sank near Antikythera in the first century B.C. carried in its cargo a lifesize bronze portrait statue of a philosopher. Divers recovered the head, both arms and feet, and part of the figure's cloak. They also saw the main section of the torso but failed in their efforts to wrest it from the bottom of the sea.

The elderly sage would have been shown standing, his right arm raised and his left one holding a stick. The bearded face bears the imprint of advanced age, just as the disheveled hair reflects a mind largely concerned with issues more universal than personal. Altogether the pose and attitude conform to traditions developed in ancient Greece for the representation of philosophers, who as mature and respected members of society often found themselves honored with portrait statues.

Here the artist not only gave his image naturalistic features; he also made them the vehicles of character. The small eyes seem capable of penetrating vision, despite damage to the inset material of the orbs. Both the sharp focus of the eyes and the angle of the head connote an alert and deliberating spirit. And so does the brow, furrowed as though by years of intense concentration. But however much the hair may appear in need of combing, the beard and moustache fall in a slightly irregular but artfully balanced manner suggesting the orderly nature of what lies within.

In his use of unidealized form to portray a unique personality, the creator of this superb work exemplified the principles of Hellenistic sculpture. But the long, continuous observance of such conventions and the absence of a factually based chronology for the art of the Hellenistic period make it difficult to establish a reliable date for the *Antikythera Philosopher*. This, however, does not detract from the self-evident quality of the piece.

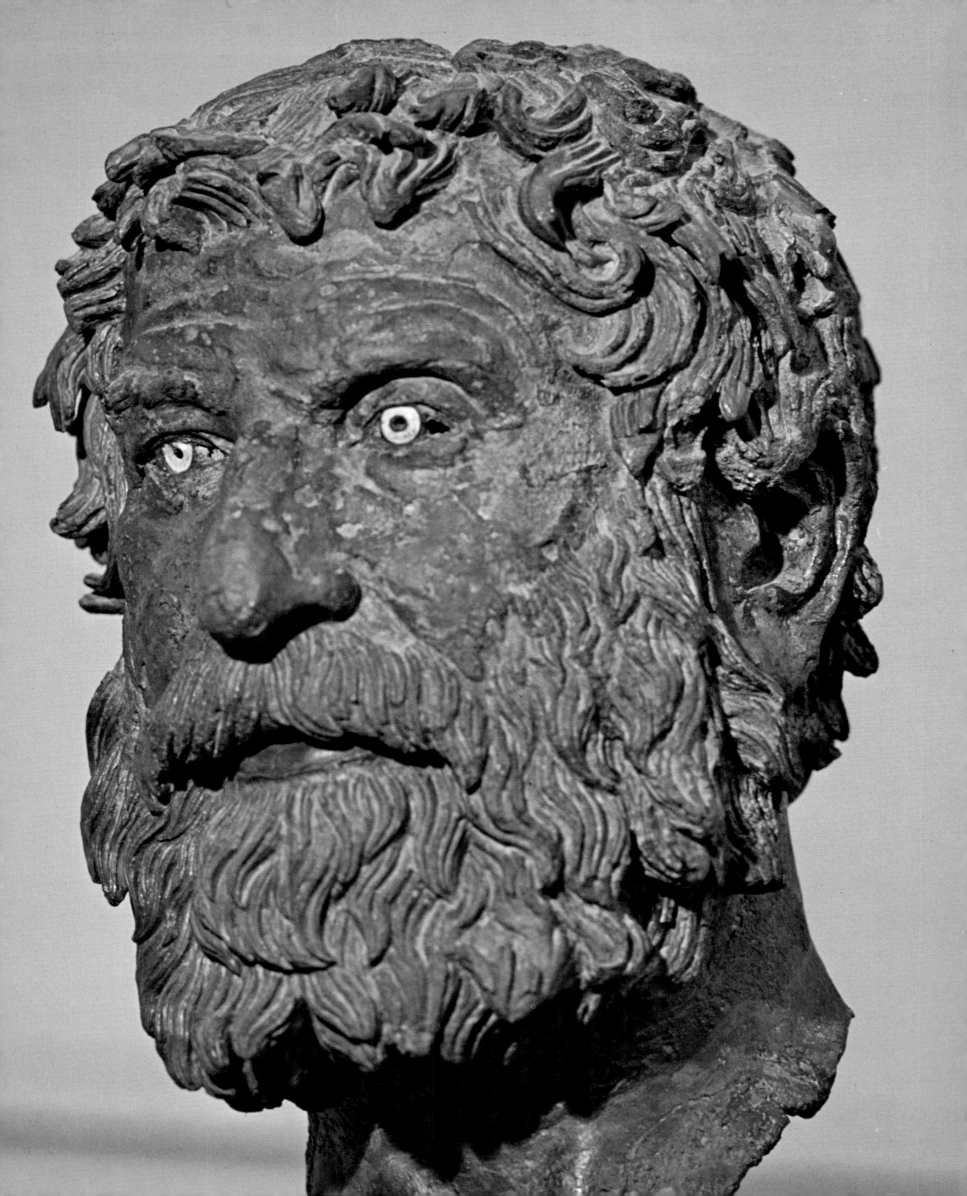

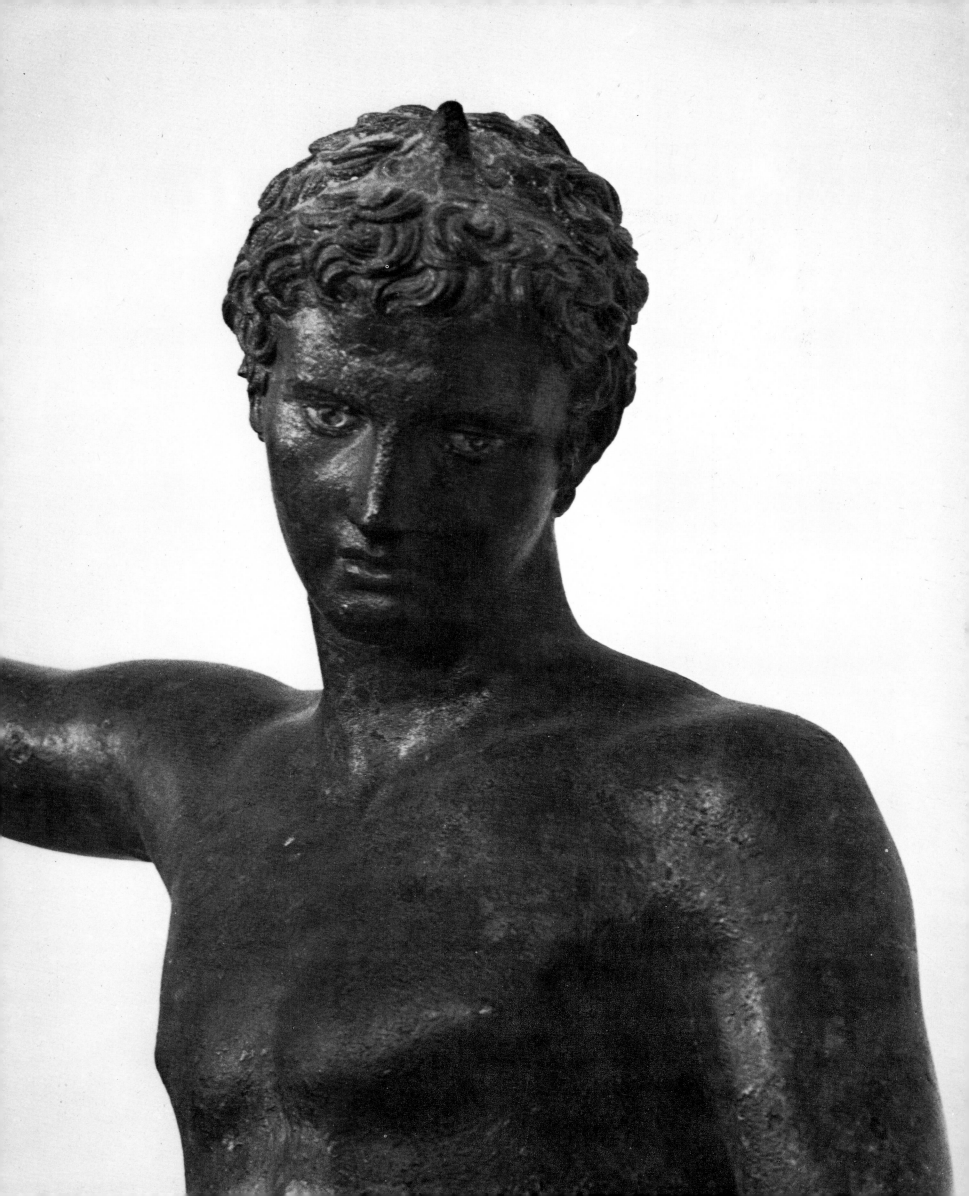

THE BAY
OF MARATHON

In 1925 fishermen working in Marathon Bay accidentally snagged a superb bronze image of a handsome youth in their nets. No one knows how the statue happened to be there. Nothing else of particular interest or importance was discovered then, nor have more recent explorations produced good archaeological clues.

Had the statue plunged into the sea on board a sinking ship, the site might have yielded other freight or part of the ship itself. Nevertheless, the possibility that the so-called *Marathon Youth* formed part of a ship's cargo cannot be dismissed.

Perhaps the figure belonged to one of the sanctuaries near Marathon and came to be disposed of willfully. Tossing it into the bay could have constituted a symbolic act intended to dramatize political and military conquest or the overthrow of the Olympian religion.

The fruitlessness of recent, thorough investigations of the underwater site indicates that we may never have enough archaeological information about the *Marathon Youth* to be certain of where the statue originated, who destroyed it, when, or why.

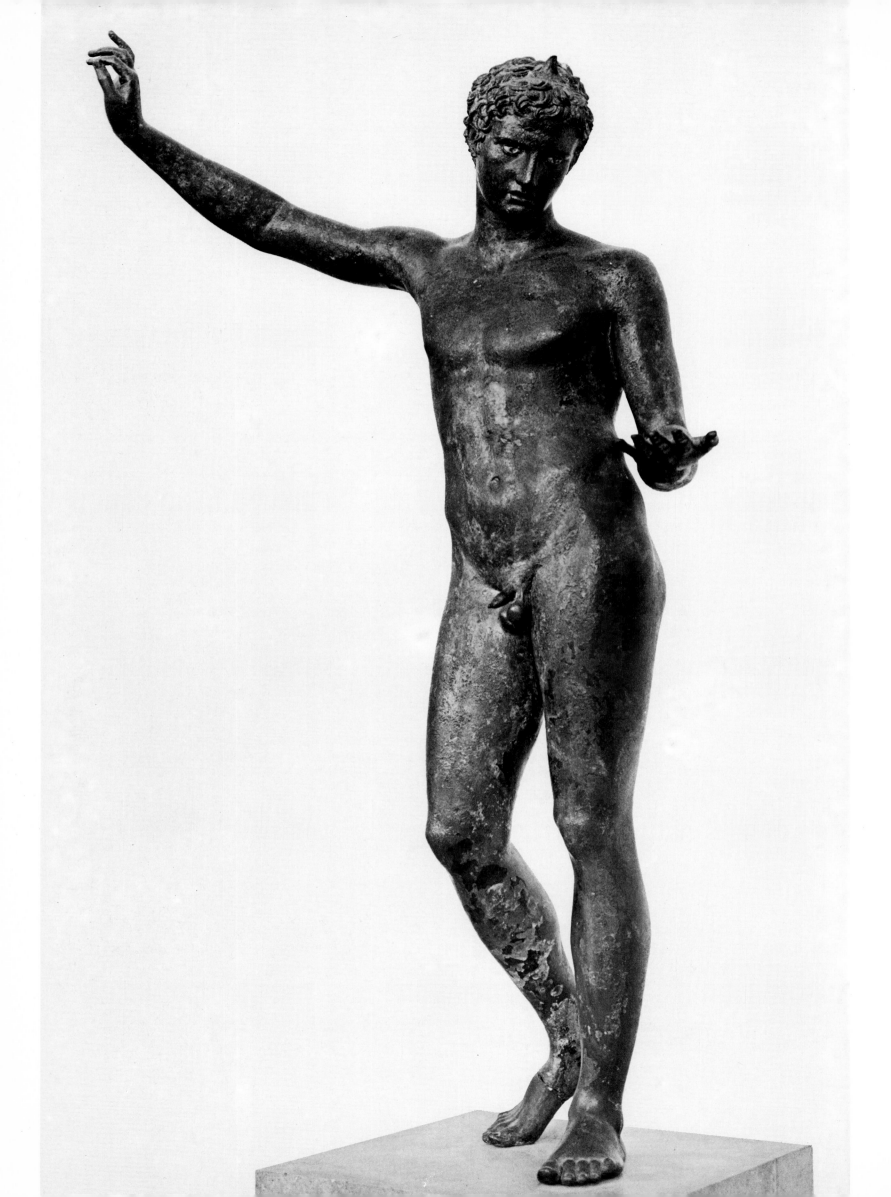

THE MARATHON YOUTH

LATE CLASSICAL, SECOND HALF OF THE FOURTH CENTURY B.C.

HEIGHT: 1.3 M.
FOUND IN THE BAY OF MARATHON, A.D. 1925
NATIONAL MUSEUM, ATHENS

The statue netted in Marathon Bay portrays a youth standing about three-quarters the height of a mature man. The size makes it difficult to determine whether the figure represents a subject who has yet to reach full growth or whether the image was simply scaled somewhat smaller than actual lifesize. A well-defined bone structure, the absence of baby fat, and the muscular development all seem characteristic of an adolescent boy.

Posed in a pensive attitude, the nude youth performs an action whose significance remains a mystery. He would seem to be oblivious to the outside world, lost in thought as his eyes focus on whatever once rested in his left hand. The missing object was attached by a pin set in a large cavity drilled into the palm. The posture of the left arm, leveled from its finger tips to its elbow, appears to have been designed to hold a large, flat-bottomed object, perhaps something with the size and shape of a tray or platter.

The right arm extends in the opposite direction,

with the hand raised above the figure's head. There the tips of the thumb and forefinger meet, their delicate touch emphasized by the graceful but tensed arcs of the other fingers. The hand probably held a thin or small article, pulling it away from the flat piece carried on the left hand and arm, or using it to attract the attention of some creature balancing on that horizontal surface.

After cleaning the statue and mending the right foot, the conservators at the National Museum in Athens considered it possible that the arms came from restorations made in Roman times. The left arm has a break halfway between shoulder and elbow, and the right arm shows another break near the middle of the bicep. But without more conclusive evidence, the issue cannot be settled. Even if the arms are restorations, they must conform to the original composition, since the position of the shoulders and upper arms sets the angles at which the limbs could go.

Unlike most Classical poses, this one departs

from established canons. Similar compositions exist, but none repeats that of the *Marathon Boy* precisely, and none comes close enough to reveal what the figure is doing.

A distinguishing feature that may hold promise for disclosing the identity of the subject and his activity is the circlet banded about the head. The flame-shaped leaf attached to it at the center front may represent a badge of membership or office in some company, perhaps even a religious group. Similar crowns have been found on other figures in Classical Greek art, but no convincing explanation of their meaning has been proposed.

Fortunately, the style of the *Marathon Boy* poses no mystery. Its soft and dreamy qualities are familiar to us from what we know of the works created by Praxiteles, whose artistic personality is unmistakable, as sensuously smooth and subtle as anything produced in the history of sculpture (see p. 135).

In the years following its discovery, the *Marathon Boy* was sometimes attributed to the famous fourth-century sculptor himself. But thanks to more recent finds, our knowledge of the Classical style has been so enriched and actually altered that such an assignment no longer seems feasible. The sheer quality of the Greek originals now known leads us to expect that a statue by Praxiteles would necessarily be of unsurpassed excellence. Meanwhile, the *Marathon Boy*, for all its beauty and sensitive handling, lacks the grandeur of definition and articulation that comes from the greatest, most exquisite modeling. Although conceivably produced within the circle of Praxiteles, the sculpture cannot be included in the oeuvre of an artist who was one of the two supreme masters of his time, itself a moment of extraordinary cultural climax.

The Marathon figure stands in a pose similar to that of the *Antikythera Young Man* (pp. 92–99)— a relaxed, spiraled S-curve—but opened, by virtue of arms extended at varying angles to the trunk, into a fully three-dimensional composition. The great sculptors of the Early Classical period, such as the Master of the Artemision Zeus, designed dramatically open forms that keep them, however great their extensions, within the confines of an essentially two-dimensional or planar space. The freer, more complex organization of the *Marathon Youth* reflects aesthetic developments that occurred during the last half of the fourth century B.C., probably under the leadership of Lysippos (see p. 135).

All this makes it seem likely that the *Marathon Youth* dates to the last half of the fourth century, after the innovations of Praxiteles and at least some of those associated with Lysippos had been established. Not only does the Marathon work display affinities with the gentle, quiet expression favored by Praxiteles, but it also evinces a proportional scheme close to that of the famous master. At the same time, the Marathon sculptor would surely have been younger than Praxiteles, since the statue seen here indicates that its creator saw and understood some of the pioneer ideas of Lysippos.

The *Marathon Youth* respects the traditions of Classical Greek sculpture set forth in the fifth century B.C., a time when human forms became the vehicles for the expression of concepts and accomplishments. However, the conventions of High Classical art underwent transformation in the Marathon figure, which reveals the hand of an artist in intimate touch with the stylistic developments that occurred toward the end of the Late Classical period. Symptomatic of the new order are the subject's more vulnerable personality, the greater privacy and contemplation of the moment depicted, and the shift in both form and subject from the heroic to the human.

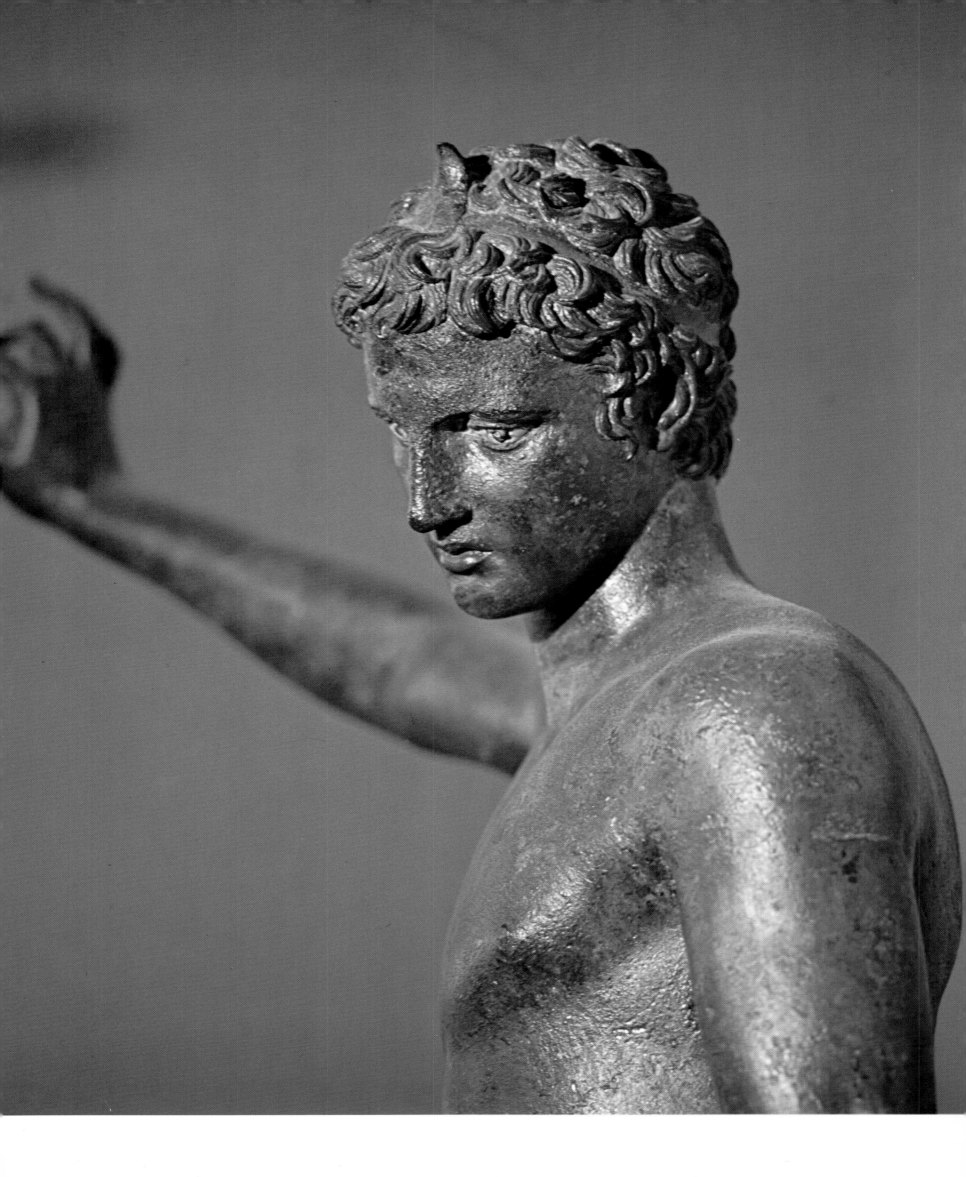

THE ADRIATIC SEA

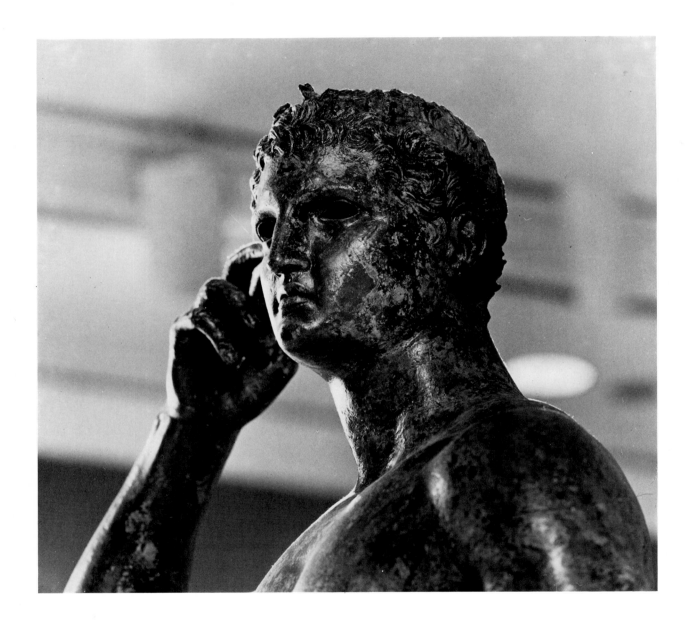

Circumstances surrounding the discovery of a lifesize statue in the Adriatic Sea remain shrouded in secrecy owing to potential legal problems. A law enacted in 1939 makes all antiquities found after that date in Italy or its territorial waters the property of the Italian state.

Fishermen, trawling in the Adriatic off the eastern Italian coast, netted the statue in the wake of a rough storm during June 1964. After taking the piece to their home port, Fano, they decided to sell it rather than turn their precious catch over to state

authorities. The men also agreed to divide the profit, in keeping with their practice whenever they discovered ancient vases and sold them undercover.

Having broken the law, the fishermen are hesitant to discuss the site where they made their big find. Also tight-mouthed are the various people who dealt with the sculpture after its discoverers had sold it, since their actions too went counter to Italian statute. As a consequence, few entertain much hope of gaining specific archaeological evidence about the bronze figure.

Fano is a port midway between Rimini (ancient Ariminum) and Ancona on the Adriatic coast of Italy, and presumably the fishermen were trawling near their home port when the bronze figure appeared in their nets. The storm that had just occurred might have dislodged and even moved the sculpture from its burial place. Even so, it could hardly have traveled far, and we therefore feel safe in assuming that the piece came from Italian coastal waters somewhere between Rimini and Ancona.

Greek and Phoenician trading ships sailed up the eastern Adriatic at least as early as the fifth century B.C., and maritime traffic along that coast became even heavier in Roman times. But the region offers no site famous in antiquity for impressive collections of Greek statues; thus, no particular place immediately presents itself as the sculpture's logical destination.

For all its secret parts, the modern story of the statue contains more certainty than its ancient history. An antiquarian from Gubbio, a town about fifty miles inland from Fano, borrowed money from a rich cousin to purchase the barnacle-encrusted bronze. When he failed to repay the loan, the wealthy cousin and his brother took the statue to their priest, who hid it for them. Anonymous tips eventually brought the antiquarian, his two rich cousins, and their priest to trial. Meanwhile, the statue had been spirited out of Italy and hidden abroad, so that it could never be produced as evidence in court. This prompted the Rome Appeals Court to dismiss all charges in 1970, declaring that no crucial facts could be established in the absence of the statue. The decision effectively cleared the way for the public sale of the sculpture, since by acknowledging the inability of the Italian government to claim the figure as state property, it permitted museums or collectors to consider buying the work without fear of its being repossessed as stolen goods.

Following the Appeals Court decision, the statue reappeared. An international art consortium called "Artemis," working with Heinz Herzer, a dealer in Munich, acquired the heroic figure. It was cleaned and in 1977 sold to the J. Paul Getty Museum.

The so-called *Getty Victor* makes an invaluable addition to the corpus of Greek bronze sculpture, and it would enrich our lives even more were its archaeological context known. Without good and convincing contextual, historical, or literary evidence that can be related to the statue, we have little reliable means of identifying the subject portrayed, the nature of the original commission, or the place where the statue stood.

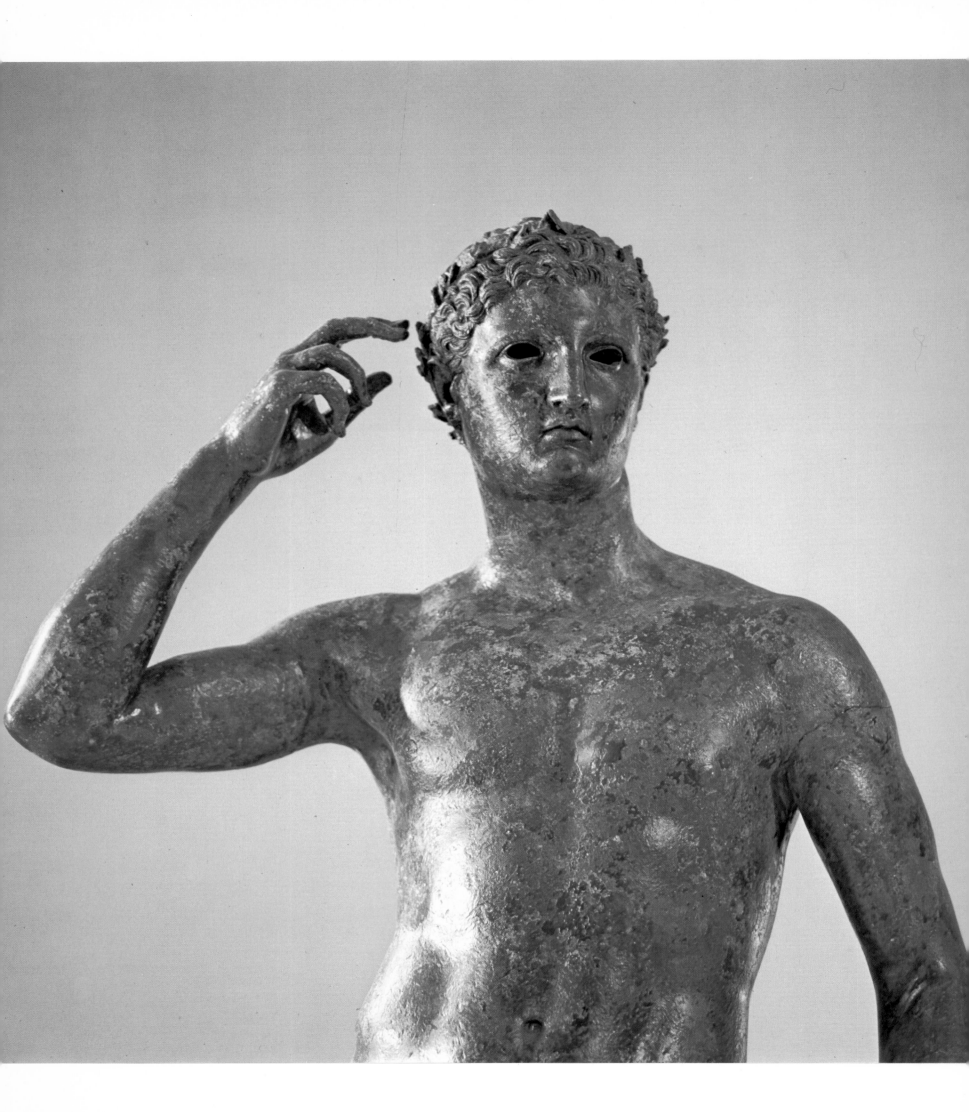

110

THE GETTY VICTOR

EARLY HELLENISTIC, LATE FOURTH CENTURY OR EARLY THIRD CENTURY B.C.

PRESERVED HEIGHT: 1.54 M.

FOUND IN THE ADRIATIC SEA, A.D. 1964

J. PAUL GETTY MUSEUM, MALIBU, CALIFORNIA

This remarkable piece reappeared to grace the world only in 1964, when Italian fishermen pulled it, barnacle-encrusted, from the eastern Adriatic Sea. Acquired by the Getty Museum in 1977, the statue represents a young man posed in the manner often favored by Greek artists for their portrayals of victorious athletes. The overall figure originally stood about 1.7 meters tall, which makes it lifesize.

Winners in the Panhellenic Games were crowned with leafy wreaths, symbols of the glory that had become their prize and the fame they brought to their home towns. The crown therefore constituted an essential feature of the sculpture portrait that the athlete or his city-state often commissioned to celebrate a victory. Usually the subject has been posed with his right hand touching the wreath as if to place the diadem on his head or merely adjust it. Either way, the gesture, as here, draws attention to the symbol of victory, which means that the main function of the arm must be seen as artistic.

Of its crown the *Getty Victor* retains only the foundation cord and a few leaf fragments. Originally, the foliage extended so far that the first two fingers of the athlete's hand touched it, which would have made the gesture weightier and more purposeful.

Each Panhellenic sanctuary had its own distinctive crown. Olympia wove its wreaths of olive, while Delphi used laurel, Nemea wild celery, and Ismia pine. What remains of the *Getty Victor's* crown indicates that it had been composed of olive leaves, thereby proclaiming the subject a champion in the Olympic Games. As a monument of Olympic success, the statue must have been erected at Olympia itself or in the athlete's home town.

The figure has lost its feet, broken away above the ankles, as though the sculpture had been wrenched from its base. Such rough, disfiguring treatment of art seems more characteristic of looters than of true collectors. And we know that Ro-

111

man generals made a practice of "capturing" statues as well as people in the course of their raids on Greek cities. Thus, the image now in the Getty Museum may well have been Roman booty from the great Panhellenic sanctuary at Olympia or from somewhere else in the victor's native region.

In the absence of feet, the statue is supported by a rod set through its right leg. Thanks to superb restoration work, the figure can be displayed in a standing position, but balancing it on only the right leg makes the image lean leftward more than it probably did originally. The tensed muscles of the left leg confirm this, since they indicate that it too was designed to support some of the figure's weight. The composition would appear more rhythmic and unified if the figure could be seen standing on the ball and toes of its right foot, with the body tilted somewhat more toward the viewer's right. Although authorities frequently speak of a statue's "weight-bearing leg," the *Getty Victor* demonstrates that the phrase should not be taken too literally, given the fact that Greek figures almost always rest some weight on the "free leg" and gain balance from it.

The nude figure is that of a young man whose trim body seems rather lightly muscled for a competitive athlete. The short, wavy hair conforms to the tousled, naturalistic style cultivated by Greek youths during the Classical period, and it has been fully modeled in the plastic, three-dimensional manner characteristic of Late Classical and Hellenistic art.

The specific, individualized facial features indicate a desire to convey the identity of a particular individual. A firm jaw and the straightforward confrontation of the viewer connote a self-confident, proud personality, one that could be capable of a certain hauteur.

A marble head at the Smith College Art Museum in Northampton, Mass., resembles the *Getty Victor* so closely that it may represent the same handsome young man.

The bow shape of the arm and the gently curved fingers look as though the figure once supported something loosely in its left hand and the crook of the left arm. The missing object may have been a branch, like those held by young men on Greek

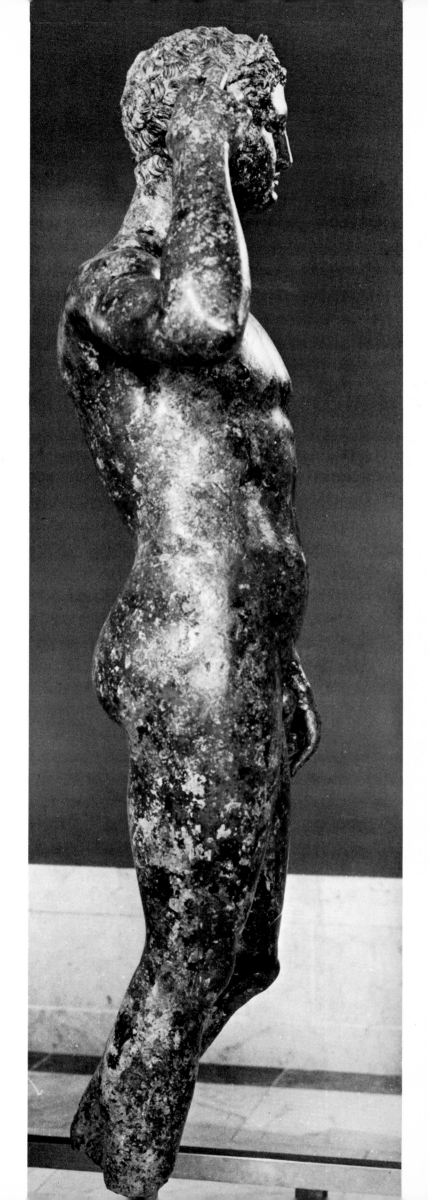

112

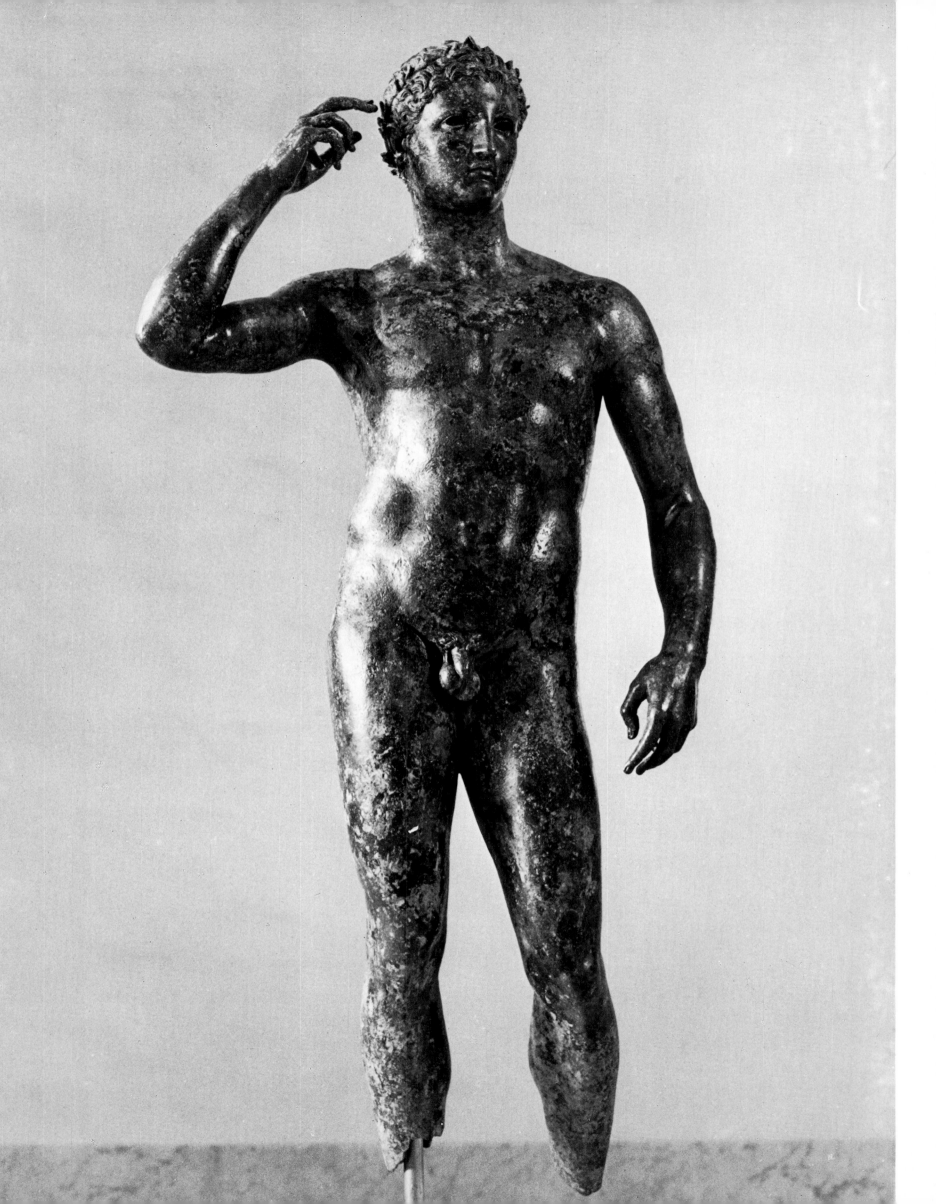

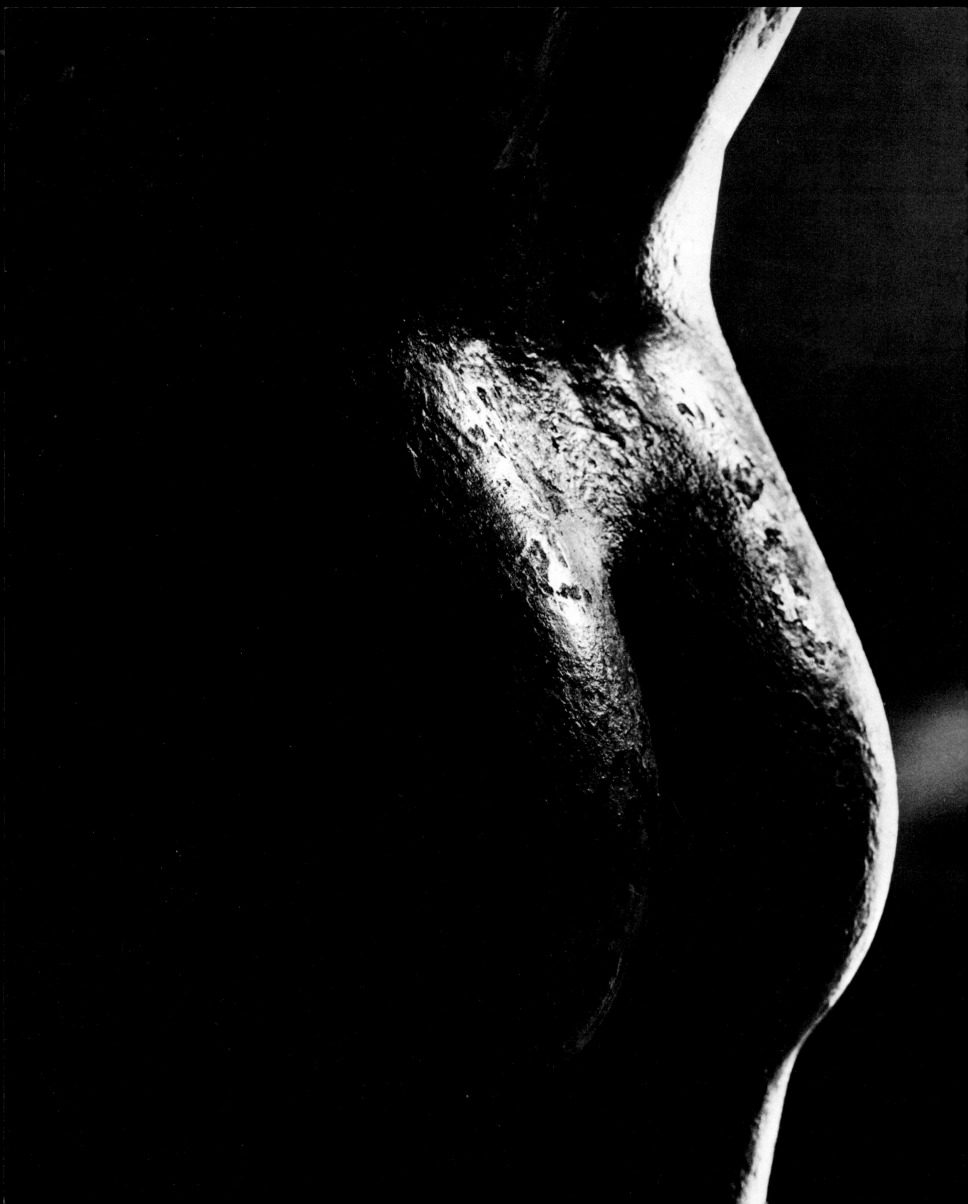

coins minted in Silenus during Classical times.

The pose falls into the shape of an S-curve, its sinuous form accentuated by the sweeping arcs of the figure's arms. The result is an exaggerated and more swayed version of the basic contrapposto design developed by Polykleitos in the mid-fifth century (see p. 135). The spine, although undulating, spirals only slightly, which permits the torso to remain almost frontal. Unlike the compositions attributed to Lysippos, however, the pose arranged for the *Getty Victor* holds the arms to the same plane as the torso, rather than extending them at diverse angles into three-dimensional space.

Of the compositions attributed to Lysippos, only that of the Agias figure in the Delphi version of the *Daochos Group* displays a design of comparable planarity. All the other statues attributed to Lysippos have been much more adventurously posed, with the figures spiraling about a central axis and also extending into a variety of planes (see p.135).

Another departure from the style of Lysippos is the scale of the *Getty Victor*'s head, which, although smaller than required by the canons of High Classical sculpture, measures larger than the model that Lysippos formulated in the mid-fourth century.

For the excellence of its design and modeling, the *Getty Victor* must be considered the work of a major artist. But fine as the piece may be, it falls short of the magnificence and power of certain other bronze statues that survive from Greek antiquity. Thus, it lacks the unsurpassable quality that Lysippos was said to have produced. Certainly the *Getty Victor* issued from the hands of an accomplished sculptor, one obviously and profoundly influenced by Lysippos, but an attribution to that great master cannot be supported in the instance of the Getty statue, without more evidence than the figure itself provides.

Nevertheless, the *Getty Victor* constitutes the finest monumental Greek bronze statue now to be found anywhere outside Greece and Italy.

RIACE MARINA

The most recent discovery of Greek monumental bronze sculpture was made in 1972 by an Italian scuba diving while on vacation. In addition to the fish he sought, the amateur diver found two statues half-buried not far from the shore of Riace Marina, a village near Porto Foricchio. This area along the southern Italian coast happens to be the ancient shipping lane between the important Roman ports and the harbors of Greece.

Prompt notification very quickly brought archaeological authorities to the scene. At the same time that they arranged for the recovery of the statues, the experts also initiated a search of the area. Although this failed to discover the ship that had carried the sculpture, it did turn up some rings from the vessel's sails and a few fragments of amphoras from the cargo. The rings indicate that the ship lost a mast about the same time that the statues went overboard. The clues point to a vessel struck by a storm so violent that a mast snapped. The statues could have broken loose from their moorings and fallen into the sea or been cast away to lighten the load.

Good evidence supports the notion that the sculpture was being shipped away from its original site. One indication of this is the fact that the statues were not new when they plunged into the water. One of the figures, for instance, had been repaired at some considerable time after the initial casting. Moreover, we know that the ancient Greeks set up their bronze foundries as informal, temporary structures near where the sculpture would stand. We also know that Greek master sculptors traveled wherever their commissions took them, but nothing tells us that a mail-order trade ever existed for large-scale Greek sculpture.

Wealthy Romans were avid collectors of Greek sculpture, and Roman generals returned from conquests in Greek lands parading stolen statues like prisoners of war. It seems likely, therefore, that the two statues found off the southern Italian shore near Riace Marina went into the sea while being transported from their original Greek site to Rome.

Since both statues share the exact same scale, stand in the same pose, consist of the same bronze alloy, traveled together on the transport ship, and lay alongside one another in burial, they surely must have been made at the same time and erected at the same site. Most likely, they formed part of the same original monument.

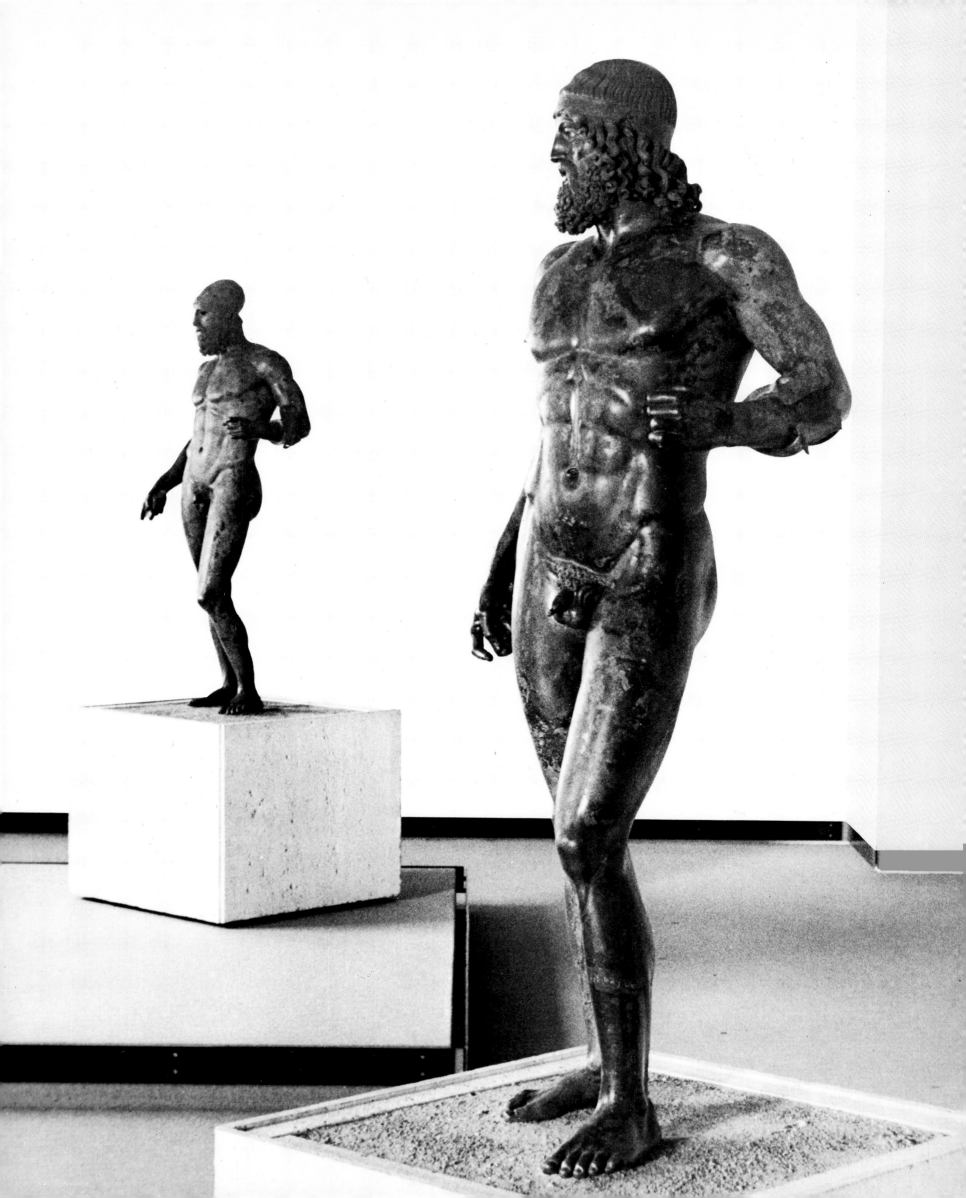

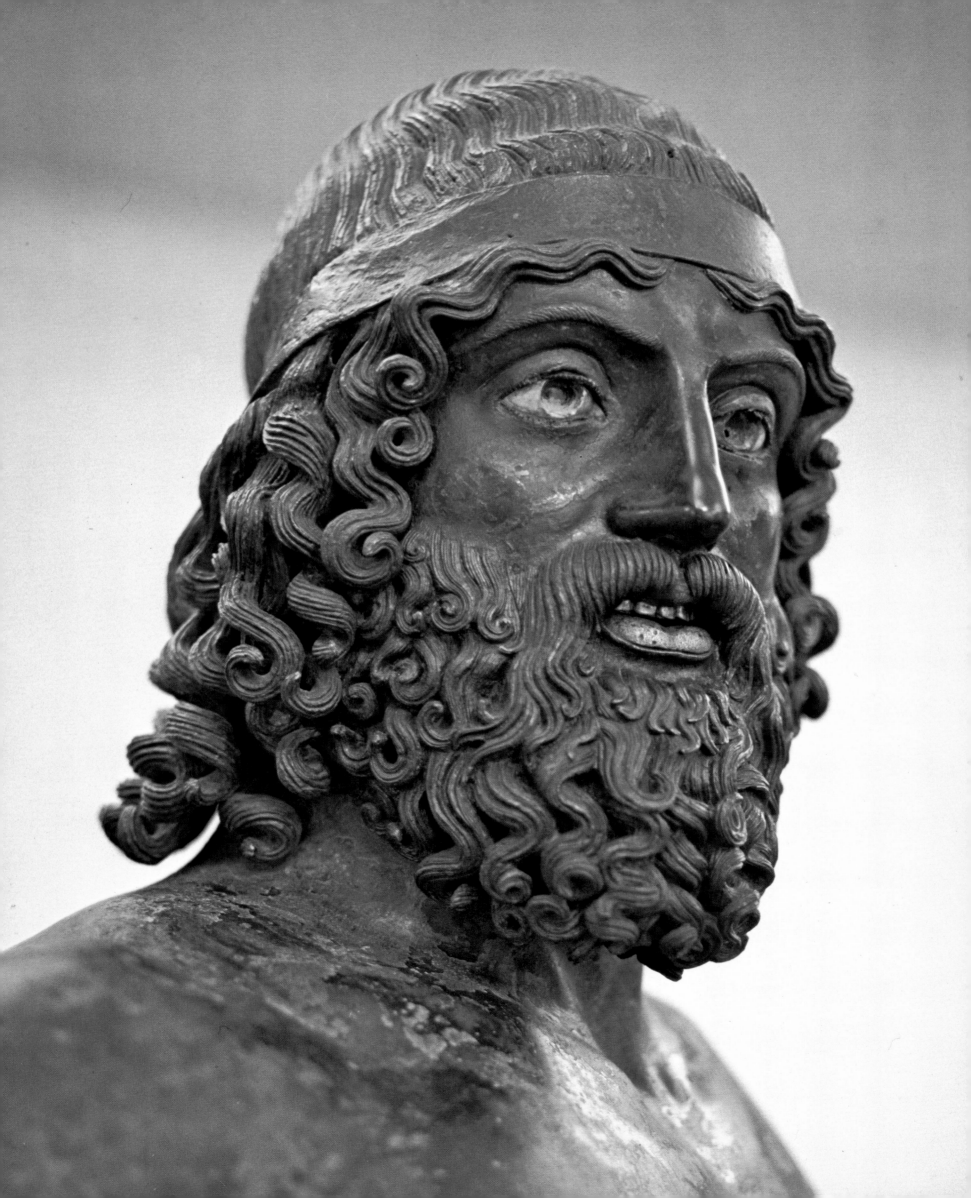

WARRIOR A

CLASSICAL, MID-FIFTH CENTURY B.C.

HEIGHT: 2.06 M.

FOUND IN THE IONIAN SEA NEAR RIACE MARINA, A.D. 1972

NATIONAL MUSEUM, REGGIO DI CALABRIA

A work of supreme beauty and quality, *Warrior A* from the recent find at Riace Marina confronts the world in a stance that could hardly be more expressive of character. With shoulders thrown back, carriage erect, and head held high, this warrior seems the very embodiment of the courageous, mighty leader. As his eyes penetrate the spectator, his mouth opens as if ready to speak. Given the thoughtful attitude, his speech, like his action, should flow from reason.

The trim, fully developed form betokens physical power and self-discipline. The body could in fact be that of a young male in his prime, but during the fifth century B.C. only middle-aged men normally wore thick, short beards such as the one seen here. Furthermore, the facial features have been sharpened by more years than a young man could boast.

The "warrior" label has been adopted for the figure because originally it held a standing spear in its right hand and carried a shield on its left arm. But the image could also be interpreted as a "victor," since a band wound about the head provides the base for a leafy wreath, the crown bestowed upon champions. The strong, confident posture and the commanding mien suggest that if a warrior, the subject must have been a general, whose wreath would identify him as a victorious one.

The basic pose, showing the figure with its weight on one leg while the other leg bends forward, constitutes a hallmark of the Classical period. The load transfer also engages the rest of the lower body, causing every part of the statue's right side to rise. A far cry from the Archaic formula that made images look stiff and inert (see pp. 45–49, 52–57), the new Classical composition endows figural sculpture with the appearance of vitality and movement.

The Master of Warrior A went further and reinforced the sense of motion and tension by rotating the body, a stylistic process that can be seen at its

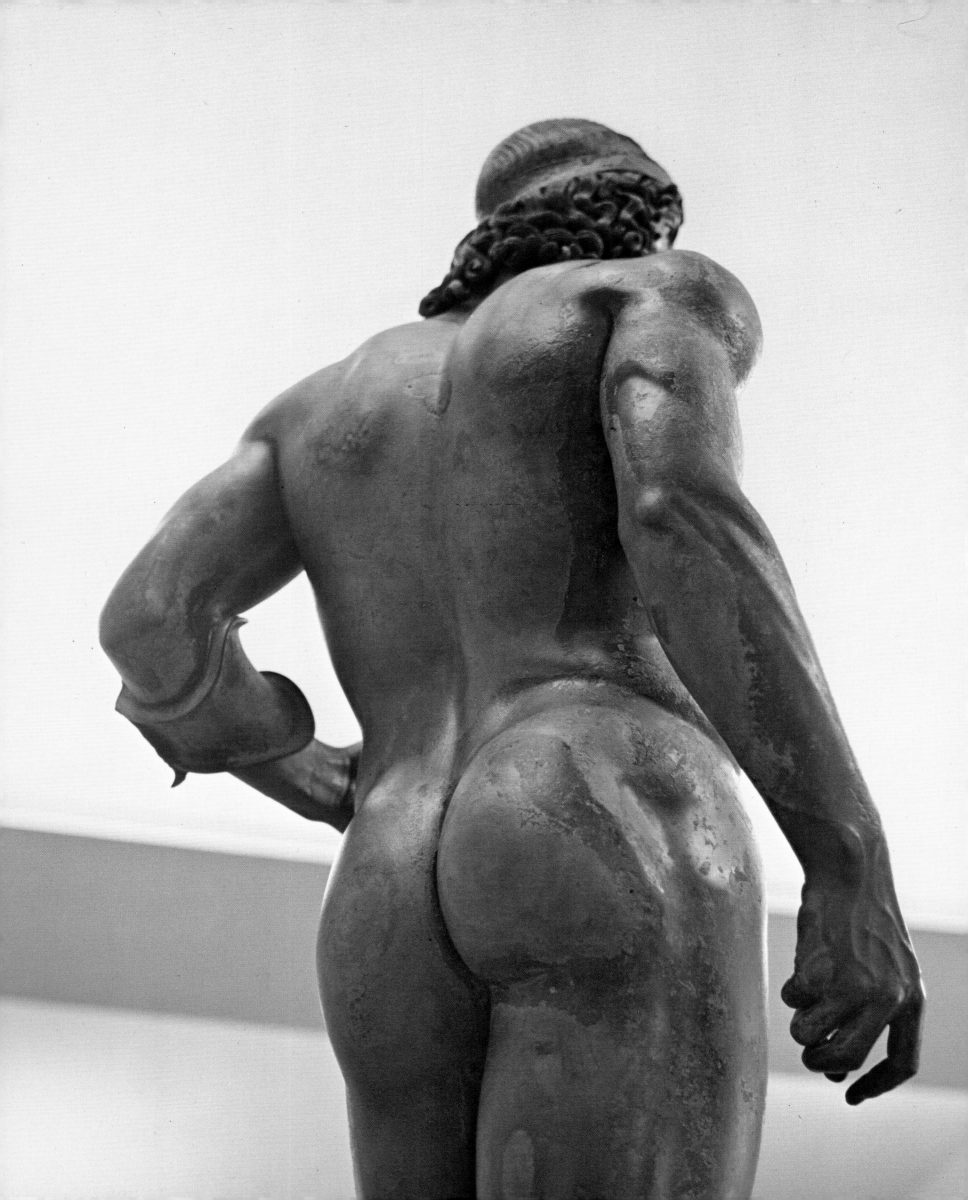

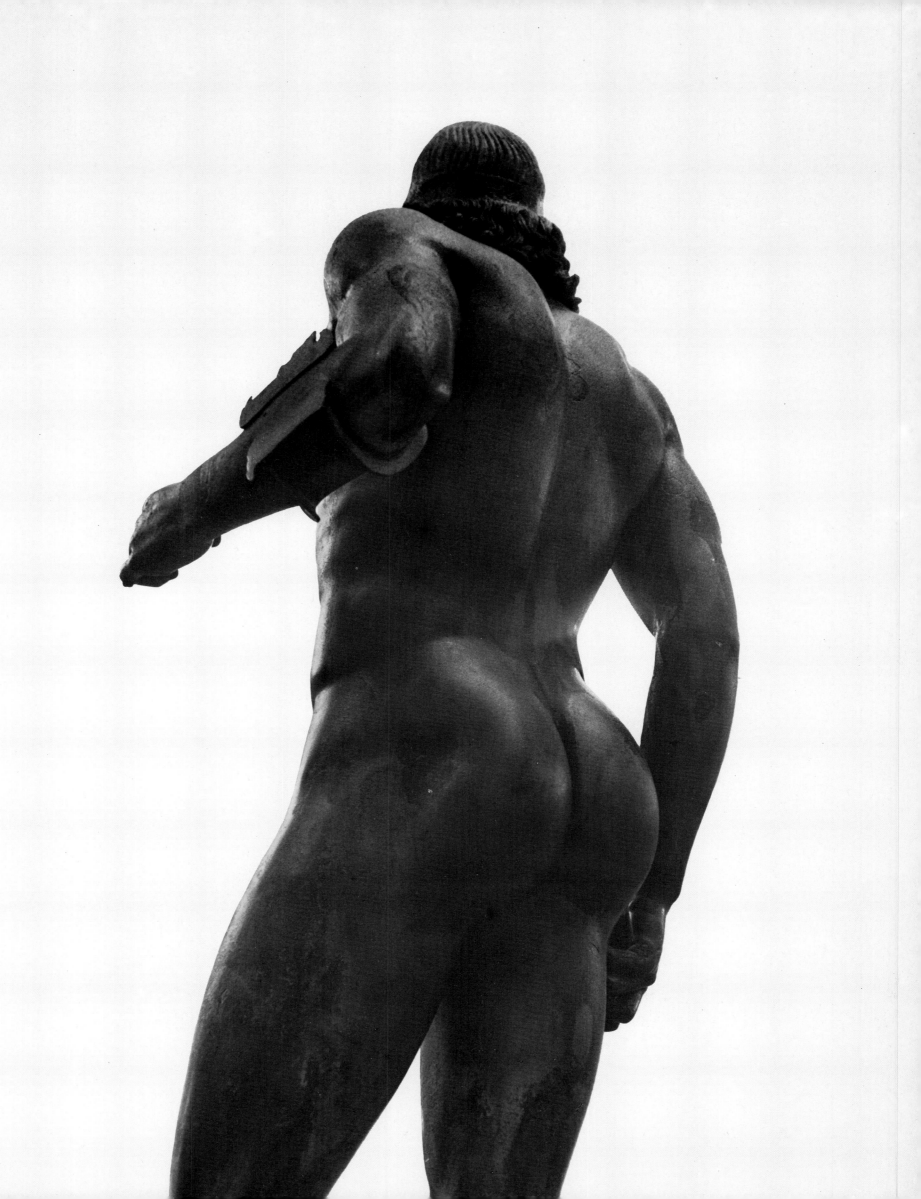

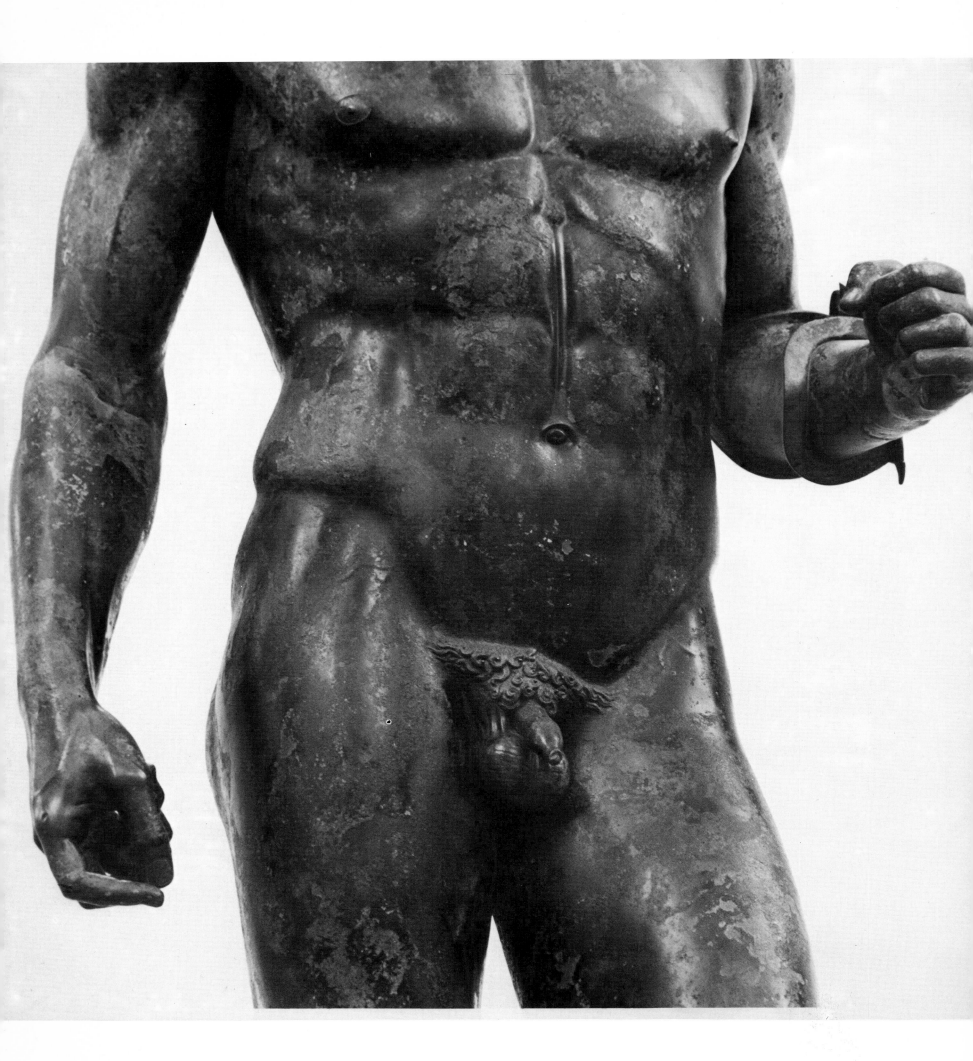

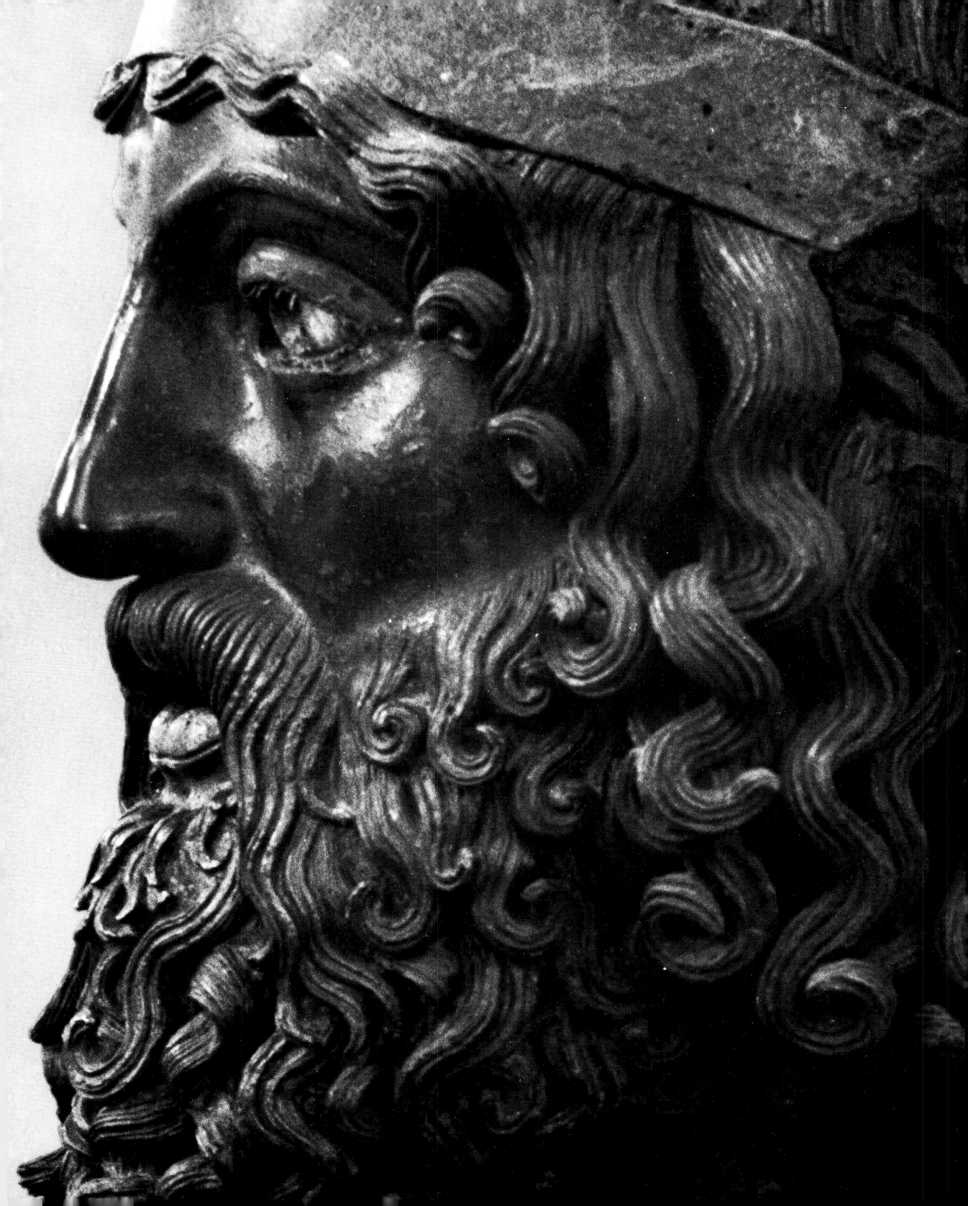

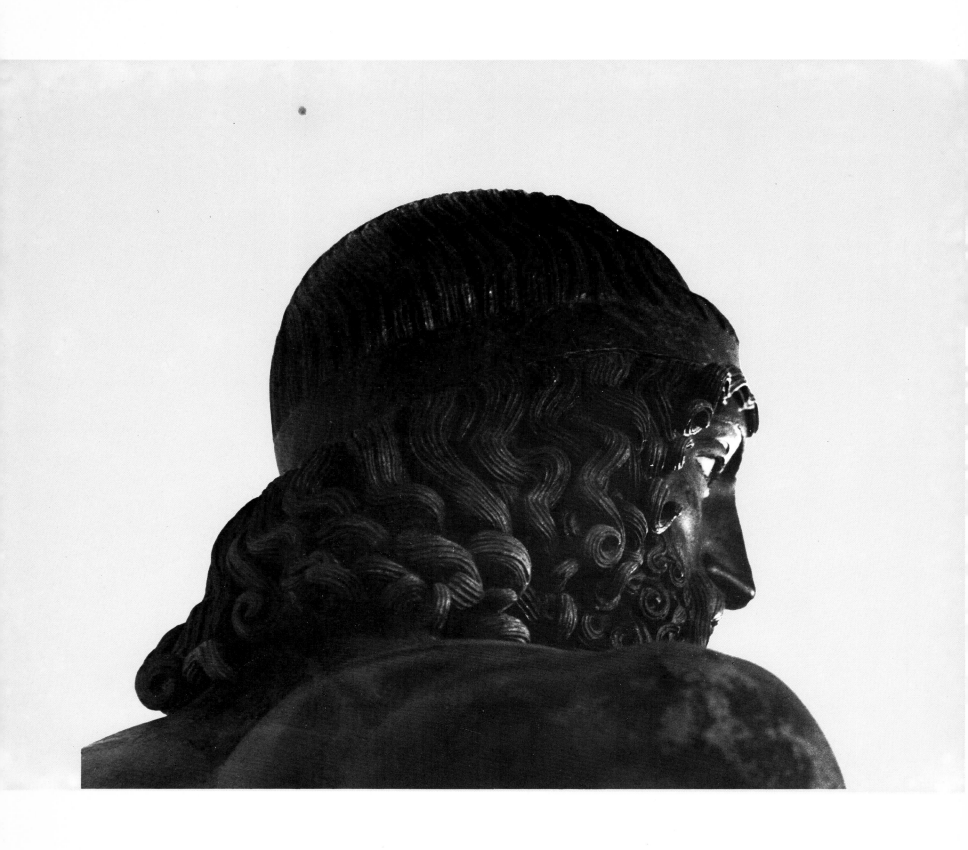

genesis in the *Delphi Charioteer* (pp. 20–31). A comparison of this Early Classical work with the Classical *Warrior A* reveals the degree to which the latter work, with its progressively sharper turn of torso and head, had been liberated from the aesthetic constraints imposed by old rules.

The equilibrium of tension and rest in the legs finds its complement in the warrior's upper anatomy, where the left arm hangs in repose while the right one flexes and bends at the elbow. The spear steadied on the left has disappeared, leaving behind the mass of lead that once anchored the weapon. All that remains of the shield formerly carried on the right is its central strap, still wrapped about the figure's arm. The right hand gripped the shield's inside cord.

Lifelike veins stand out with particular, almost pulsating clarity on the warrior's hands and feet, their naturalistic, ramified pattern a witness to the sculptor's thorough understanding of human anatomy. Still, the figure is no replication of a specific body, but rather an idealized form drawn from knowledge of skeletal and muscular systems.

To increase the illusionism of his work, the Master of Warrior A fashioned the statue's distinctive parts separately and set those pieces into the main mass, a technique widely practiced by Greek sculptors. In this instance, the lips and nipples were made of copper, the teeth of silver, and the eyes of colored stone and ivory.

Such close analysis and resolution of the conflicting needs of art and nature, evident everywhere in *Warrior A,* reflects a mind that conceived the whole to be a unity of distinct and recognizable parts, which function together but maintain their individual identities. At work here is an artistic personality whose formidable powers, as we shall see, were quite different from those to be found in *Warrior B* (pp. 128–133).

Warrior A provides spectacular viewing from every angle. Since the back is as beautifully designed and as sensitively modeled as the front, the sculpture may have been made for an open space where it could be seen from all sides. In Classical Greece statues of this scale and expense stood in public places, and the larger the piece the greater the likelihood of its placement out-of-doors, where it could be approached from every side. *Warriors A* and *B* being so similar, they may well have come from one elaborate monument, whose message must have been impressive indeed.

The idea of a monument commissioned for an important public site seems all the more feasible since *Warrior A* would seem to represent a hero who led a Greek military triumph. But his precise identity and the location of his monument pose a problem that has yet to be solved, owing to the scanty archaeological evidence and the lack of relevant inscriptional or literary information. However, the art makes its own statement, the character of which would be hard to mistake. It tells us that the mid-fifth-century Greeks who commissioned this sculpture valued rational action, courage, physical fitness, and success. They also remembered that they owed their freedom from the threatening Persian Empire to military strength and strategy. The men who espoused those values and achieved those goals were revered as heroes twice over, worthy of portrayal in beautiful, idealized human form.

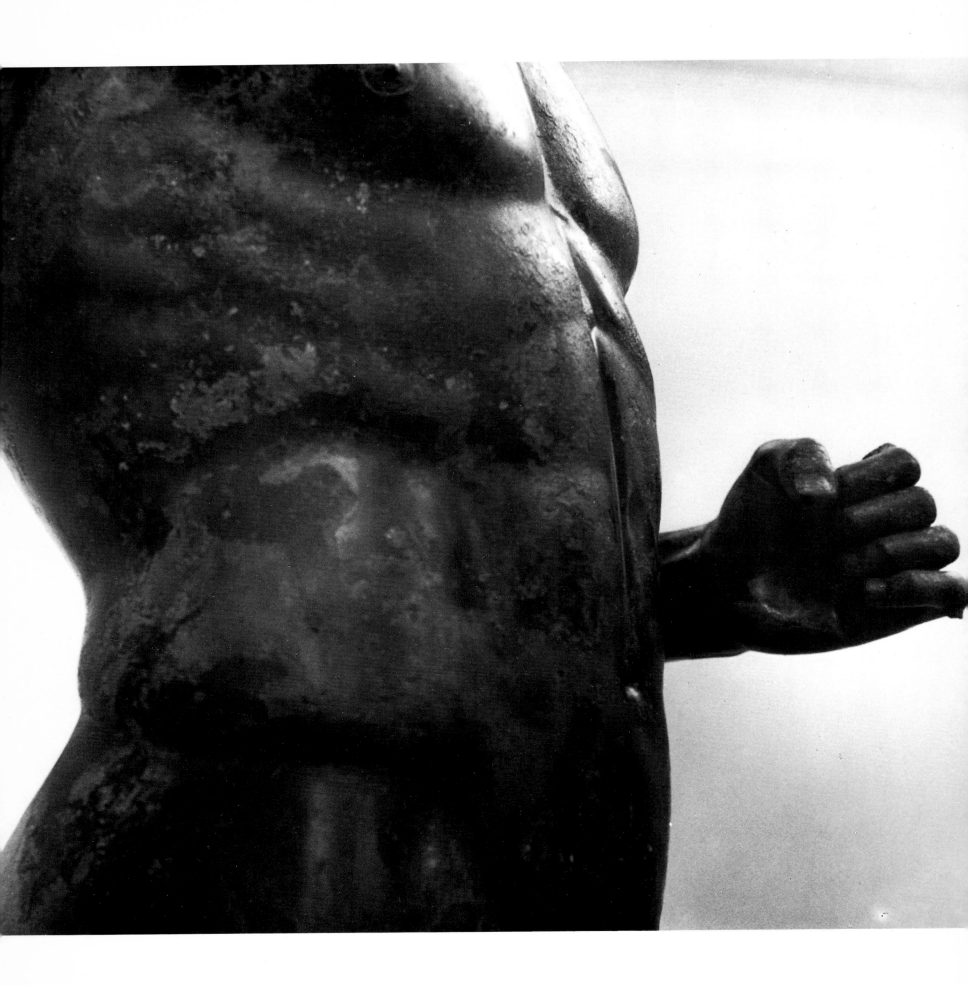

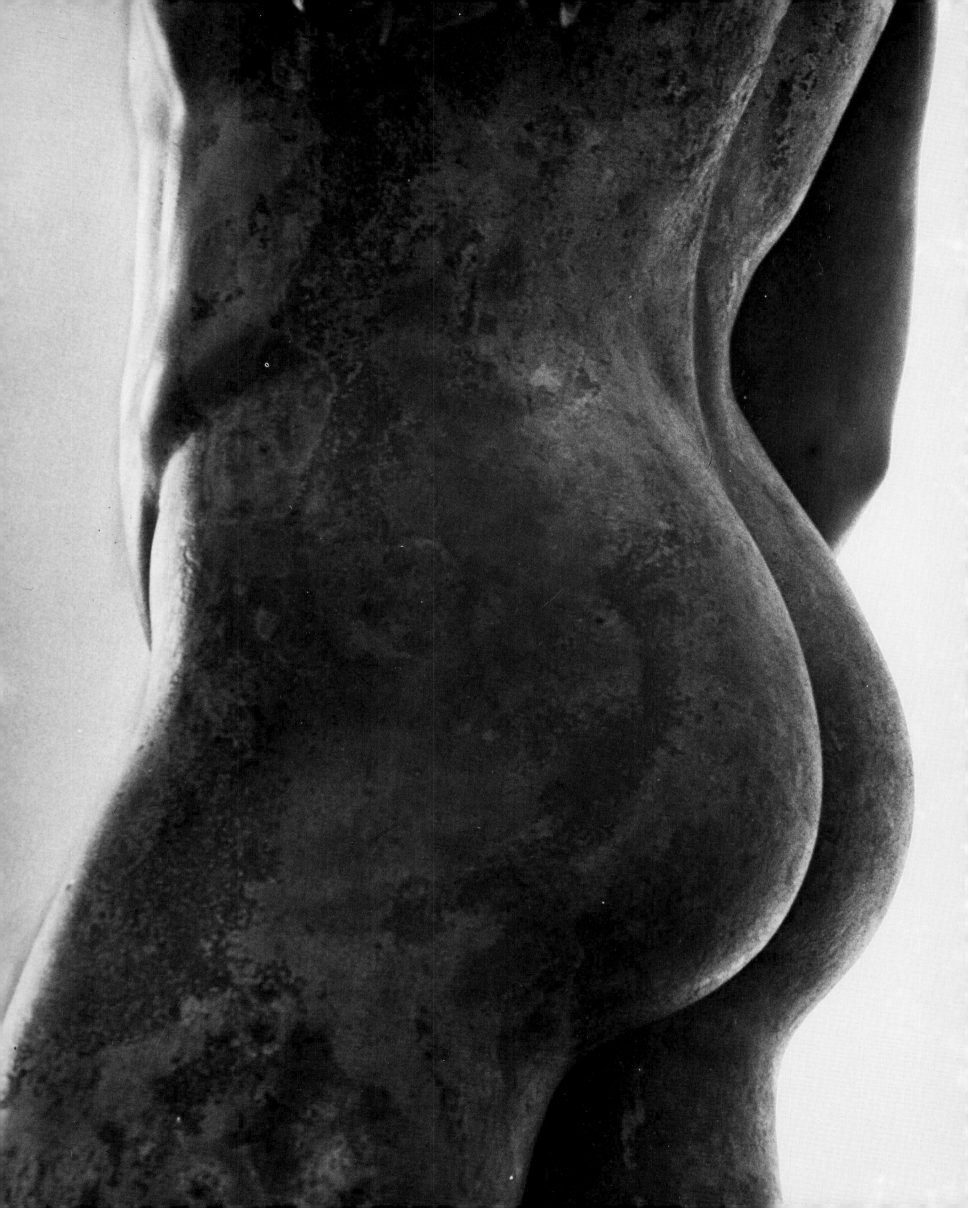

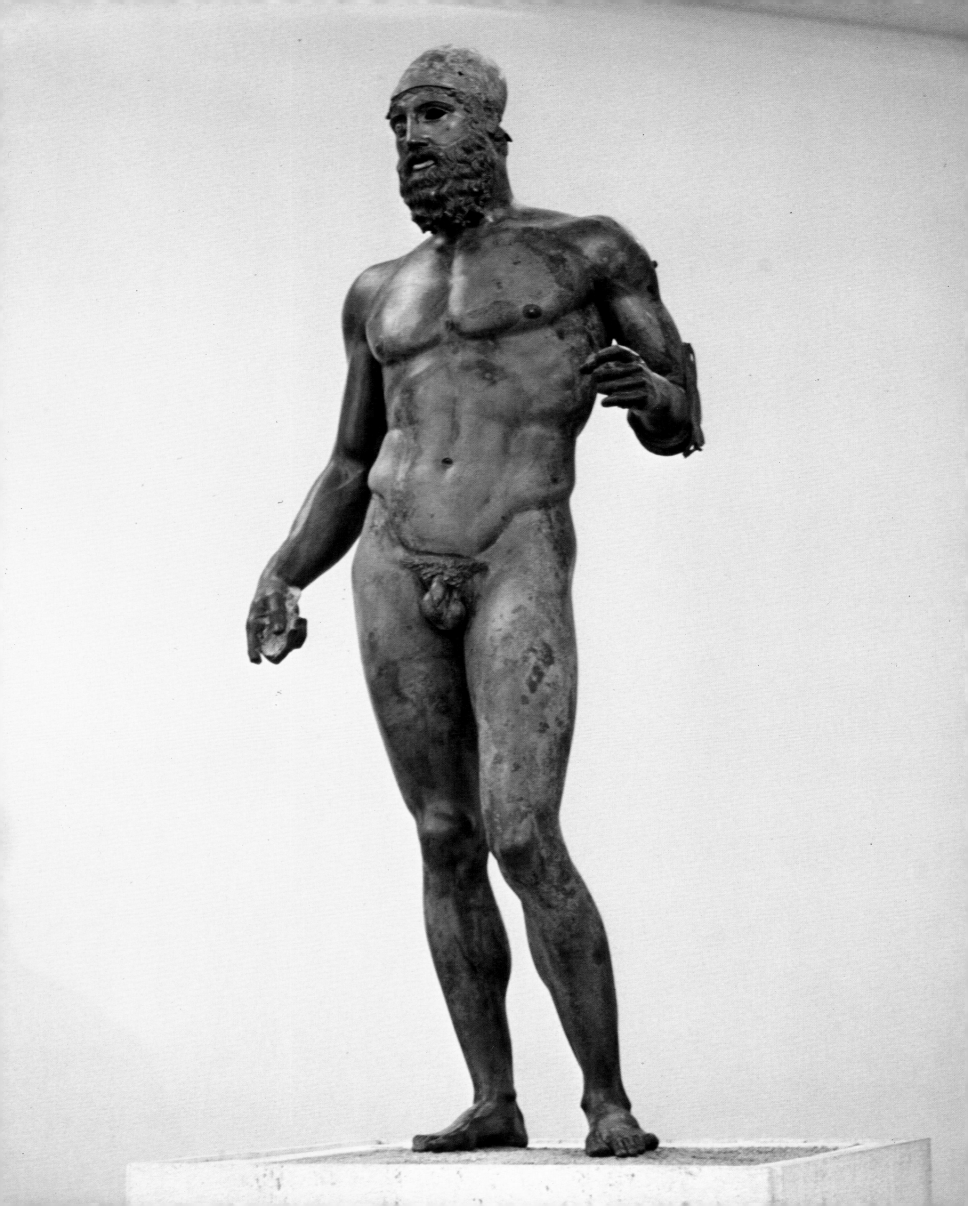

WARRIOR B

CLASSICAL, MID-FIFTH CENTURY B.C.

HEIGHT: 2.06 M.
FOUND IN THE IONIAN SEA NEAR RIACE MARINA, A.D. 1972
NATIONAL MUSEUM, REGGIO DI CALABRIA

Warrior B, discovered along with *Warrior A* in the Ionian Sea off the coast of southern Italy, has survived in less good condition than its companion in burial. The most noticeable damage to the sculpture is that on the head. The helmet has been lost, making the head appear encephalitic, since the crown forms a lopsided dome meant to support the helmet. While helmeted, the head would have resembled the famous portrait of Perikles known from Roman copies.

The restorers have managed to save the figure's badly deteriorated right eye, but nothing could be done about the missing left one. Also gone are the shield formerly carried on the left arm and the spear once held by the right hand. We know that those weapons existed from the position of the warrior's arms and hands, the central holding strap still attached to the left arm, and the lead solder that bonded the spear to the right palm.

Even before the removal from its original site,

Warrior B had undergone repairs to its arms, evidence of which appears in break lines around both biceps. Moreover, the bronze alloy used for the main mass differs from that found below the breaks, where the metal seems to have been mixed from a recipe not known until Hellenistic times. The surface veins on the arms, especially those on the hands, have been articulated with the same precise definition characteristic of the original work. Otherwise below the breaks, the arms reveal relatively angular transitions between areas and a greater profusion of muscles, manifestly a taste more Hellenistic than Classical. But since the contour of the lower arms completes the outline established by the shoulders and the arms above the breaks, we may assume that the later parts conform to the original design. It could be that the present arms are simply replacements made to match the original ones in a repair carried out more than a century after the statue had been cast.

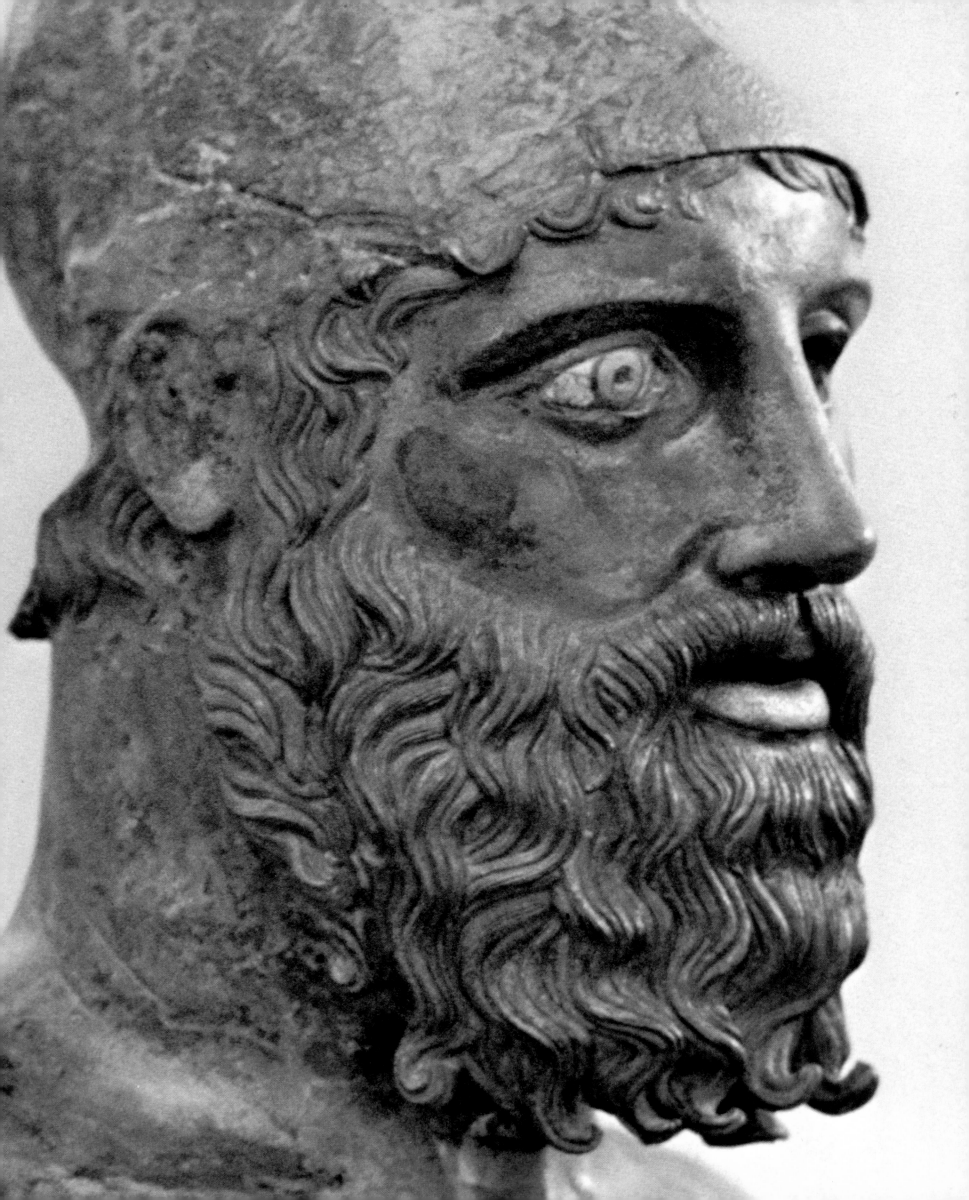

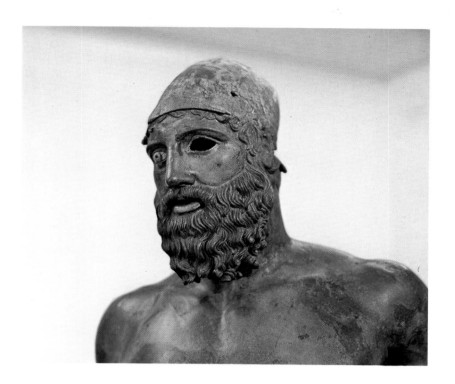

Amazing similarities exist between *Warrior B* and its companion, *Warrior A* (pp. 118–127). The statues even share the same heroic scale, since each stands 2.06 meters tall. The subjects portrayed are both mature men with short beards, and both appear in the nude, splendid specimens that seem all the more so for their lack of evident self-consciousness, a quality typical of Classical Greek men. Each has been posed to turn slightly to his right, with the right leg bearing most of the figure's weight. In both instances the right hand steadied a spear, falling in a relaxed attitude at the image's side, while the left arm, bent at the elbow, carried a large shield. The same technique served for the one sculpture as for the other; thus, shields and spears were cast separately, just as the eyes were made as independent parts and set into the mass. The bronze too is the same (except for the lower arms of *Warrior A*), a median mixture among the alloys used in ancient Greece for monumental sculpture, but unique in its particular compound of copper and tin.

Differences arise, however, when it comes to personality. Compared to the commanding, self-assured carriage of *Warrior A,* the posture of *Warrior B* seems that of a gentle, almost retiring spirit. Whereas tension runs through the spiral twist of *Warrior A*, the pliant body of *Warrior B* swings into a soft, relaxed Polykleitan S-curve (see p. 135). Equally proud men, they have both accepted their military roles, although the firm, aggressive character of *Warrior A* appears better suited for battle than the uncombative nature of *Warrior B*.

The *Warriors* also reflect two distinct artistic personalities. The style of the sculptor who created *Warrior A* adhered more closely to the Early Classical tradition, while the author of *Warrior B* worked in a High Classical mode. Despite the similarity of the poses, the *Warrior A* artist loosened the stiff frontal stance of Archaic statuary and ro-

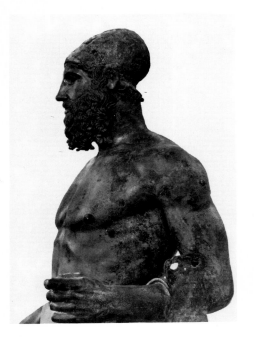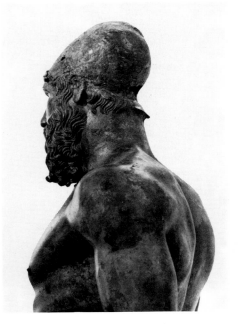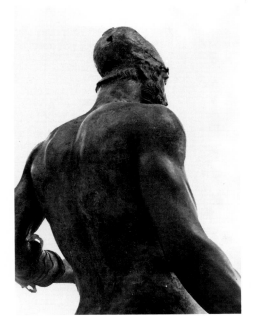

tated his figure along a spiral like that of the *Delphi Charioteer,* but the Master of Warrior B went further and adopted the S-curve introduced by Polykleitos. While the former viewed sculpture as a union of separate and distinct but functionally integrated parts, the latter conceived of his statue as an indivisible entity, in which forms flow together in a unified, organic whole.

The special artistic mentality of each sculptor is particularly evident in his handling of hair. Clearly, the Master of Warrior A liked to distinguish each and every lock. But while differentiating hair and flesh, the *Warrior B* artist contrived to make them seem manifestations of the same continuous form.

For a comparable pairing of artistic opposites, we have only to consider the pedimental sculpture from the Temple of Zeus at Olympia. There, the artist in charge of the space over the main entrance (the east end) worked in a more conservative style than that of the progressive master responsible for the figures on the west pediment. Such disparity has its logic, however, given the probability that the more important commission would have gone to a senior sculptor and the less prestigious assignment to a junior colleague. Some such division of labor may explain the difference in both style and expressive content displayed by the Riace Marina bronzes.

Because of the constant factors related to the Riace figures—similar poses, common locus of production, identical alloy of bronze, same monument—the variations in style and feeling become all the more fascinating and informative as indices to developments leading from the crisply defined, vigorous naturalism of Early Classical art to the more unified, softer idealizations of High Classical expression. But whatever the direction of their formal qualities, *Warrior A* and *Warrior B* are equally triumphant as witnesses to the eternal magnificence of ancient Greek art.

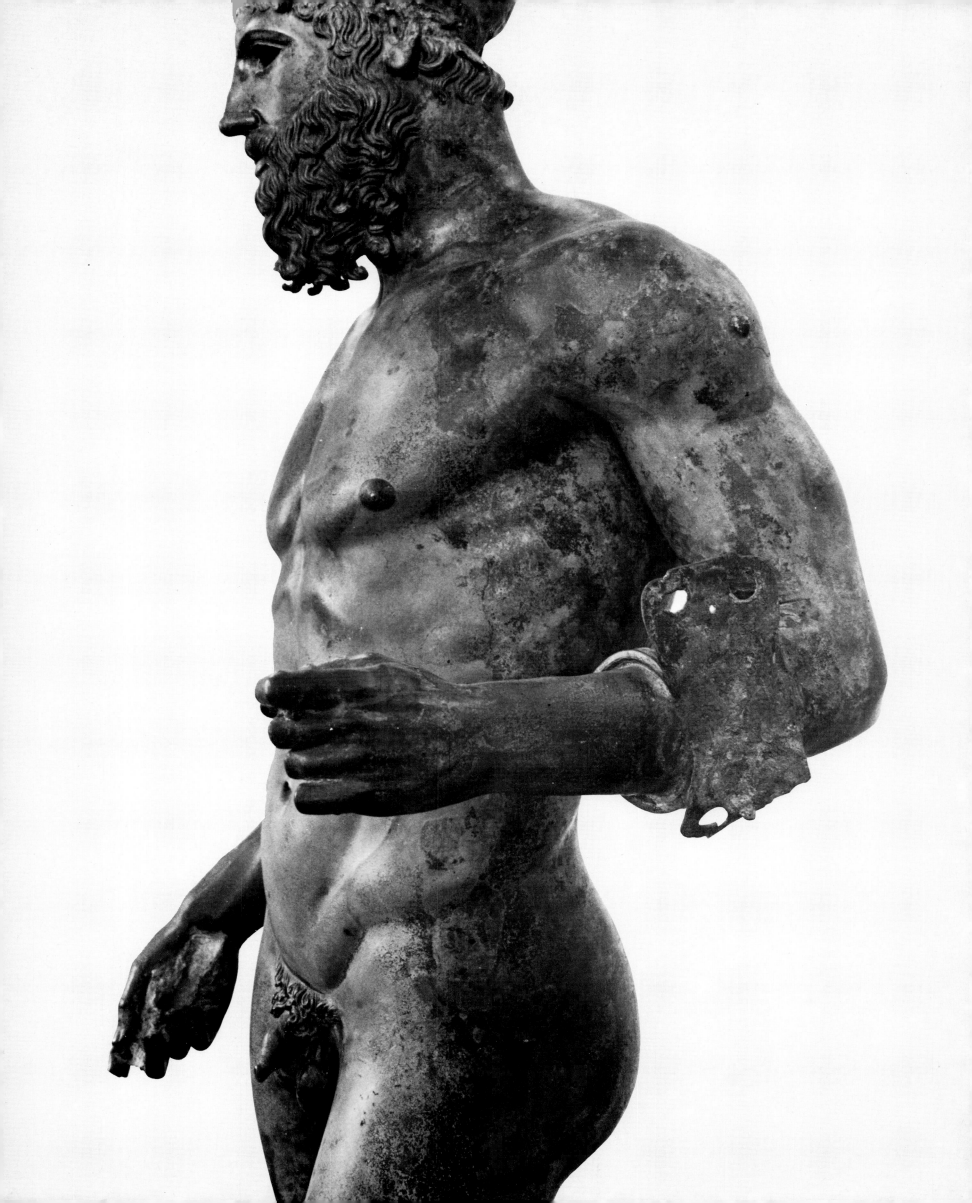

APPENDIX

ILLUSTRATIONS FOR COMPARISON

RIGHT: *Athena Promachos.* Greek bronze of the sixth century B.C. National Museum, Athens.

 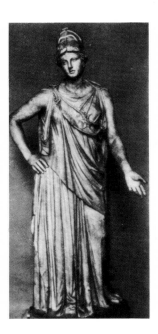

CENTER RIGHT: *Prince Ankh Haf.* Egyptian Old Kingdom, 4th Dynasty, 2900–2750 B.C. Museum of Fine Arts, Boston.

FAR RIGHT: *The Mattei Athena.* Roman copy in marble of the *Pireaus Athena,* c. 350 B.C. (see pp. 58–61). Louvre, Paris.

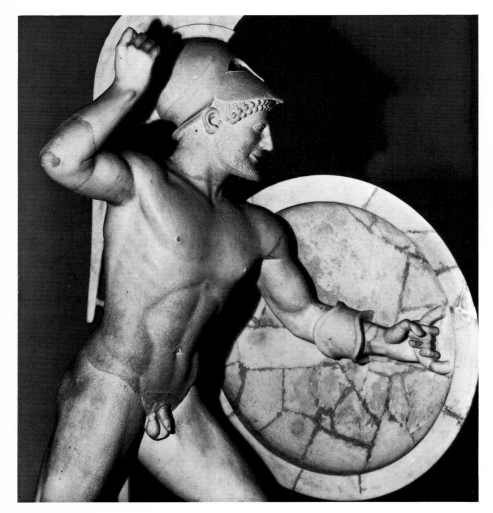

LEFT: *Warrior,* from the west pediment of the Temple of Aphaia at Aegina. c. 490 B.C. Marble. Glyptothek, Munich.

ABOVE: *Poseidon Brandishing His Trident.* Obverse side of a silver coin from Poseidonia. c. 510. Staatliche Museen, Berlin. (Reproduced from Kraay and Hirmer, *Greek Coins,* published by Thames and Hudson, London, and Harry N. Abrams, N.Y.)

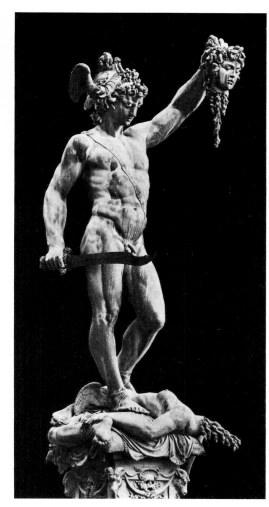

NEAR: Polykleitos, *Doryphoros.* Roman copy in marble of a Greek original of c. 450–440 B.C. Vatican Museums, Rome.

FAR: Benvenuto Cellini, *Perseus.* 1545–54. Bronze. Loggia dei Lanzi, Florence. (Photo courtesy EPA-Alinari, N.Y.)

NEAR: Praxiteles(?), *Hermes and Dyonysos.* c. 340 B.C. Marble. Museum, Olympia.

FAR: Lysippos, *Apoxyomonos.* Roman copy in marble after a bronze original of c. 330 B.C. Vatican Museums, Rome. (Photo courtesy EPA-Alinari, N.Y.)

SUGGESTED READING

Beazley, J. D., and Bernard Ashmole. *Greek Sculpture and Painting.* Cambridge (England), new ed., 1966.

Bieber, Margarete. *The Sculpture of the Hellenistic Age.* New York, 2nd rev. ed., 1961.

Boardman, John. *Greek Art.* London and New York, rev. ed., 1973.

Bol, P. C. "Grossplastik aus bronze in Olympia," *Olympische Forschungen,* IX. Berlin, 1978.

Busignani, A. *Gli Eroi di Riace.* Florence, 1982.

Carpenter, Rhys. *Greek Sculpture.* Chicago, 1960.

Chamoux, F. "L'Aurige de Delphes," *Fouilles de Delphes,* IV:5. Paris, 1955.

Charbonneaux, Jean. *Greek Bronzes.* Paris and New York, 1962.

Comstock, Mary, and Cornelius C. Vermeule. *Greek, Etruscan and Roman Bronzes in the Museum of Fine Arts, Boston.* Greenwich, 1971.

Doehringer, S., D. G. Mitten, and A. Steinberg, eds. *Art and Technology: A Symposium on Classical Bronzes.* Cambridge (Mass.), 1970.

Dorig, J. *Onatas of Aegina.* Leiden, 1980.

Frel, J. *The Getty Bronze.* Malibu, 1983.

Hanfmann, George M. A. *Classical Sculpture.* Greenwich, 1967.

Harrison, Evelyn B. "Archaic and Archaistic," *The Agora of Athens,* XI. Princeton, 1965.

Havelock, Christine. *Hellenistic Art.* New York, 2nd ed., 1981.

Kallipolitis, V. G., and Evi Touloupa. *Bronzes of the National Archaeological Museum of Athens.* Athens, n.d.

Karouzou, S. *National Archaeological Museum: Collection of Sculpture.* Athens, 1968.

Kluge, K., and K. Lehmann-Hartleben. *Die antiken Grossbronzen.* Berlin and Leipzig, 1927.

Lamb, W. *Greek and Roman Bronzes.* Enlarged by L. K. Congon. Chicago, 1969.

Lippold, G. "Die griechische Plastik," *Handbuch der Archäologie,* III, 1. Munich, 1950.

Lullies, R., and M. Hirmer. *Greek Sculpture.* New York, rev. and enlarged ed., 1960.

Mattusch, Carol. "Bronze Workers in the Athenian Agora," *Excavations of the Athenian Agora,* Picture Book No. 20. Princeton, 1982.

Mitten, D. G., and S. Doehringer. *Master Bronzes from the Classical World.* Mainz, 1967.

Palagia, O. *Euphranor.* Leiden, 1980.

Pausanias. *Guide to Greece.* English trans. and commentary by J. Frazier. London, 1913. Also by P. Levi (London, 1971).

Picard, C. *Manuel d'archéologie grecque, la sculpture,* I–V. Paris, 1935–63.

Pliny the Elder. *Natural History.* Trans. by K. Jex-Blake and E. Sellers. London, 1896.

Pollitt, J. J. *Art and Experience in Classical Greece.* Cambridge (England), 1972.

Richter, Gisela M. A. *Sculpture and Sculptors of the Greeks.* New Haven, 4th ed., 1970.

Ridgway, Brunilde S. *The Archaic Style in Greek Sculpture.* Princeton, 1977.

———. *Fifth-Century Styles in Greek Sculpture.* Princeton, 1981.

———. *The Archaic Style in Greek Sculpture.* Princeton, 1977.

Robertson, Martin. *A History of Greek Art.* Oxford, 1975.

Sjöqvist, Erik. *Lysippus.* Cincinnati, 1966.

Stewart, A. F. *Skopas of Paros.* Park Ridge (N.J.), 1977.

Svoronos, J. N. *Das athener Nationalmuseum.* Athens, 1908–13.